japaNese ANiMatioN

From Painted Scrolls to Pokémon

japaNese ANiMatioN

From Painted Scrolls to Pokémon

brigitte koyama-richard

Flammarion

To my parents

Preface

Playful and educational, with an artistic flourish at times, Japanese cartoons (anime*) are an integral part of Japanese life in this early twenty-first century. Whether intended for the big or small screen, designed for cable TV subscribers, run on a mobile phone, or directly marketed as a DVD, Japanese animation, with its originality and quality, has gone beyond the borders of its homeland. Though Western audiences are now familiar with *Goldorak, Dragon Ball, One Piece, Naruto, Pokémon*, etc., they know only the tip of the iceberg, given the profusion of output from Japan. And though we may have become so blasé that nothing surprises us anymore, it is important to remember that animation was not born overnight. Centuries of research were needed to perfect this technique, which is continually evolving. Human beings have always sought to express movement and to give life to the things around them. Yet, in trying to achieve this, the course has sometimes been a faltering one. From illuminated scrolls to the emergence of the first animated films, as well as prints, automatons, and pre-cinema, through to contemporary anime, this book reveals the artistic secrets that have shaped this Japanese graphic sensibility, teeming with imagination, which has given rise to the gems of contemporary animation. It will also investigate Japan's future in this field.

CONTENTS

Preface

Animation's Long Journey Through Time **11**

Illuminated scrolls or illusions
of movement 11

Monsters and *yōkai*: a painted scroll
parading one hundred demons 13

The rise of the merchant classes 16

The art of playing with perspective 24

Japanese and "Western-style" Chinese art 25

Shadowgraphs and "*ombres chinoises*" 37

Magic lanterns 43

Interview with Laurent Mannoni,
curator of the technology collection
at the Cinémathèque Française 46

Utsushi-e, the magic lanterns of Japan 52

Interview with Yamagata Fumio,
director of the Minwaza company 54

Automata 60

Interview with Suzuki Kazuyoshi,
director of research at the National
Museum of Nature and Science, Tokyo 63

Pre-cinema and Great Inventions **67**

The illusion of movement 67

The emergence of cinema and cartoons 71

The pioneers of Japanese animation 72

The Big Production Companies **85**

Tōei, a half-century of animated films,
1956–2006 85

Interview with Watanabe Yoshinori
(Ryōtoku), former vice president of Tōei 94

Interview with Shimizu Shinji, director
of Tōei's Planning Department 106

Interview with Mizuki Shigeru, mangaka 109

Tezuka Osamu (1928–1989), god of manga
and father of TV anime 114

Interview with Matsutani Takayuki,
president of Tezuka Productions 125

Interview with Kotoku Minoru, production
manager at Tezuka Productions 127

Interview with Shimizu Yoshihiro,
rights manager at Tezuka Productions 129

A new version of *Astro Boy* 132

Yokoyama Ryūichi and the Otogi Studio 132

Tatsunoko Production 134

Interview with Narushima Kōki, president
and CEO of Tatsunoko Production 140

TMS Entertainment 142

Shin-Ei Dōga 148

Production I.G. 152

Interview with Ishikawa Mitsuhisa,
president and CEO of Production I.G. 158

Madhouse 160

Interview with Maruyama Masao,
 chief creative officer at Madhouse 162

Interview with Rintarō, director
 and producer at Madhouse 164

Hello Kitty, one of Japanese animation's stars 168

The evolution of Japanese animation 169

**The Empire of Manga and Animation:
the Role of the Big Publishers** **171**

Interview with Kubo Masakazu, producer
 and editor in chief at Shogakukan 175

A great manga figure: Chiba Tetsuya 179

Interview with Chiba Tetsuya, *mangaka* 181

Interview with Igarashi Takao,
 vice president at Kōdansha 183

Interview with Ishii Tōru,
 editor-in-chief at Kōdansha 185

From manga to anime 188

Back to their roots 193

**Kawamoto Kihachirō, Grand Master
of Puppet Animation** **195**

Interview with Kawamoto Kihachirō 204

The Dōjōji painted scroll 212

Revival and Consecration of Japanese Anime **219**

The new generation: Katō Kunio, the poet
 of Japanese animation 220

Interview with Katō Kunio, animator
 at Robot Communications Inc. 221

The Suginami Animation Museum, Tokyo 224

Interview with Suzuki Shin.ichi, director
 of the Suginami Animation Museum 225

Notes 229

Glossary 231

Selective Bibliography 235

Acknowledgments 244

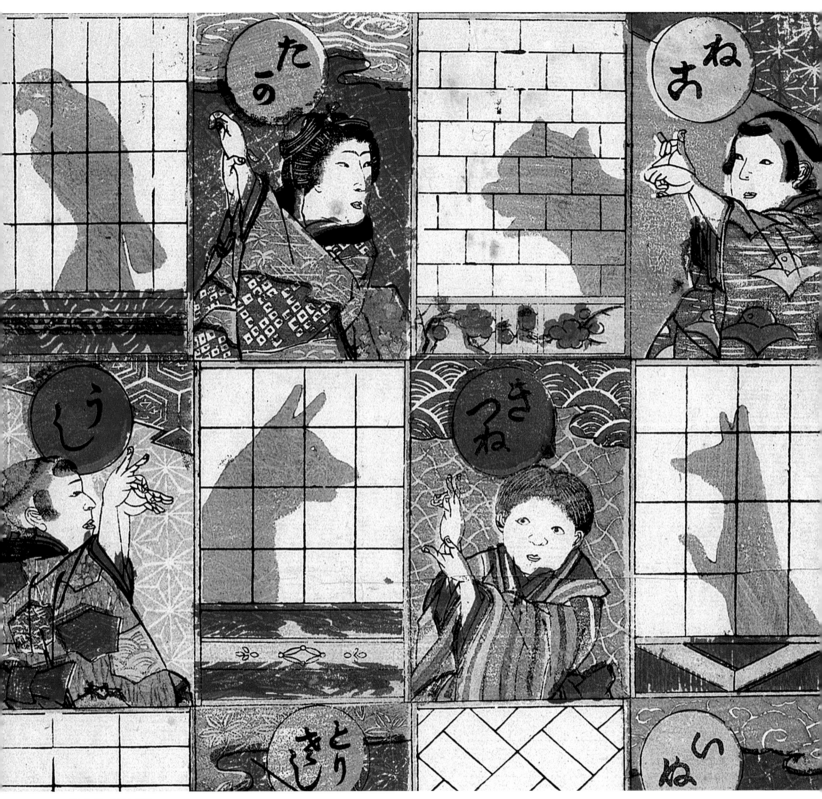

Detail of fig. 67.

ANIMATION'S LONG JOURNEY THROUGH TIME

Illuminated scrolls or illusions of movement

The Japanese have always been experts at incorporating and integrating elements taken from foreign cultures, restyling them to fit their own specific universe. While it was not until the sixteenth century that European influence began to show itself, that of China—particularly in the field of art—goes back much further.

Chinese in origin, illuminated scrolls are a case in point, demonstrating the Japanese people's remarkable sense of adaptability. These precious scrolls, designed for monks or the aristocracy, appeared in Japan around the tenth century; two hundred years later, they were to attain an unprecedented virtuosity. Illustrating religious, literary, or historical scenes, they also provided the image of a fantastical bestiary and adapted morality tales or stories designed for children.

In *One Thousand Years of Manga* (Flammarion, 2007), such scrolls were presented as the beginnings of the cartoon. The present volume is an invitation to explore this idea, based on research by Japanese experts who argue that these scrolls are not only the precursors of manga*, but also of animated feature films. Of all the masters of animation or scholars at the root of this assertion, Imamura Taihei was one of the first to tackle and analyze the issue in his "Essay on Japanese Anime." Takahata Isao then went on to develop and illustrate

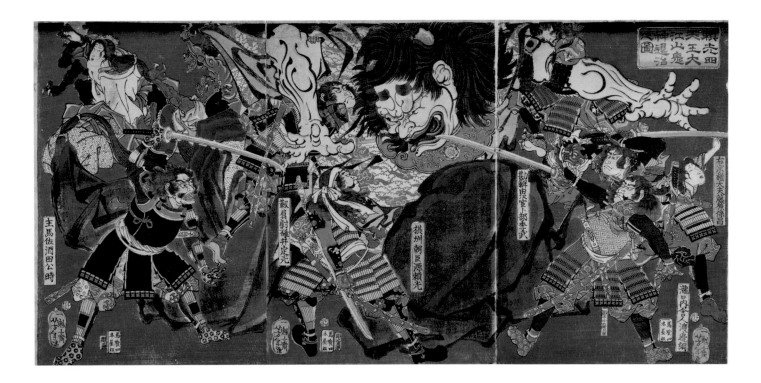

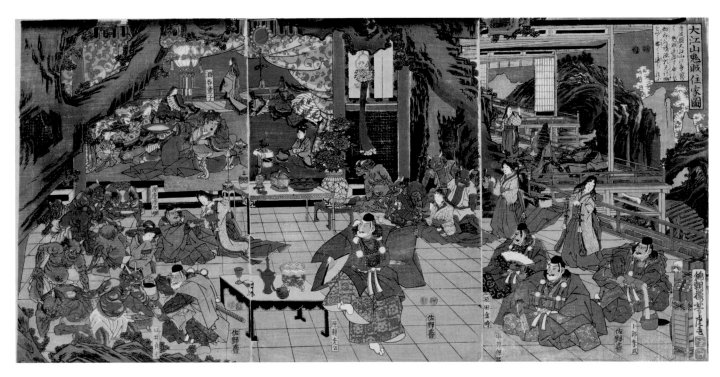

1
Tsukioka Yoshitoshi, *Raikō shi tennō Ōeyama kijin taiji no zu
(Raikō—Minamoto no Yorimitsu—and the Four Heavenly Kings
Slaying the Demon of Ōeyama)*, 1864. Polychrome woodblock
print, triptych, Kumon Institute of Education.

2
Kinchōrō Yoshitora, Utagawa Yoshitora, *Ōeyama kizoku
sumi ka no zu (The Demon of Ōeyama)*, Edo period,
c. 1847–52. Polychrome woodblock print, triptych,
Kumon Institute of Education.

it in his work, *Evocations of Cinema and Animated Films in Twelfth-Century Painted Scrolls Listed as "National Treasures."* The famous director Rintarō also clearly confirmed this in the interview he granted me for this book. All of these people quite rightly consider that there are too many similarities between these two modes of expression. By adopting the myriad perspectives taken from China and supplementing them with new elements—real-life facial expressions, blocks of color as in celluloids (cels)*, parallel movement, effects of zoom, the portrayal of characters linked to action—the world created in the painted scrolls was close to that of animation. To illustrate my argument, I have chosen to focus not on classical painted scrolls listed as "National Treasures," but on works largely unknown to Western audiences that are worth discovering for their fanciful and original nature and structure.

Monsters and *yōkai*:
a painted scroll parading one hundred demons

Strange happenings, the supernatural, magic, and the inexplicable fascinate us—as the worldwide success of *Harry Potter* goes to show. In Japan, *yōkai**—a kind of supernatural being that has various guises, or uncontrollable, terrifying, or friendly phenomena—have haunted folk tales and stories, as well as the art world, for centuries.

Represented in pictorial form since medieval times, they would appear in books or on painted scrolls. Demons and *yōkai* were very popular and gave rise to a host of variations. The Pokémon, Mizuki Shigeru's *yōkai* and the ones that charm us so in Miyazaki Hayao's *Chihiro (Spirited Away)*, the *tanuki** in Takahata Isao's film *Ponpoko*, the hero's metamorphoses in *Dragon Ball*, and those in *Naruto*—aren't these all a legacy of the *yōkai*, a prime example of which can be found in the painted scroll of *The Night Parade of One Hundred Demons?* Given their animistic worldview, it is hardly surprising that the Japanese have recourse to a wealth of *yōkai* in their art, literature, manga, and animation.

One of the oldest tales, *Shuten Dōji (The Drunken Boy Ogre)* was widely illustrated from the Nara to the Edo period in the form of

Figs. 3–6

3–6 *(Pages 14–15)*
Anonymous, *Hyakki yagyō emaki (The Night Parade of One Hundred Demons)*, late Edo period. Painted scroll, 15 ½ x 436 in. (38.9 x 1,109 cm), Kumon Institute of Education.

The Night Parade of One Hundred Demons has been the source of many pictorial representations. With a dash of humor, it brings together a collection of metamorphosed objects. Folk belief held that once an object reached its hundredth year, it would turn into a *yōkai*. It was therefore advisable to abandon it before the fateful date. However, legend had it that some objects nonetheless managed to change their form, resolving to take revenge on the humans who cast them out after using them for years. They spread terror, but were vanquished in the end, finding repentance in the Buddhist faith.

While the human beings who chance upon this parade fear for their life, the *yōkai* for their part appear to be enjoying themselves immensely. The objects' spirits and the demons frolic gaily in their procession. Kitchen utensils (including a cauldron with a grotesque face wheeled along on a board), *sutra** scrolls and other objects of worship, a lantern, musical instruments (such as the *koto** or *biwa**), a colorful phoenix, she-demons applying their make-up, an umbrella *yōkai*—this motley crew of revelers dances, sings, and leaps until sunrise. Then they are all swift to turn tail, to avoid vanishing into daylight, so they can return at nightfall.

The figures on this type of scroll painting, designed to be unrolled piece by piece and admired in a small group, appear to come to life gradually—as in a film.

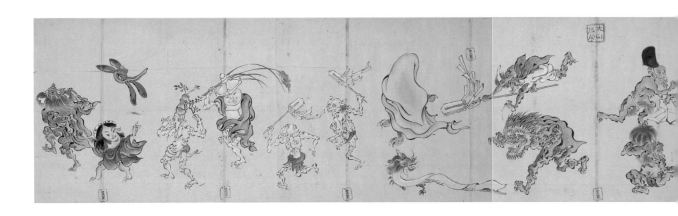

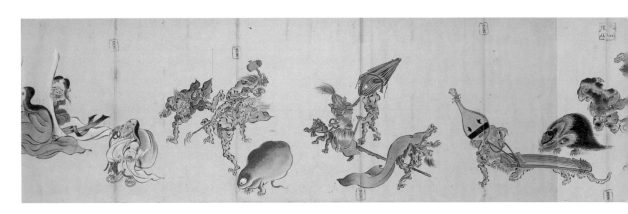

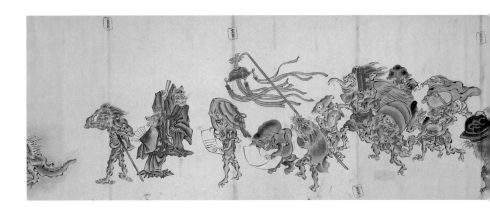

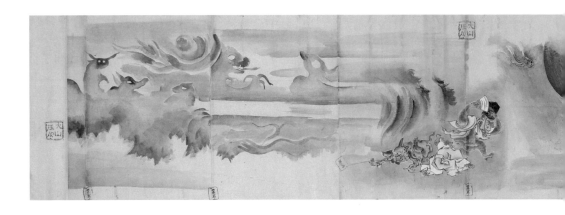

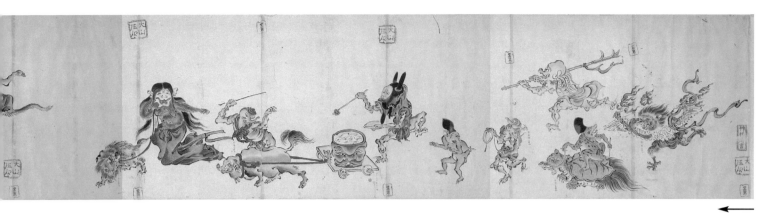

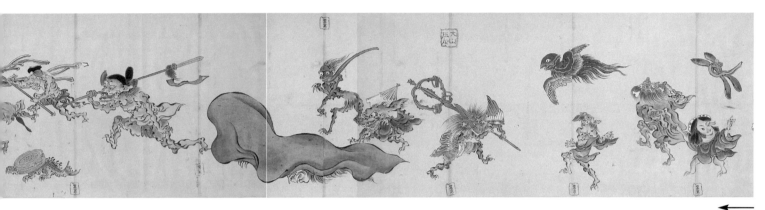

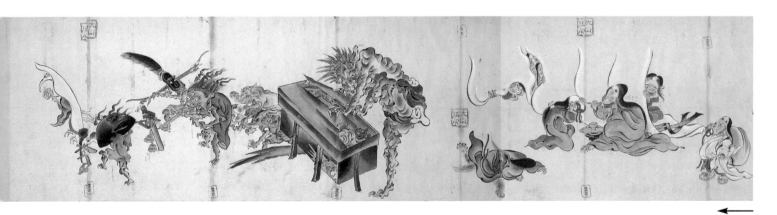

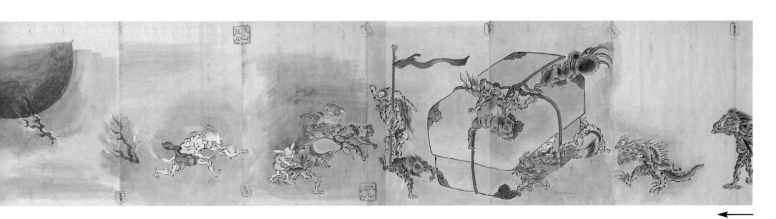

Anonymous, *Kowata gitsune (The Kowata Fox)*. Extract from a painted scroll, 1662–73, Kumon Institute of Education.

This moral tale recounts the love story of a young vixen and a seductive aristocrat. Unable to win the man's heart with her actual appearance, the vixen decided to take the form of a beautiful maiden before setting out to seduce the young man. Her mother, shown here with a human face and the body of a fox, reluctantly accompanied her as far as the handsome aristocrat's residence; seized by sudden panic, she pointed out a flaw in her daughter's metamorphosis—in her haste, the vixen had forgotten to hide her tail, which was sticking out from her kimono! The girl thanked her mother and completed her transformation. Seeing her radiant beauty, the young man fell madly in love with her. They were married, had a daughter, and lived happily until the child's third birthday. That day, the little girl received a big dog as a gift. Terrified, the vixen realized that her trickery would soon be disclosed. She drafted a long letter to her husband, revealing the truth and begging for his forgiveness. In tears, she then left the family home, regained her original appearance, and became a nun.

painted scrolls known as *Nara ehon* (Nara picture books)*, precious illuminated works or collections of polychrome woodblock prints. The *jōruri* puppet theater, *kabuki**, and *noh** also had their own versions.

The notion of metamorphosis, highly present in cartoons such as *Dragon Ball, Songoku*, or *Ranma 1/2*, was already to be found in traditional accounts and pictorial representations—painted scrolls and woodblock prints—in which countless foxes and *tanuki* (a kind of raccoon dog) would take on a human form to treat us to some exciting adventures.

Painted scrolls were a way of telling a story from various angles, with bird's-eye views of an interior landscape, dispensing with ceilings and roofs, thereby revealing the scene within, a technique known as *"fukinuki yatai*."* Wisps of cloud evoke the passage of time or the shift from one scene or action to another. There may also be close-up shots of certain figures, as in *The Drunken Boy Ogre*. The part of the scroll in which the monster's head breaks away from its body, flying off only to fall down again slightly further on, is truly evocative of an episode in a movie. And the one hundred demons scroll alone is a fine example of an action progressing frame by frame. The monsters set on various vertical planes give a sense of depth, perspective, and movement. Metamorphosis is also a very frequent theme in such scrolls.

Painted scrolls now form part of Japan's cultural heritage. One might think that they are now obsolete as a means of expression—yet they are nothing of the sort. This pictorial form continues to interest artists, as is borne out by Mizuki Shigeru—the *"yōkai master"*—who used it to tell the story of his life, just like in a movie (see Chapter III on Tōei, p. 85).

The rise of the merchant classes

Painted scrolls, like paintings and folding screens, were the preserve of the aristocracy and religious figures. With the advent of the new shogun* capital, Edo*, in 1603, and the institution of a new military regime, *sankin-kōtai**, merchants saw their fortunes increase to the detriment of those of the lords. In fact, this system obliged the latter to leave their faraway provinces to come and live in the capital with their large entourage of servants, and then to go back to their lands, leaving their wives and children behind as hostages.

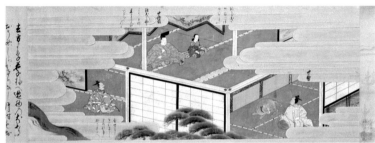
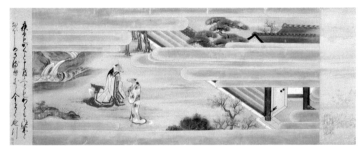

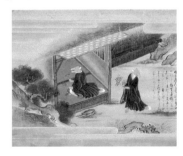

15–25 *(Pages 18–23)*
Anonymous, *Shuten Dōji emaki,* **1695. Painted scroll, 12 x 707 in. (30.9 x 1,796 cm), Kumon Institute of Education.**

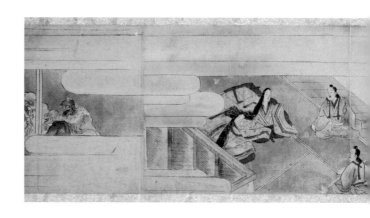

Shuten Dōji was the name of a monster living in the Ōe mountains, to the northwest of Kyoto. He would terrorize and kill the inhabitants, abduct the girls, and lay waste to the surrounding vicinity. To put a stop to his exactions, valiant warriors under the command of the shogun Minamoto no Yorimitsu (1147–1199) and the protection of four Buddhist divinities, set out to find him. They succeeded by guile in gaining access to his dwelling. Surrounded by the many servants and guards in his pay, Shuten Dōji was getting ready for a feast. At nightfall he regained his monstrous appearance, his nails and teeth giving way to claws and fangs, and demanded the favors of nine captive princesses. Just as there seemed to be no way out of this diabolical scene, the shogun's brave soldiers appeared and cut off the head of the creature: half-beast, half-demon. The shafts springing from Shuten Dōji's jaws convey his howling, rage, and pain as in a cartoon film. His head came crashing down and was used as a headdress by Yorimitsu. The men picked themselves up and went out to exterminate the monster's accomplices. The captive princesses were set free at last and the warriors, bringing back the blood-streaked head of their victim (borne in pails by servants here), made their triumphant return to the capital to receive their honors.

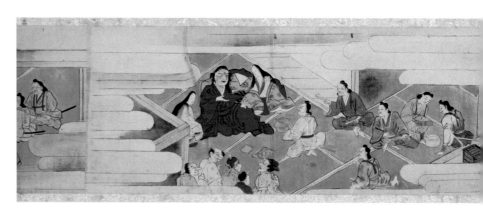

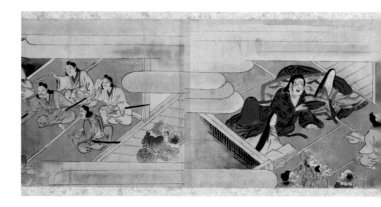

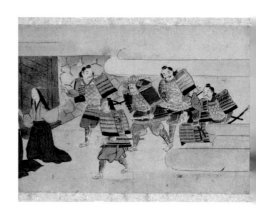

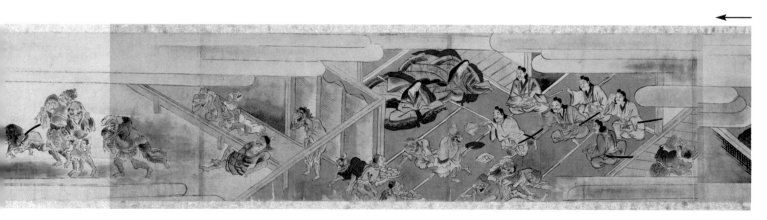

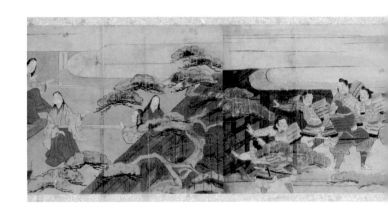

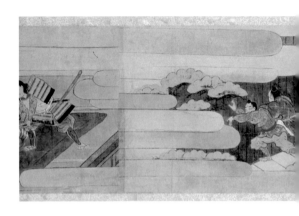

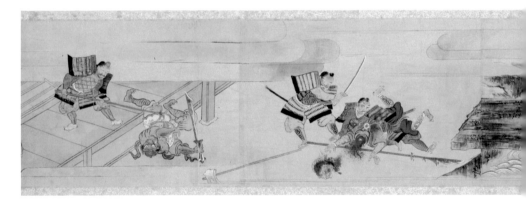

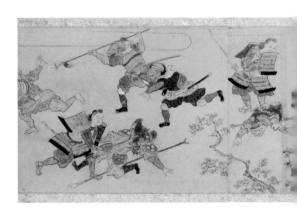

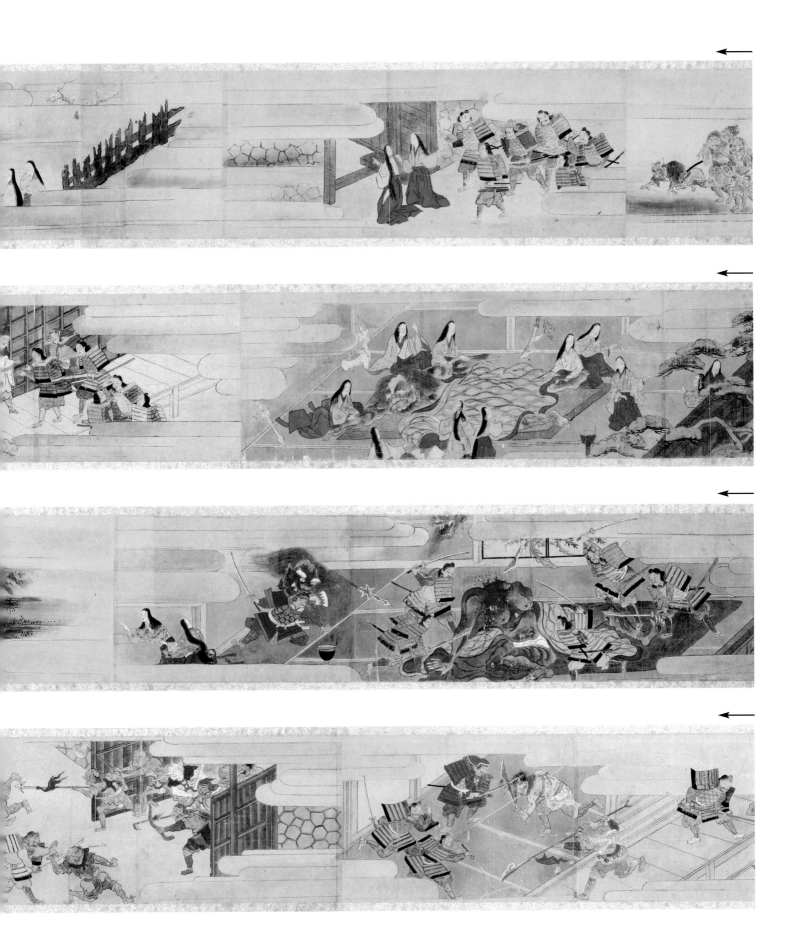

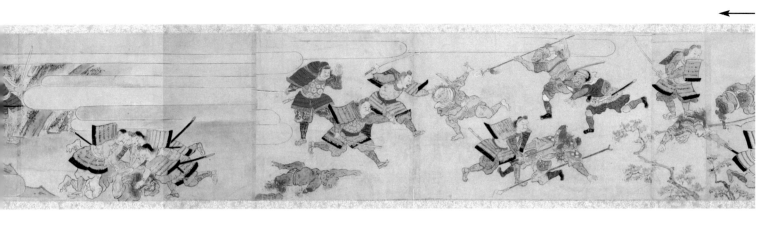

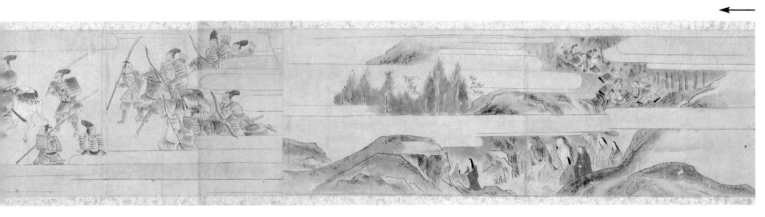

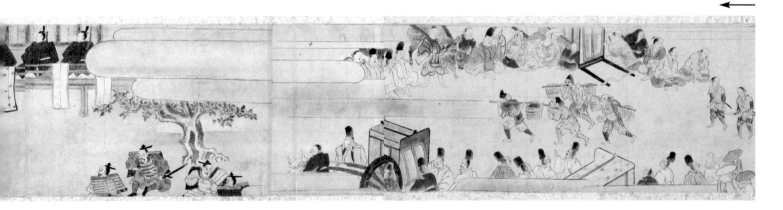

The newfound wealth of the merchant class gave rise to a blooming literary and artistic culture, as well as a highly developed art of living. Polychrome woodblock prints emerged from 1765 onward, thereby granting all Japanese people—regardless of their social class—access to a wide variety of images. Playful, educational, and widely circulated, they were to occupy a fundamental role in the graphic art of manga in the pre-modern and modern eras; their influence is still apparent today in many contemporary manga.

Very early on, even before the emergence of polychrome prints, hand-embellished woodcuts sought to convey movement through the illusion of linear perspective.

The art of playing with perspective

A time of peace and prosperity, the Edo period (1603–1868) marked the dawn of the modern age. A warrior regime, lorded over by the iron hand of the Tokugawa* shogun, Japan had begun to open her doors to the West, only to close them again progressively, first by prohibiting the introduction of Christianity (in 1613), and then by forbidding the Japanese people to leave the archipelago, or to return once they had done so (in 1653). From the 1640s onward, only the Dutch confined to the island of Dejima, the Koreans at Tsushima, and the Chinese at Nagasaki were authorized to stay in Japan. It was therefore not really a question of the nation's closure or isolation, but of the shogun's choice to establish a system of international relations with a few privileged nations.

On the cultural front, while books on Christianity were strictly prohibited, Chinese translations of Western scientific treatises were permitted. The Japanese were thereby able to familiarize themselves with Western art and linear perspective, through Chinese translations of Western works or books written by the Chinese. They also imported prints from Europe or ones executed by Chinese artists in the Western style.

Japan and "Western-style" Chinese art

In the sixteenth century, China had opened her doors to the Europeans and the Jesuits. Seeking to gain the emperor's favor in order to evangelize the country, the Jesuits decided to pass on their scientific knowledge to the court in areas such as physics, astronomy, optics, mathematics, architecture, and painting. While their desire to spread the good news was not granted—with the Yongzheng emperor prohibiting religious propaganda in 1724—their teachings were of some importance, even if China was already very well versed in matters of science.

The Italian Jesuit, Matteo Ricci (1552–1610), a brilliant scholar, moved to China in 1582, where he unstintingly shared his knowledge and presented some religious paintings. Illustrated books and prints had been in circulation throughout the seventeenth century, enabling the Chinese to become acquainted with perspective and new angles in landscape painting. Yet it was not until the arrival of the Jesuit artist Giuseppe Castiglione (1688–1766) that the Chinese went from expressing a passing interest in Western art to actually assimilating it, with the creation of a synthetic art that drew on elements from both cultures. Entering China in 1715, aged twenty-seven, he was to serve three emperors: Kangxi; his son Yongzheng, who succeeded him in 1722; and his grandson Quianlong, who came to power in 1735. Like the French Jesuit Jean-Denis Attiret (1702–1768) who joined him in Beijing in 1739, he was among the teachers of oil painting, converging perspective, chiaroscuro, trompe-l'oeil, and realism in painting. Their output was huge, including portraits of the emperor and various court figures, landscapes in the Chinese style but using European techniques, porcelain ornamentation, and the decoration of imperial residences.

The Chinese disciples of these missionaries spread their teachings throughout the land. This accounts for the fact that Western perspective is widely apparent in the celebrated woodblock prints of landscapes of the city of Suzhou, which went on to influence the Japanese prints known as *"ukiyo-e*."*

26
Ōneisai, untitled *saya-e,* anamorphosis, 1750.
Woodblock print highlighted
with brush-applied color.
© NagoyaTV JAPAN.

27
Anonymous, *Pierrot,* anamorphosis published
by the Walter brothers, Paris, 1868–69.
Color prints, Cinémathèque Française
collection – Conservatoire des Techniques, Paris.

Another Italian Jesuit, Claudio Filippo Grimaldi (1638–1712), went to China in 1682. Trained as a physicist, with a sound knowledge of optics, he treated the emperor to a magic lantern show. In his book *The General History of China. Containing a geographical, historical, chronological, political and physical description of the empire of China,* first published in French in 1735, the French Jesuit father Jean-Baptiste du Halde (1674–1743) refers to the automatons and *camera obscura* that he saw in the Beijing convent. He describes Grimaldi's show with its various demonstrations of anamorphosis using a polygon lens, followed by a magic lantern projection that was a resounding success.

These kinds of catoptrical (mirror) anamorphoses were probably the basis of similar experiments in China during the same period, which in turn gave rise to the form of *saya-e*** (scabbard prints) in Japan. Their name came from the fact that in Japan they were viewed using the lacquered wooden sheath of a sword rather than a mirror.

Inspired by Western offerings while remaining true to their ancestral traditions, the Chinese therefore gave rise to a new pictorial expression that was to transform the vision of Japanese artists.

Most "Western-style" Chinese works, including a large number of stereoscopic views, reached Japan via the port of Nagasaki. With their use of linear perspective and interplays of light and shade, they often

28–29
Anonymous, untitled anamorphosis, Japan, nineteenth century.
Woodblock print. © Hyōgo Prefectural Museum of History.

30–31
Domenico Piola, anamorphosis after *The Raising of the Cross*
by Rubens, seventeenth century. 26 ¾ x 32 in. (68 x 83 cm),
Musée des Beaux-arts, Rouen.

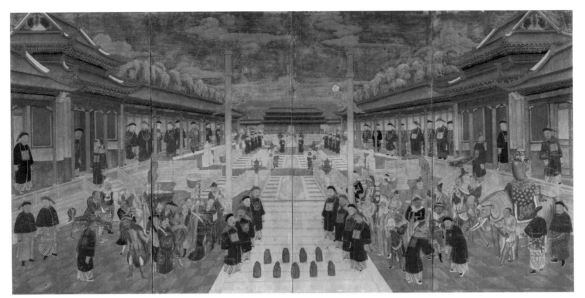

32
Anonymous, *Chūgoku kyūtei zu (View of a Chinese Palace Interior)*, Qin Dynasty. Set of four panels, color on paper, 44 ½ x 89 ¾ in. (113.2 x 228 cm). © Kobe City Museum.

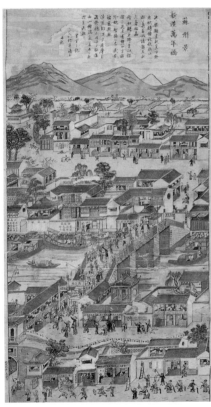

33
Anonymous, *View of the New Bridge in Suzhou*, Qianlong emperor (reigned 1736–95). Hand-painted woodblock print, 70 x 27 ½ in. (180 x 70 cm). © Kobe City Museum.

depicted Chinese landscapes or interiors. We still do not know whether they were imported alone or together with optical viewing boxes, as scientific opinion is divided. More plentiful than the paintings, hand-colored woodblock prints of the city of Suzhou arrived in abundance, to be studied and copied by the Japanese.

From the 1740s, Okumura Masanobu (1686–1764) and Nishimura Shigenaga (1697–1756) excelled in the art of the stereoscopic print. Maruyama Ōkyo (1733–1795) developed this technique, leaving behind some very interesting works. He also copied Suzhou prints, such as the *Optical Print of the Wan-Nien-Ch'iao Bridge in Suzhou*, Fig. 35 and took his inspiration from certain landscapes in which the Chinese wittingly mixed Eastern and Western perspective *(View of* Fig. 33 *the New Bridge in Suzhou)*.

Other Western stereoscopic prints came to Nagasaki via China and Holland. They often included a title written back to front in several languages.

Most of the first stereoscopic Chinese works to reach Japan are now carefully preserved in the Kobe City Museum.[1] These very fragile devices, made of wood and sometimes lacquered and richly decorated, are now seldom exhibited.

34
Anonymous, *The Seafront at Suzhou, Suzhou, China,*
Qin Dynasty, eighteenth century. Watercolor, Victoria
and Albert Museum, London.

35
Maruyama Ōkyo (attrib.), *Koso Mannenbashi zu megane-e
(Optical Print of the Wan-Nien-Ch'iao Bridge in Suzhou),*
1751–64. Woodblock print highlighted with hand coloring,
8 ¼ x 10 in. (20.9 x 27 cm). © Kobe City Museum.

36
Anonymous, *Nanking Street Scene,* stereoscopic view,
France, n.d. 13 x 21 in. (33 x 53.6 cm). © Hyōgo Prefectural
Museum of History.

37
Anonymous, *Middahaten jō zu megane-e (Optical Print of
Middhaten Castle),* 1764–89. Color on paper, 10 ¼ x 15 in.
(26.1 x 38 cm). © Kobe City Museum.

This view is a fine example of the diligence with which a Japanese
designer copied an etching by A. Van der Laan of Holland,
reproducing the original work's interplay of light and shade to
perfection.

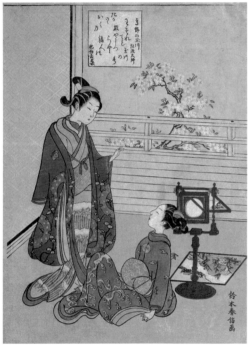

38
Zograscope imported to Japan
in the Edo period. © Kobe City Museum.

39
Suzuki Harunobu, *Kōya no Tama (The Tama River at Kōya: a Boy and Girl enjoying European Optical Prints)*, before 1770. Polychrome woodblock print from the *Mu-Tamagawa* series.
© Kobe City Museum.

The optical prints were inserted vertically or horizontally, depending on the model, and observed through a lens. Landscape prints all shared a similar feature—the portion at the bottom of the frame was systematically accentuated to reinforce the sense of perspective. In the Edo period, diagonal optical devices known as "zograscopes" in Britain were also imported. A wooden support bearing a biconvex lens in a frame was set on a base. A mirror was fitted to the frame in order to set upright the deliberately inverted imprinted image and to give an impression of enlargement and perspective.

In Japan, such prints or stereoscopic paintings were considered as forms of entertainment rather than as artworks. Some were designed for use with optical devices, while others were intended for the naked eye.

Alongside its commercial relations with China, the Japanese government fostered relations in the eighteenth century with the Westerners of the Dutch trading post, from whom it received a report entitled *Oranda fusetsu gaki* (Dutch news of the world). The ability to communicate therefore became imperative for Japan. To this end, Confucian philosopher and historian Arai Hakuseki (1657–1725), then in service of the Tokugawa shogun Ienobu (1662–1712) followed by that of his successor Tokugawa Ietsugu (1709–1716), assigned two Japanese to study Dutch. "Dutch studies" (*rangaku**), focused on investigating Western art and sciences, gradually developed. Yet it was not until 1855 that the government created a school dedicated to the translation of foreign works and to the teaching of Western sciences—the Bansho Shirabesho*.

An expert in Western sciences, Shiba Kōkan (1747–1818) produced the first copper prints, hand-embellished with color. He then turned to the study of oil painting and *ukiyo-e* printmaking, which he learned from the famous artist Suzuki Harunobu (1725–1770); he was given the artist's name "Suzuki Harushige." Several experts in Western studies of the same generation, such as Odano Naotake (1749–1789), Satake Shozan (1748–1785), and Aōdō Denzen (1748–1822), experimented with the use of Western techniques and linear perspective in their works.

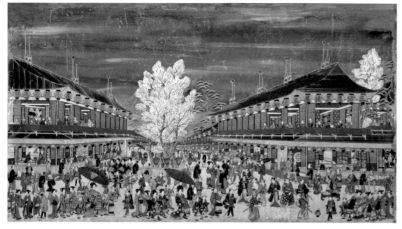

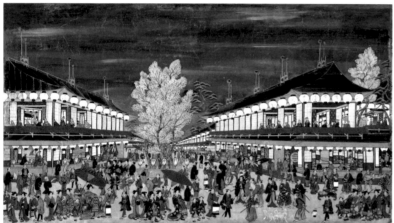

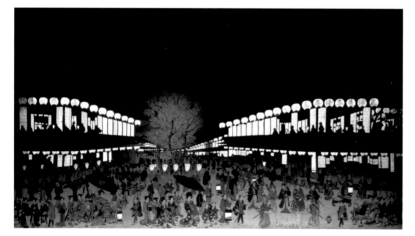

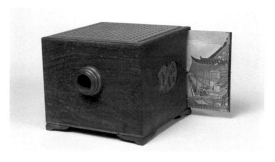

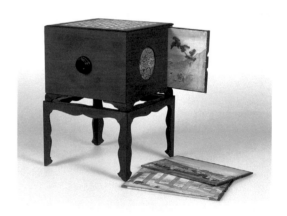

40–42
Anonymous, *Kage karakuri ukiyo-e,* stereoscopic print for optical viewing device, 1848–68. Polychrome woodblock prints, 21 x 39 in. (55 x 100 cm). © Edo-Tokyo Museum.

In these three stereoscopic prints, we see night gradually falling in a lively district of Edo during the cherry blossom season.

43–44
Maruyama Ōkyo (attrib.), *Archery Contest at Sanjūsangendō Temple in Kyoto,* optical viewing device and optical print, Edo period. Paint on wood. © Kobe City Museum.

45
Japanese optical viewing device (direct reflection type) and optical print by Yamaguchi Soken, Japan, 1788. © Kobe City Museum.

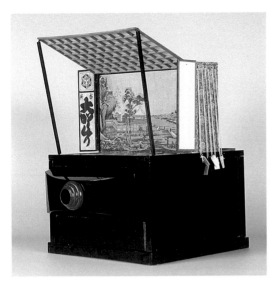

46
Optical viewing device Japan,
Edo period. © Kobe City Museum.

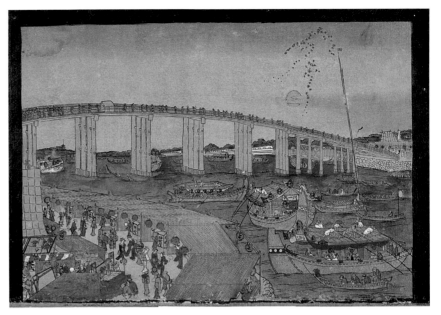

47
Kitao Masayoshi, *The Sumida River seen from the Ryōgoku**
Bridge in Edo, optical print designed for the above device (left).
© Kobe City Museum.

48–49
Anonymous, *Chateau of Flowers on the Champs-*
Élysées (Day and Night), **nineteenth century.**
Cinémathèque Française collection –
Conservatoire des Techniques, Paris.

Print for Pierre Henri Amand Lefort's Polyorama
panoptic viewer, recto-verso color lithograph per-
forated to produce light effects and second layer of
paper with openwork sections, Paris, manufac-
tured from 1849 onward.

Also imported were pyramid-shaped optical devices mounted with
a rectangular box containing the mirror and the optics. The print was
placed at the bottom of this box and observed through the interplay
of a biconvex lens and a mirror slanted at 45°, set above the print and
opposite the lens.

In other rectangular (parallelepiped) optical viewing boxes, the
print could be inserted horizontally or vertically.

Some miniature models were also produced, though very few such
examples remain today. Other versions allowed several frames to be
presented in succession by pulling strings on the box's side
corresponding to each frame.

In the same way that the Europeans produced lithographs of scenes
shifting from day to night, the Japanese created prints with night- and
day-time effects. The brightness could generally be adjusted by means
of an opening, or "roof," on the top of the device. There might be one
or more prints, depending on the model used. The image was lit by
natural light. It would grow darker at the front but remained bright

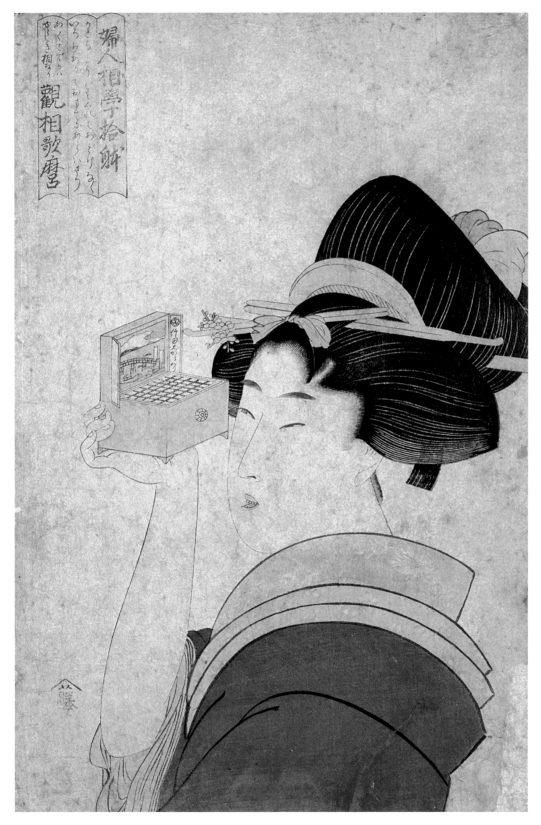

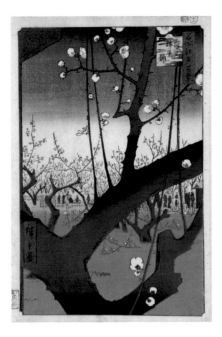 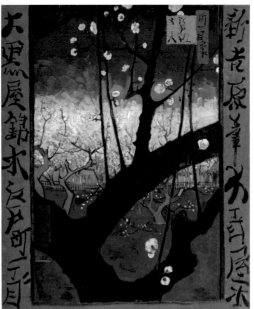 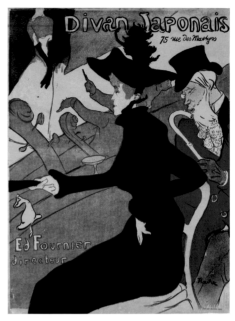

51
Utagawa Ando Hiroshige, *Meisho Edo Hyakkei Kameido ume yashiki (One Hundred Views of Famous Places in Edo: Plum Garden, Kameido),* Edo period. Polychrome woodblock print. © NagoyaTV JAPAN.

52
Vincent van Gogh, *Flowering Plum Tree (after Hiroshige),* Paris, 1887. Oil on canvas, 21 x 18 in. (55 x 46 cm), Van Gogh Museum, Amsterdam.

53
Henri de Toulouse-Lautrec, *Le Divan japonais,* 1893. Color lithograph, The British Museum, London.

at the back when the roof was closed little by little. The optical prints were perforated with holes that traced the outline of the portion of the design to be lit, and transparent color papers were stuck onto them. Japanese artists such as Katsushika Hokusai (1760–1849) and Utagawa Hiroshige (1797–1858) gradually assimilated linear and atmospheric perspective, incorporating it into their prints while retaining their traditional features of cleverly contrasting colors and line. They often delighted in exaggerating close-up views.

Fascinated by Hiroshige's use of medium close-ups and perspective, Van Gogh produced copies of these prints and drew inspiration from them. The composition of works by Hokusai, Hiroshige, or other great Japanese artists influenced many Western painters, including Manet, Monet, and Toulouse-Lautrec. Little did these artists suspect that what they deemed so "novel" was originally a product of Western perspective.

In his famous *Manga,* Hokusai conveyed with remarkable skill the expression of movement, hinted at in the painted scrolls; as did Kawanabe Kyōsai (1831–1889). Kyōsai was also a master of this art— and that of personification, now found in contemporary manga and Japanese anime.

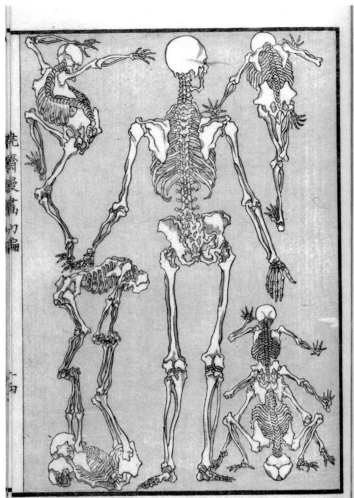
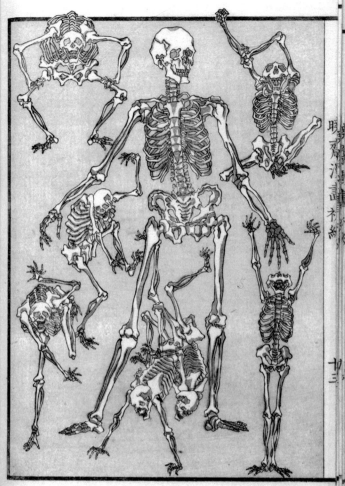

54–55
Kawanabe Kyōsai, *Kyōsai Manga, Gaikotsu (Kyōsai manga shohen) (Skeletons from "Kyōsai's Rambling Drawings: First Series")*, 1881. Color woodblock-printed illustrated book, 8¾ x 5¾ in. (22.5 x 14.9 cm). © Kawanabe Kyōsai Memorial Museum.

Kawanabe Kyōsai particularly loved to draw skeletons, always with a whimsical twist. If we were to crop each of them, they would be seen to dance, as in an animated film.

56
Kawanabe Kyōsai, *Tokuwaka ni gomanzai (Crab Preaching to Turtles)*, 1871. Color woodblock print. © Kawanabe Kyōsai Memorial Museum.

The original title of this drawing is based on an ancient wordplay in praise of youth and longevity.

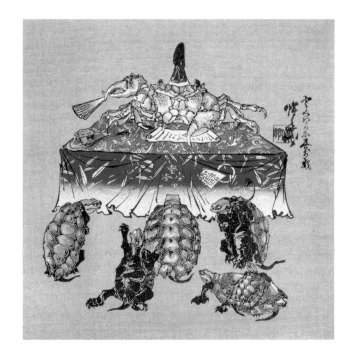

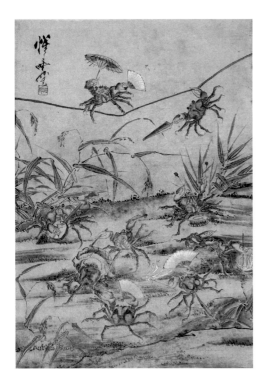

57
Kawanabe Kyōsai, *Kani no tsuna watari (Crab Tightrope Performance)*, 1871. Hanging scroll, ink, and color on paper, 19½ x 13¾ in. (49.8 x 34.9 cm). © Kawanabe Kyōsai Memorial Museum.

Kyōsai painted strikingly dynamic animals, succeeding in endowing them with human expressions. Known for his many drawings of frogs—his favorite creature—here are two fine examples of what he could make crabs do.

58
Kawanabe Kyōsai, *Kyōga gojū san tsugi no ichimai, Kuwana shinkirō (One of Fifty-Three Stations on the Tokaido by Comic Drawing: Mirage of Kuwana)*, 1866. Ō-ban, color woodblock print. © Kawanabe Kyōsai Memorial Museum.

59
Kawanabe Kyōsai, *Seisei Kyōsai Gajō 1 (Seisei Kyōsai Gajo) (Sinking the Bell with the Large Snake from Album of Paintings by Kyōsai)*, 1870. Album, ink, and color on paper, 4¾ x 6¾ in. (12.3 x 17.2 cm). © Kawanabe Kyōsai Memorial Museum.

Kyōsai was already a brilliant master of the technique used to express the notions of speed, noise, or movement (as here), frequently occurring in contemporary anime and manga.

Shadowgraphs and *"ombres chinoises"*

Games or performances using shadows have existed for a very long time. In seventeenth-century Europe, they were known as *"ombres chinoises"* (literally, "Chinese shadows" or shadowgraphs). In Asia, puppet shows in which the silhouettes are projected onto a screen by a light source also date back to ancient times. Generally black and white, they sometimes used color, as in examples originating from Java, or in the openwork painted shapes cut out of buffalo hide.

In Japan, shadowgraphs appear to have been nothing more than a game that consisted in adopting ludicrous poses behind paper doors to amuse family and friends, and it is often maintained that they did not evolve into performances. However, some drawings depicting shadow plays designed for a limited audience would suggest the contrary, even if they never enjoyed the level of success found in neighboring countries. The processes most akin to animation were the *"lanterne vives"* (living lanterns) or "spinning lanterns," common in sixteenth-century Europe. The Japanese lanterns used as shop signs or in popular children's games followed a similar principle, with a candle set in their center and a strip of translucent paper decorated with painted silhouettes turning around a kind of propeller. Such lanterns often featured in prints and in paintings.

60
Shadow play implement, Java, twentieth century. © Hyōgo Prefectural Museum of History.

61
Anonymous, untitled Japanese print, n.d. © Hyōgo Prefectural Museum of History.

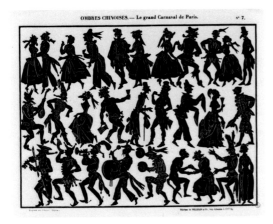

62

Anonymous, Shadow theater, Paris, twentieth century. Photolithograph, Musée des civilisations de l'Europe et de la Méditerranée, Paris.

63

Anonymous, *Shadowgraphs: the Great Carnival of Paris*. Musée des civilisations de l'Europe et de la Méditerranée, Paris.

There are also similar prints in Europe—this one reminds us of the French *images d'Epinal*.

64

Anonymous, untitled Japanese print, n.d. © Hyōgo Prefectural Museum of History.

Printmakers often depicted scenes using shadow-graphs, with a byline at the side to explain the drawing's meaning.

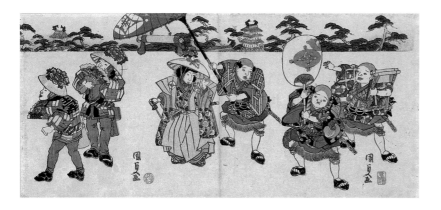

65
Utagawa Kuniyasu, *Kodomo daimyō gyōretsu (Procession of Children as Daimyō*)*, Edo period. Polychrome woodblock print, 6 ½ x 18 ¼ in. (16.5 x 46.3 cm), Kumon Institute of Education.

Far removed from the stiff portrayals of apparently well-behaved children found in Western painting, little Japanese boys and girls are always depicted in a very natural way—having fun or going about their business. The artist has deliberately represented the children's games in the form of a triptych, structured in the style of painted scrolls.

66
Kitao Shigemasa, *Yatsushi hakkei Karasaki no yō (Eight Views of Karasaki One Rainy Evening)*, c. 1770. Polychrome woodblock print, *chūban* format, Kumon Institute of Education.

The two children in this image are having fun with shadowgraphs behind a paper door.

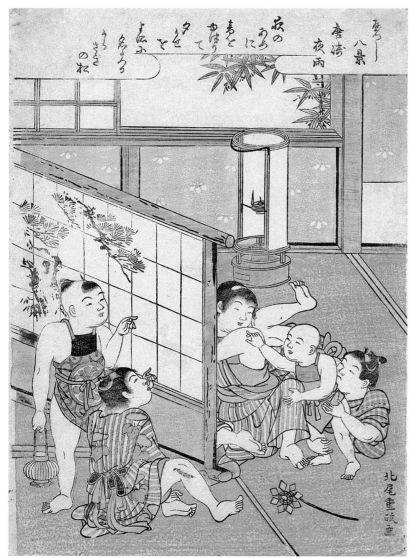

67
Anonymous, *Shinpan yubi no kage-e (New Series of Shadowgraph Prints using Fingers)*, n.d., Kumon Institute of Education.

Many cheap prints depicted children or their games. The names of the animals or figures featured were written in *kana** in colorful circles.

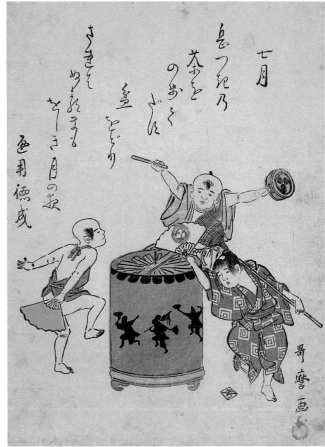

68
Kitagawa Utamaro, *Kodomo jūnikagetsu, shichi gatsu (Children and the Twelve Months of the Year: the Month of July)*, c. 1781–1800. Polychrome woodblock print, chūban format, Kumon Institute of Education.

More famous for his portraits of beautiful women, Utamaro also painted prints for children, such as this one that shows a group of kids dancing around a lantern one fine day in July.

69
Keisai Eisen, *Shiki no nagame osana asobi, rokugatsu Fuji mōde no yūdachi (Views of the Four Seasons: Children at Play, a June Downpour at Mount Fuji),* Edo period, c. 1819–30. Polychrome woodblock print, *ōban* format, Kumon Institute of Education.

70
Anonymous, *Dōji yūkyō no zu (Children at Play),* middle of Edo period. Paint on paper, 8 x 10 in. (21.2 x 27 cm), Kumon Institute of Education.

71
Yamamoto Shōun, *Kodomo asobi mawaridōro (Children at Play: Lantern),* Meiji period. Polychrome woodblock print, *ōban* format, Kumon Institute of Education.

The Japanese adapted these lanterns, which also came to Japan via China or Holland. Set on the ground or hanging, children loved them.

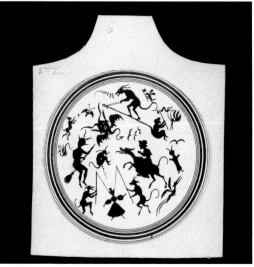

72 *(Above)*
**Séraphin (attrib.), *Acrobat,* France, 1790–1830.
Metal shadow puppet with movable joints,
Cinémathèque Française collection –
Conservatoire des Techniques, Paris.**

In the West, *lanternes vives* and shadow theaters
were also popular in the eighteenth century.

73 *(Top right)*
**Anonymous, Print for shadow theater, Paris,
c. 1840. Black and white print. Cinémathèque
Française collection – Conservatoire des
Techniques, Paris.**

In the nineteenth century, shadow plays enjoyed
renewed interest, thanks to Rodolphe Salis and the
shows he put on in his popular cabaret, "Le Chat
noir," with artists such as Henri Rivière.

74–75 *(Above right and far right)*
**Anonymous, *Masakado megane,* optical game
comprising a seven-faceted lens, late Edo
period. 7 x 3½ x 1¼ in. (20 x 8.8 x 3.2 cm).
© Hyōgo Prefectural Museum of History.**

Other optical games would fascinate children,
such as this lens with seven facets, known as the
"Masakado eye-glasses" in Japan, in honor of the
valiant warrior Taira no Masakado (d. 940). Many
legends grew up around this figure, and it was said
that fighting him was like being up against seven
warriors. This accounts for the name of this game,
which presents an image multiplied by seven.

Magic lanterns

In the wake of the play on shadow and perspective emerged a new form of expression that was shortly to bring radical change to the world of imagery, greatly fueling the desire for animated pictures.

In 1659 the magic lantern—forerunner of the cinema—made its first appearance at The Hague in the laboratory of the Dutch astronomer Christiaan Huygens. Laurent Mannoni, author of the remarkable work, *The Great Art of Light and Shadow: Archaeology of the Cinema* (2000), offers a colorful definition:

> Everything about the magic lantern, even the effects that it produces, is 'magic.' Smoking and shot through with light, made of iron and wood and topped with a chimney, equipped with a set of lenses, a parabolic reflector, and a kerosene or oil lamp, its primary purpose is to project a whole parade of diabolical, licentious, religious, political, or scientific images, hand-painted onto glass plates.… The *lanterna magica*, the daughter of optics and magic, opens up the way for every fantasy, special effect, and enchantment.[3]

While optical viewing devices were able to provide entertainment for only a limited number of spectators huddled around them, the magic lantern was aimed at a larger audience, albeit with insufficient brightness. Wealthy individuals were quick to obtain one, while peddlers ensured their spread from one town to another, filling their mainly illiterate spectators with both wonder and dread.

The magic lantern made it possible to enlarge images via the juxtaposition of lenses; its hand-painted translucent slides were of great beauty. The Jesuits living in China were swift to adopt the process, using it for religious purposes. Once they had presented it to the emperor, the magic lantern entered Japan, where it was adapted and reemerged as a local version. Initially aimed at the well-to-do classes, and subsequently hawked by peddlers, the magic lantern also became a reasonably priced toy in early nineteenth-century Europe. It soon became within most people's reach and provided access to a wealth of morality tales and fables, which the audience could follow from the booklet sold together with the plates. The most famous tales the world over were popularized in this way.

76
Anonymous, "The Magic Lantern"
in *Les artistes anciens et modernes*, 1854.
Print, Musée National de l'Education.
Museum of Education – INRP, Rouen.

77
Anonymous, "The Magic Lantern"
in the French children's magazine *Le Bon Génie*,
no. 30, Print room, Bibliothèque Nationale
de France, Paris.

78
Anonymous, *Peau d'âne (Donkeyskin)*, disk
with images printed in series, Lapierre,
Paris, 1890. Cinémathèque Française
collection – Conservatoire des Techniques, Paris.

79
Nils Olgerson, Magic lantern plate, printed
in series, UK, c. 1880. © Conservatory
for film techniques, Cinémathèque Française
collection – Conservatoire des Techniques, Paris.

In his novel *In Search of Time Lost*, Marcel Proust penned what is now a famous passage on the subject of magic lanterns. In the first volume, *Swann's Way*, he recalls his childhood and the awful moment of bedtime:

> Someone had indeed had the happy idea of giving me, to distract me on evenings when I seemed abnormally wretched, a magic lantern, which used to be set on top of my lamp while we waited for dinner-time to come; and, after the fashion of the master-builders and glass-painters of gothic days, it substituted for the opaqueness of my walls an impalpable iridescence, supernatural phenomena of many colors, in which legends were depicted as on a shifting and transitory window…. And, indeed, I found plenty of charm in these bright projections, which seemed to emanate from a Merovingian past and shed around me the reflections of such ancient history.

While eighteenth-century plates took their source from painting, nineteenth-century versions were closer to caricature and illustration. The magic lantern then became more sophisticated and was

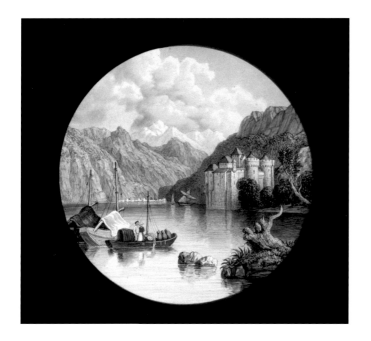

used for educational purposes. In 1895, Raymond Poincaré, then minister of public instruction, urged for more appealing forms of education; magic lanterns were one of the methods advocated to achieve this goal. A costly proposition for the State budget, the colored plates were replaced by black and white paper prints. The process therefore gradually gained ground, paving the way for audiovisual education.

In Japan, although writings dating from the 1770s do mention magic lanterns, they did not really become known until the eighteenth century, when they arrived via the port of Nagasaki. Found in entertainment districts, these lanterns—known as "devil lanterns"—began to grow in significance, particularly from the Meiji period (1868–1912) onward. They then assumed an educational role and, from 1880, were widely used in schools as a visual aid in various disciplines.

Who better to explain these magic lanterns than Laurent Mannoni? I visited him on several occasions at his research lab at the Cinémathèque Française in Paris, which contains a large number of high-quality plates. Surrounded by invaluable documents and all kinds of optical viewing devices and cinematographic cameras, he gives a passionate account of how he discovered pre-cinema art.

80–81
Carpenter and Westley, *Château de Chillon, Switzerland* and *Louis Philippe's Land,* hand-painted magic lantern plates, London, c. 1850. Cinémathèque Française collection – Conservatoire des Techniques, Paris.

82
Radiguet and Massiot (manufacturer Molteni, Paris), *Late Explanation 3,* magic lantern print, c. 1910. Chromolithograph. Cinémathèque Française collection – Conservatoire des Techniques, Paris.

INTERVIEW WITH LAURENT MANNONI

Curator of the technology collection at the Cinémathèque Française

Brigitte Koyama-Richard: You have written some remarkable books on magic lanterns. What gave rise to this passion?

Laurent Mannoni: It emerged when I was a teenager, thanks to my mentor, Lotte H. Eisner (1896–1983), a film historian and curator at the Musée du Cinéma of the Cinémathèque Française. She would invite me to her house on Saturdays and we would discuss the silent movies and filmmakers she loved. In 1920s Berlin she had rubbed shoulders with all the big names in German cinema (Lang, Pabst …). She personally knew filmmakers all over the world (Kurosawa, Satyajit Ray, Truffaut, Herzog …). In her kitchen, as I was making tea, I noticed an odd device placed on the top of a cupboard. It was a polychrome lantern, an intriguing and fascinating object. That is how I learned of the existence of "cinema archaeology." Ever since, borne along by passion, I began my research work with a view to writing a book on the subject. This was *The Great Art of Light and Shadow*, first published in French in 1994.

B. K.-R.: You work among the treasures held by the Cinémathèque Française. How do you present this collection to the public? I was thinking in particular of your latest exhibition on Georges Méliès, which was amazing.

L. M.: We regularly organize exhibitions to display the treasures of the Cinémathèque Française and to reveal the beauty of this forgotten world, the "prehistory of cinema." Our exhibitions are in-depth explorations of the cosmogony of an author (Méliès, Marey, Demenÿ …) or technique (the magic lantern, the art of deception, expressionist cinema …), particularly in the revival of ancient techniques: projections using magic lanterns, reconstructions of devices (zoetrope, praxinoscope, stroboscopic disk, *théâtre optique* …), or optical effects. Since 1994, we have held nine exhibitions on the emergence of cinema. Every time, we issue a catalog, which provides a way of reviewing a subject that until now has had little coverage. We have already published fifteen books on the subject.

B. K.-R.: In the Edo period, Japan invented a new form of magic lantern. What is your view of it?

L. M.: I was lucky enough to see a magic lantern performance in Tokyo in 2006 and I was staggered by its exceptional quality and beauty, as well as by its agility. Robertson's phantasmagoria reached Tokyo in 1801. I feel that it influenced the art of projection in Japan, as the nineteenth-century magic lantern shows known as *"utsushi-e*"* were almost always based on the phantasmagoria's principle of mobile rear projection. Yet there was one important addition—several lanternists hidden behind the screen walked around with their devices on their stomachs, thereby making their projections very dynamic and full of movement.

B. K.-R.: Your area of research has taken you all over the world. Is it still possible to find new and unpublished material or plates for magic lanterns?

L. M.: It is still possible, and there are some remarkable findings. We work a lot with dealers, and particularly with private collectors, who sometimes part with exceptional pieces. Certain subjects relating to the prehistory of cinema have yet to be explored completely.

B. K.-R.: We rarely have the opportunity to admire optical prints and magic lantern shows. You are currently preparing a large exhibition on this subject. What is your objective?

L. M.: The exhibition "Magic Lantern and Painted Film" opens at the Cinémathèque Française on October 14, 2009. The Cinémathèque Française has one of the world's finest collections of glass plates for magic lanterns, with some seventeen thousand items dating from the mid-eighteenth century up to the 1920s. It contains pieces from virtually every one of the main countries of production: France, Italy, the UK, Germany, and the United States. All the techniques of painting and printing are there, including glaze and aniline painting, painting in series, chromolithography, and photography. Many plates are finely mechanized and at times equipped with complex animation devices. All subjects are covered: travel, physical and natural sciences, religion, politics, history, daily life, eroticism, scatology, devilry, phantasmagoria. There are pieces that are one of a kind, regarded as masterworks by all experts—eighteenth-century Fragonard-style or Lebrun-inspired plates; magnificent plates from the Royal Polytechnic (1860s);

phantasmagoria plates; finely mechanized slides; a large corpus of the production of the artist Desch (active in Paris under Napoleon III); and even some surprising surrealist photographs. Our aim is to reveal the beauty of this collection through its finest pieces, to present the art of painting on glass and of light projection, as well as to demonstrate how the magic lantern influenced cinematographic art.

B. K.-R.: Thank you and good luck for this exhibition.

– June 2009 –

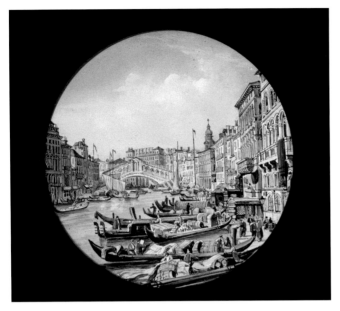

83
Carpenter and Westley, *Venice, the Grand Canal and Rialto Bridge,* hand-painted magic lantern plate, London, c. 1850. Cinémathèque Française collection – Conservatoire des Techniques, Paris.

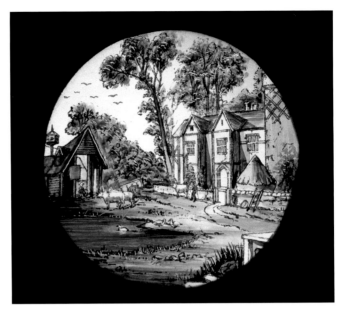

84
Anonymous, *Countryside Scene,* hand-painted magic lantern plate, UK, c. 1880. Cinémathèque Française collection – Conservatoire des Techniques, Paris.

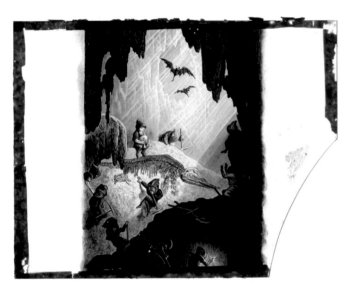

85
Anonymous, *Imps in a Cave,* Royal Polytechnic hand-painted magic lantern plate, London, c. 1850. Cinémathèque Française collection – Conservatoire des Techniques, Paris.

The resemblance is so striking that one might think that this very refined plate inspired Walt Disney to design Snow White's dwarfs. Of note here is the enchanting contrast between the bright light of day and the dim gleam of the lamp that lights up the mine where the dwarfs work. Just as they discover the remains of a fabulous beast, two bats fly into this shaft of light.

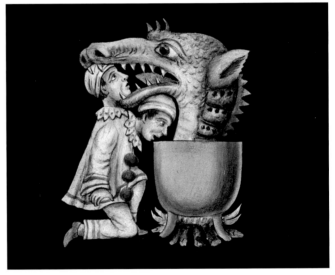

86
Mallet (attrib.), *Pierrot and Monster,* hand-painted animated magic lantern plate, Paris, 1862. Cinémathèque Française collection – Conservatoire des Techniques, Paris.

Some plates are not without humor. Here, the unfortunate Pierrot seems to wonder what fate has in store for him with this gigantic monster that has emerged from a tiny cooking pot.

87
Newton and Co. Ltd, *Mode of Exhibiting the Phantasmagoria,* photographic plate, London, c. 1880. Cinémathèque Française collection – Conservatoire des Techniques, Paris.

Both Western and Japanese magic lanterns made it possible to enlarge certain images suddenly. In the West, phantasmagoria spread from the 1780s onward, but it was Étienne-Gaspard Robertson's (1763–1837) fantascope in particular, produced in the last few years of the eighteenth century, that launched the vogue for this type of show. Mounted on a stand and sliding on rails fixed behind the screen, it allowed terrifying apparitions to loom up suddenly and then fade away. In Japan, this process was used in all *utsushi-e* magic lantern shows.

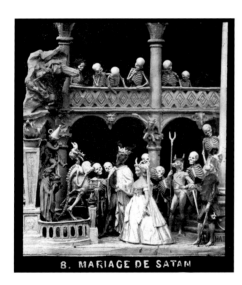

88
Habert (sculptor), Mazo (publisher), *Devilry, the Marriage of Satan,* magic lantern plate, Paris, 1860–63. Photograph highlighted with color, Cinémathèque Française collection – Conservatoire des Techniques, Paris.

Skeletons inspired the greatest artists. They also came to life on magic lantern plates.

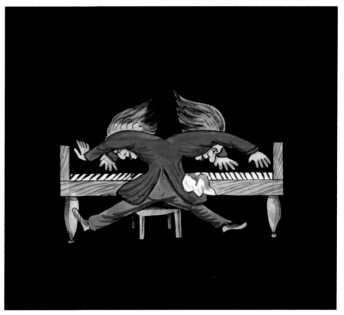

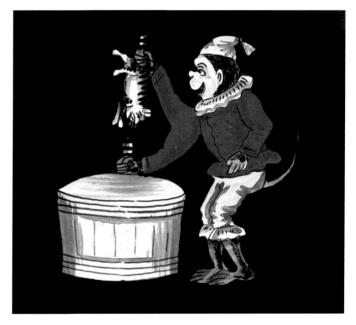

89
Anonymous, *Pianist,* hand-painted animated magic lantern plate, France, c. 1890. Cinémathèque Française collection – Conservatoire des Techniques, Paris.

90
Anonymous, *Monkey and Cat,* hand-painted animated magic lantern plate, France, c. 1890. Cinémathèque Française collection – Conservatoire des Techniques, Paris.

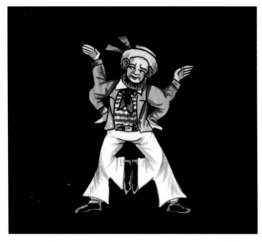

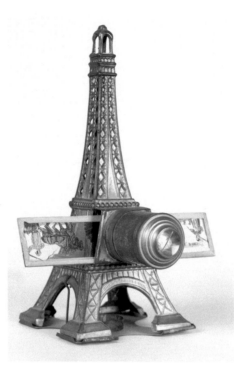

91 *(Top, far left)*
Anonymous, *Dancing Figure,* hand-painted animated magic lantern plate, France, c. 1890. Cinémathèque Française collection – Conservatoire des Techniques, Paris.

92 *(Middle, far left)*
Anonymous, *Figure Bearing His Family on His Back,* hand-painted animated magic lantern plate, France, c. 1890. Cinémathèque Française collection – Conservatoire des Techniques, Paris.

93 *(Left)*
Louis Aubert (manufacturer), Eiffel Tower magic lantern, Paris, 1889. Cinémathèque Française collection – Conservatoire des Techniques, Paris.

Disparaged or praised to the skies, the Eiffel Tower—symbol of the 1889 Universal Exposition in Paris—was reproduced on a wide variety of objects or quality toys such as this magic lantern.

94 *(Below)*
Anonymous, *Devilry,* hand-painted magic lantern plate, n.d. Cinémathèque Française collection – Conservatoire des Techniques, Paris.

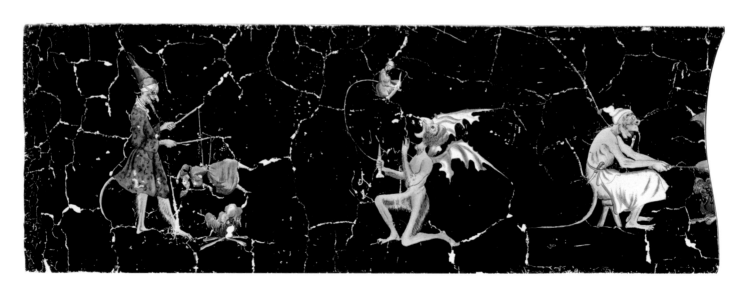

95 *(Above)*
Anonymous, *Street Scene in China,* **hand-painted magic lantern plate, France or England, c. 1870. Hand-painted on gelatin, Cinémathèque Française collection – Conservatoire des Techniques, Paris.**

Exoticism was in vogue in 1870, following the Universal Exposition held in Paris three years earlier. But Chinese curios were soon to give way to *Japonisme,* which would permeate every artistic field.

96 *(Below)*
Anonymous, *Humorous Scene,* **magic lantern print, Bing toy company, Nuremberg, c. 1900. Chromolithograph on glass, Cinémathèque Française collection – Conservatoire des Techniques, Paris.**

Some prints like this one are surprisingly evocative of cartoons.

97–102 *(Above)*
Anonymous, *The Boisterous Goat,* **c. 1900. Photographic plates on glass, Maison de la Bonne Presse, Paris.**

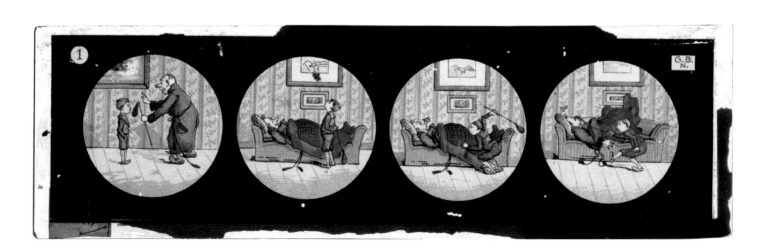

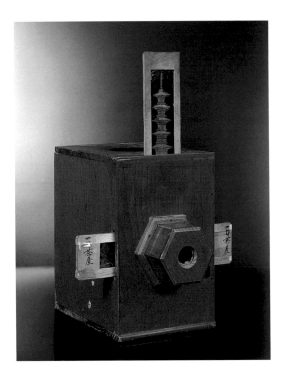

103
Furo, box for *utsushi-e* magic lantern,
Edo period. © Matsue Kyōdōkan.

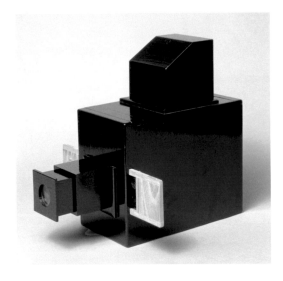

104
Furo and *tane-e,* box for *utsushi-e* magic
lantern, Edo period. © Hyōgo Prefectural
Museum of History.

Utsushi-e, the magic lanterns of Japan

Intended for performances, *utsushi-e* magic lanterns made their first appearance in 1803. They were a new twist on the Western magic lanterns and optical viewing devices that had inspired them. Unlike the latter, which offered a fixed image to be viewed through a lens, and the former, which were projected but also offered a fixed image that was changed successively by setting the lantern on a projection base, the *utsushi-e* lantern was movable.

Fascinated by magic lanterns, the Japanese began to wonder whether they could not be transformed into a theatrical device. They found the Western variety made of metal heavy and difficult to manipulate; they therefore made lanterns from paulownia wood, which was lightweight and difficult to ignite, lit by lamps of rapeseed oil. They called them *"furo*"* (bathtub), because they were similar in form to traditional wooden bathtubs.

The *furo* was placed at the operator's chest height; he made the image move as he walked around. As the light was very dim, seven or eight *furo* were used for each show, thereby allowing the brightness to be made more intense and to introduce various characters at the same time. Yet, in spite of this, the lighting remained dim, making it possible to play to no more than a few dozen spectators.

The *furo* contained two lenses. The images were painted onto glass, 2 x 2 in. (5 x 5 cm), affixed to wooden frames, *tane-ita*.* The screen was always made of Japanese paper, which allowed the light through more easily. By moving closer to or farther away from the screen, the operators behind it managed to vary the size of the characters and introduce a sense of perspective.

Such shows were real theatrical productions, as musicians and narrators would accompany the projected images. The repertory included pieces for both children and for adults. Today there remain very few prints depicting *utsushi-e* lantern shows.[2]

In the Kansai region, *utsushi-e* magic lanterns were known as *"nishiki kage-e*"* (images of shadow and brocade). In Shimane Prefecture, particularly in Izumo, the expression *"kage ninge*"* (shadow puppets) was used. In Edo, they were referred to as *"Edo utsushi-e"* ("*utsushi-e* from Edo" or "projections from Edo").

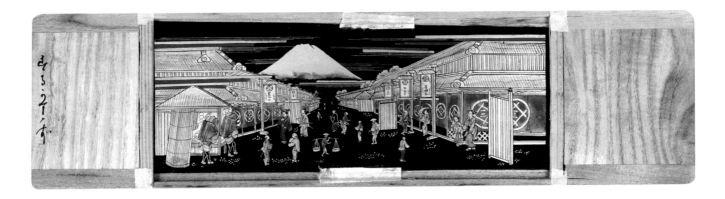

Popular during the Edo period, *utsushi-e* gradually died out, giving way to new cinematographic inventions. Fortunately, Yamagata Fumio and his Minwaza Company have breathed new life into this marvelous art, which still attracts numerous spectators. They also put on splendid shadow theater performances, based on classical tales, for a general audience. Bringing together musicians who play ancient instruments such as the *shamisen** or *shakuhachi** and major artists from traditional theater or *rakugo**, it is a spectacle in its own right. The stream of images follows the narrator's rhythm. Epic, tragic, or moving tales alternate with comic or even slightly risqué stories, which the audience found really amusing. The beauty and magical nature of the projected images mean that the presence of the operators who work with astonishing dexterity behind the screen is forgotten.

105–106
Furo and *tane-e*, box for *utsushi-e* magic lantern and plates for use with it, Late Edo period. 14 ¼ x 5 x 13 in. (36.3 x 15 x 33.2 cm). © Hyōgo Prefectural Museum of History.

The images are painted on a black ground, whereas magic lantern plates are very colorful. Together with a *furo*, they were given as a wedding present to a young lady of high station. They include a series of twenty-three slides of places famous in the Edo period.

INTERVIEW
WITH YAMAGATA FUMIO

Director of the Minwaza company

Brigitte Koyama-Richard: When and why did you first become interested in *utsushi-e* magic lanterns?

Yamagata Fumio: I had been doing shadow theater shows for many years. Unlike the shadow theater traditionally found in Asia, the Japanese version uses the most recent lighting mechanisms. Magic lanterns are practical devices that made it possible to project small images of the sun, moon, etc. One day I read an article in a specialist photography magazine that said, "In 1803, the first *utsushi-e* using magic lanterns were shown in Edo. On glass plates, artists had painted images that were made to move via special effects and projected with a magic lantern." This was therefore a technique that Japan had lost and forgotten. With the conviction that it is the variety of modes of expression that make theater richer, I immediately set about learning more about these *utsushi-e*.

B. K.-R.: What is the difference between Western magic lanterns and those used in *utsushi-e*?

Y. F.: Western magic lanterns were made from metal because their light came from a flame; as such, they were quite heavy. When they were imported from Holland, the Japanese lacked the technical know-how necessary to make this type of apparatus from metal. They made wooden replicas, improving them at the same time. These lightweight models were easy to operate when walking. They were known as *furo*. Small images were projected initially, before the creation of a technique that enabled big-screen projection.

It was then possible to bring to life a large number of characters as in *kabuki* or *bunraku**, and from the outset, *utsushi-e* lanterns provided a real spectacle.

B. K.-R.: Isn't it difficult to produce exact recreations of *utsushi-e* lanterns and images?

Y. F.: In *utsushi-e* performances, the glass plates used were very fragile and set within wooden frames that became warped with time. They are damaged when handled, which is why the descendants of these show-masters—who have religiously conserved these precious objects—refused to show them to me. Making faithful reproductions of these items requires time and funding that I was unable to obtain, on the pretext that they were "irrelevant, old-fashioned stuff." Undeterred, after ten years of passionate research, I managed to get museums and private collectors to open their doors to me. We used a computer to preserve the plates' designs. We studied the characters, their costumes, and the scenarios, and gave new life to these images, which had lost none of their original beauty—a project much appreciated by researchers.

B. K.-R.: What is the difference between the *utsushi-e* of the Edo period and contemporary performances?

Y. F.: In the 1800s, the glass was as thin as a sheet of paper and extremely fragile. At least two lenses were needed to make a *furo* and it must have been very difficult to develop lenses able to achieve the perfect focal length. One visual

record from the 1830s shows an *utsushi-e* projection. When we look at the movements of designs from this period, we might imagine that three to five *furo* were required. As they were costly to manufacture, the admission to these shows must also have been expensive. Moreover, the lantern was lit using rapeseed oil; it therefore gave off a very dim light, which precluded a large number of spectators. With the emergence of new genres of spectacle in the Meiji period, the *utsushi-e* gradually died out. The Minwaza company used acrylic plates instead of glass, and halogen lamps for greater brightness. We thereby improved upon the *furo*, but in the end came back to their original form. Indeed, even if they are less specific in their manufacture than magic lanterns, they possess other qualities that we are able to master through use. Many plays are taken from *kabuki* and *bunraku*. Our aim is to transpose the beauty of the classical language into a contemporary language of similar quality.

B. K.-R.: How many *tane-ita* plates and images do you use in one show?

Y. F.: We use around twenty-five plates and eighty images in a play lasting between twenty and twenty-five minutes, but much more for a longer work. The *furo* is not a machine, but a "utensil" or an "instrument." The result varies depending on the operator's personality. The images take on various forms and the characters are made to interact, which means that we actually use three times more images than those seen by the spectators.

B. K.-R.: How many members of your company take part in one show?

Y. F.: Generally speaking, there are seven people, each operating a *furo*. We also have a narrator and performers of traditional music: players of *shamisen*, Japanese flute, drum, and Japanese bells. A dozen people are therefore required to put on a show made up of three stories lasting between one and a half and two hours.

B. K.-R.: What is the role of *utsushi-e* in today's age of Internet and video games—and how do you see their future?

Y. F.: The difference with *utsushi-e* is that they do not require the viewer to create or imagine anything, but weave humor and human sentiment into their stories. Actors and spectators share one and the same moment and make a single whole. When we performed in Britain and the U.S., many people came up at the end of the show to see what goes on backstage. They would take the musical instruments in their hands and enjoyed making the characters move. Isn't that the magic of *utsushi-e*? I would really like to develop this art at international level by participating in technical and cultural exchanges, as well as joint performances.

– June 2009 –

107 *(Right)*
A Minwaza performance.
© Yamagata Fumio, Minwaza.

108 *(Below right)*
Monochrome print.
© Hyōgo Prefectural Museum
of History.

Ever since the Edo period, the
Japanese have been fascinated by
everything to do with optics.
Some monochrome prints such
as this one testify to their interest
in this field. In the lower center
we can see a *furo* (Japanese magic
lantern) and, at the upper left, a
Western magic lantern.

109 *(Below)*
Anonymous, *Children
Watching a Japansese
Magic Lantern Show,* n.d.
Japanese print.
© Hyōgo Prefectural
Museum of History.

110

Nozoki karakuri, Utagawa Kunisada,*
untitled uchiwa-e, Edo period.
Polychrome woodblock print in the form
of a Japanese fan, 9 x 11 in. (22.8 x 29.5 cm).
© Nagoya TV JAPAN.

Very large-format optical viewing devices
allow several children to admire the various
prints here.

111–112

Anonymous, *Tane-e,* plates for *utsushi-e*
magic lantern, Edo period. Images
painted on glass, wooden mount.
© Matsue Kyōdōkan.

113–114

Anonymous, *Kansu no Obake
(The Kettle Ghost),* plates for use with
an *utsushi-e* magic lantern. © Hyōgo
Prefectural Museum of History.

The images shown here changed the
character's form or design.

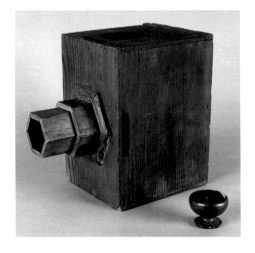

115–116
Anonymous, *Onna kōjō (A Talkative Woman),* plates intended for an *utsushi-e* magic lantern. © Hyōgo Prefectural Museum of History.

117–118
Kankan odori (traditional dance), plates intended for an *utsushi-e* magic lantern. © Hyōgo Prefectural Museum of History.

119
Furo and *tane-e,* for use with an *utsushi-e* magic lantern, Japan, Edo period. Wooden box with lens, 10 ½ x 6 x 9 ¼ in. (26.6 x 15.2 x 23.4 cm), wooden and glass plates for use with it, 2 x 8 x ¼ in. (6 x 20.2 x 0.6 cm). © Hyōgo Prefectural Museum of History.

By sliding the glass plate horizontally, the painted figure could be made to appear in different positions.

120
Contemporary image of an *utsushi-e* magic lantern show during the Edo period. © Yamagata Fumio, Minwaza.

121
Tane-ita, Magic lantern image used by the Minwaza company in its show. © Yamagata Fumio, Minwaza.

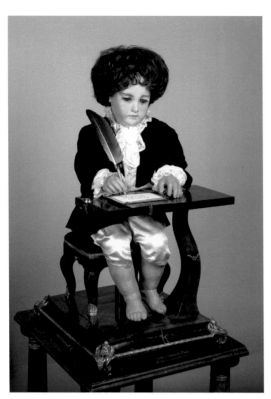

122
Pierre Jacquet-Droz, *The Writer*, 1774.
Automaton, Musée d'Art et d'Histoire,
Neuchâtel, Switzerland. © Photo mahn / S. Lori.

Automata

The West has a long history of automata. Without going back too far in time, we might recall that in the ninth century the caliphs of Baghdad or the Byzantine emperors already boasted clockwork birds made of precious metals that would sing in the trees. As early as the sixteenth century, monumental clocks with *jacquemarts* (automatons striking the hours) made their appearance in churches.

During the Renaissance, clock-making was put to good use. Leonardo da Vinci (1452–1519) created a mechanical lion, among other things, in 1510 for Louis XII's visit to Milan; in the decades that followed, the fashion for fountains and automata spread throughout all of the European courts. Scientists such as René Descartes (1596–1650) or Anathase Kircher (1602–1680) even seem to have taken an interest in the subject. In the Edo period, when the Japanese were already producing some splendid automata, the Frenchman Jacques Vaucanson (1709–1782) also created several examples that were to go down in history (*The Flute Player* or *The Digesting Duck*), while Swiss-born Pierre Jacquet-Droz (1721–1790) and his son Henri (1752–1791) designed their own versions (*The Writer, The Drawer* or Figs. 122–12[*The Musician*).

Records exist in Japan attesting that, as early as the seventh century, the Japanese had assimilated the Chinese art of building south-pointing chariots that were set at the head of the imperial procession. The Middle Kingdom also took the lead over other nations by developing its own system of clock-making; in the eleventh century, the Chinese invented automata that were able to tell the time accurately. The Japanese adopted these techniques as early as the Heian period, modifying and enhancing them. Then, during the Edo period, an age characterized by great technical change, they became receptive to Western knowledge in a variety of fields, including those of optics and clock-making.

The first European clock to enter Japan was probably the one presented to a high-ranking dignitary by François Xavier in 1551. Other Jesuits also introduced them. The Japanese wanted to understand how they worked and were swift to master the technique; they began to produce clocks as early as the late sixteenth century. Not content with merely copying them, they adapted them to their highly

complex time system, in which the length of the hours would vary according to the season, and in which the twelve animals of the Chinese calendar replaced the numerals.

While today we still do not know whether European automata were introduced at the same time as clocks and optical viewing devices, we are sure that the Japanese adapted the Western watch-making technique of the cogwheel in their automata in the Edo period, to produce some highly original creations. The greatest automaton master of the day was Takeda Ōmi (d. 1704), an expert watchmaker. In 1658, he made a puppet that he presented to the emperor. Four years later, he held a very memorable automaton performance. Many *kibyōshi**—little "yellow books" from the Edo period—were devoted to automata, particularly those of Takeda Ōmi. The mechanisms that he developed were later widely used in *kabuki* theater, which draws on a large number of special effects.

Android automata, which began to take shape as early as the thirteenth century in Europe and were then taken up by many other countries, are currently state-of-the-art in Japan.

Automata, androids, robots—man has always sought to create recreational or utilitarian objects, as is the case with Japan's twenty-first century robots. From Mary Shelley's *Frankenstein*, or *The Modern Prometheus* (1818) to *L'Ève future* (*Tomorrow's Eve*, 1886) by the French symbolist writer Villiers de l'Isle-Adam, world literature abounds in writings on the subject. Robots and androids also feature heavily in Japanese and Western cartoons. Agents of destruction or salvation, they are now the heroes of many movies.

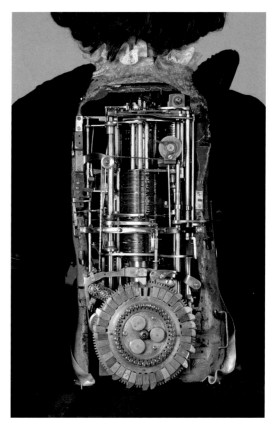

123
View from the back of the mechanism in Pierre Jacquet-Droz's *The Writer*, 1774. Automaton, Musée d'Art et d'Histoire, Neuchâtel, Switzerland. © Photo mahn / S. Lori.

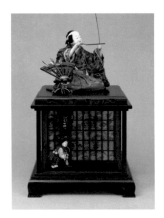
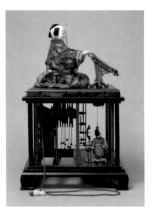
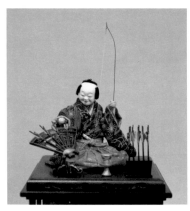
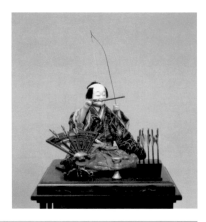

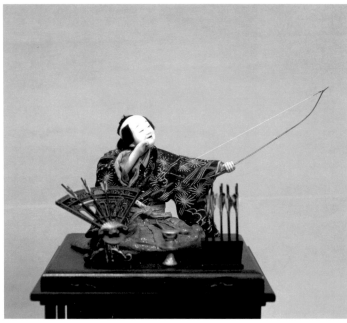
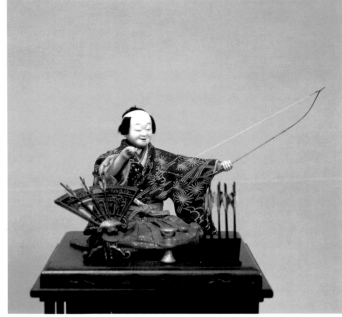

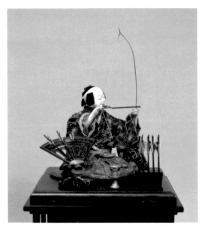

124–130
Tanaka Hisahige, *Yumi hiku dōji (Automaton Drawing a Bow)*, late Edo period. Automaton, 20 x 12 x 12 in. (51 x 32 x 32 cm). © Toyota Collection.

Among the marvels of ingenuity and aestheticism revealed by Japanese automata, the archer is an exceptional piece, as its first attempt to hit the target is designed to fail, thereby capturing the audience's attention. At the second attempt, the arrow hits the center of the target and the archer gazes at the dumbfounded spectator with satisfaction, thus soliciting his admiration at such technical prowess even today.

INTERVIEW
WITH SUZUKI KAZUYOSHI

Director of research at the National Museum
of Nature and Science, Tokyo

In 2008 the Kokuritsu Kagaku Hakubutsukan (Tokyo's National Museum of Nature and Science) held a fascinating exhibition on robots: *Dai robotto ten* ("The Great Robot Exhibition"). Designed and produced entirely by the eminent researcher Suzuki Kazuyoshi, it charted the history of robots from their beginnings to the present, from Edo period automata to the latest robots, such as Asimo, which would run and walk before the viewers, serving drinks ordered by its imaginary family. Demonstrations of all manner of robots with multiple applications enabled the layman to become acquainted with these wonders of modern technology. In organizing this event that brought together the largest robot companies in Japan, Suzuki Kazuyoshi pulled off a real feat. Fascinated by science and its applications, he was kind enough to grant me an interview in June 2009 and to talk about his hopes for the field of robotics.

Brigitte Koyama-Richard: You have organized exhibitions and written books on *karakuri ningyō** [mechanized puppets or automata] from the Edo period, as well as about robots. It strikes me as extremely rare for a research engineer to be interested in robots and the automata of centuries past.

Suzuki Kazuyoshi: I became a university freshman just as Japan was experiencing a host of environmental problems, and the benefits of science were being refuted. I found this field interesting and I wanted to find out about its origins. I therefore joined a group of students who were trying to

manufacture, as in the Edo period, the famous automaton *Cha hakobi ningyō* [*Tea-serving doll*], in order to exhibit it at the university's annual gala. It was an android made entirely of wood that walked forward carrying a cup of tea; as soon as someone took the cup, the automaton stood still; it went away when the cup was given back. I was therefore able to study the manufacture and, at the same time, the history of automata. I traveled the length of Japan in the search for information about them. We then presented this doll to the National Museum of Nature and Science, where it is still on display. Indeed, I am currently the only person in this field. As an engineer, I have always tried to approach science from the basis of historical sources, and it is the fundamental study of Japanese automata that has allowed me to go on to the field of robots.

B. K.-R.: I was fascinated by the number of Edo period automata—which are nevertheless extremely rare—presented during your robot exhibition. What, in your opinion, is the difference between Japanese and European automata?

S. K.: The Japanese have always been curious about everything. They are playful in spirit and love toys. *Karakuri* [automata] were designed to be exhibited during festivals or in entertainment districts for people's pleasure. Japan is probably the country that has created the most toys since ancient times. *Karakuri* were in keeping with the sense of peace of mind that permeated the Edo period.

As an engineer, I wanted to know how these automata were manufactured and how they were used at the time. The fundamental difference with the West is that these automata were designed to entertain the whole social spectrum, unlike Western models that were reserved for the aristocracy or important figures. Moreover, some of these automata—such as the archer—are absolutely unique, in the sense that the craftsman who designed it was really looking to surprise the viewers by having him miss the target the first time. This desire to amuse the curious onlooker and to address ordinary folk is also found in manga. In the Edo period, writers such as Takizawa Bakin, or Kyokutei Bakin [1767–1848], who published a sort of "manga," enjoyed a wide readership.

B. K.-R.: Do you mean the little illustrated "yellow books"—*kibyōshi*—that fascinated readers in the Edo period?

S. K.: Yes, that's right. And it was the fact that readers wanted to see these color drawings that gave rise to polychrome prints. These prints were created and produced for people of all social classes and were inexpensive. As artists throughout Japan—particularly in the regions of Kanto [Edo] and Kansai [Kyoto, Osaka]—were always looking to surpass themselves and to develop new techniques, the state and quality of Japanese prints advanced accordingly. This is also true of other fields.

B. K.-R.: I feel that the androids and robots found in literature and comics in the West seem quite different to their Japanese counterparts.

S. K.: In Western literature, androids and robots are presented as scientific creations. When they are too perfect or god-like, we destroy them. In Japan, we take a much more optimistic view. Animism and the belief that water, vegetation, and objects have a life of their own also account for this difference in vision and approach.

B. K.-R.: In Japan, research in the field of robotics is extremely important in industrial terms, isn't it?

S. K.: In Japan, technology advances too quickly for the laws that ought to go with it. For the moment, no law exists to authorize functional robots. We can therefore use them as toys, though it would make such a difference if we could employ them in many fields. I feel that this is linked to Edo period cultural tradition—we immediately seek to apply cutting-edge techniques to everyday life, or as games. This is why robots such as Aibo or Asimo, somewhat akin to pets, appear on the market. These techniques have also been used in cameras, video games, and the like. Fortunately, Japanese robotics is to be found in many countries in various forms; as such it can help others.

B. K.-R.: In your opinion, just how far can we go in perfecting robots?

S. K.: We have entered a new generation of robots. We are now looking to improve them so as to make everyday life easier. Though I don't make them myself, my role and job here at the museum is to explain the history of robots and the need for a future for them.

B. K.-R.: Which robot would you like to be able to create?

S. K.: Tetsuwan Atomu [Astro Boy], of course. As children we all dreamed of having such a robot. But it is, of course, a pipe dream. We will never be able to build a robot like Astro Boy—the late master Tezuka Osamu would not hear of it. It would shatter the magic. But everyone would like robots to make our lives easier, with the ability to think and communicate. They are equipped with ever more sensors and, in the future, will be required to satisfy man's wish for help in various fields.

– June 2009 –

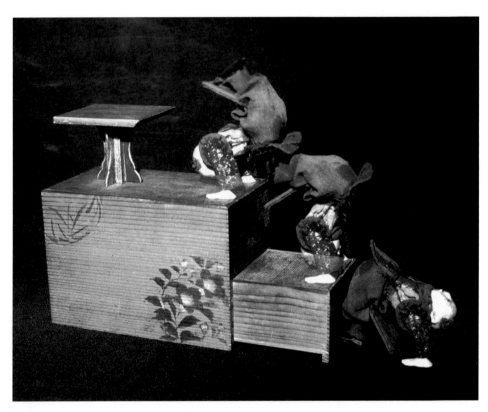

131
Anonymous, *Dangaeri ningyō (Roly-poly Doll)*,
late Edo period. © Toyota Collection.

While the Japanese might have adapted European clock-making mechanisms according to their own needs, the Europeans subsequently adapted their roly-poly dolls.

Detail of fig 22. © Planetto Eiga Shiryō Toshokan.

PRE-CINEMA AND GREAT INVENTIONS

The illusion of movement

The Western infatuation with sciences and technology in the eighteenth and nineteenth centuries gave rise to the creation of a host of optical toys and devices. Despite the relative lack of precise dating of their appearance in Japan, historians believe that the archipelago was swift to welcome most inventions in this field as early as the late Edo period.

Among the better-known Western inventions were the thaumatrope, which appeared around 1826, and the phenakistoscope, invented in 1832 by the Belgian Joseph Plateau (1801–1883), which Charles Baudelaire described so aptly in *A Philosophy of Toys*:

> There is one kind of toy which has tended to multiply for some time, and of which I have neither good nor bad to say. I refer to the scientific toy. The chief defect of these toys is that they are expensive. But they can continue to amuse for a long time and develop in the childish brain a taste for marvelous and unexpected effects. The Stereoscope, which gives a flat image in the round, is one of these. It first appeared several years ago. The Phenakistoscope, which is older, is less well known. Imagine some movement or other, for example, a dancer's or a juggler's performance, divided up and decomposed into a certain number of movements; imagine that each one of these movements—as many as twenty, if you wish—is represented by a complete figure of the juggler or dancer, and that these are all printed round the

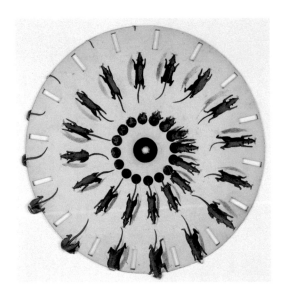

1–2
Thaumatrope, London, 1826.
Paper disk printed and highlighted
in color on both sides.

3
T.M. Baynes, Phenakistoscope disk,
Fantascope model, London, 1833.
Color lithograph.

edge of a circular piece of cardboard. Fix this card, as well as a second circular piece cut at equal intervals with twenty little windows, to a pivot at the end of a handle which you hold as one holds a fire-screen in front of a fire. The twenty little figures, representing the decomposed movement of a single figure, are reflected in a mirror placed in front of you. Apply your eye at the level of the little windows and spin the cards rapidly. The speed of rotation transforms the twenty openings into a single circular opening through which you watch twenty dancing figures reflected in the glass—all exactly the same and executing the same movements with a fantastic precision. Each little figure has availed himself of the nineteen others. On the card it spins and its speed makes it invisible; in the mirror, seen through the spinning window, it is motionless, executing on the spot all the movements that are distributed between all twenty figures. The number of pictures that can thus be created is infinite.[1]

In 1836, Joseph Plateau was still marketing the anorthoscope he had designed eight years earlier. In this device, a distorted figure is drawn in a curve on a swiftly revolving disk of oiled paper. In 1834, the Austrian Simon Stampfer (1792–1864) and the Englishman William George Horner (1786–1837) each developed independently the principle of the zoetrope, a kind of drum with slits that segmented movement. In the USA, the Englishman Eadweard Muybridge furthered the work on chronophotography initially undertaken by Étienne-Jules Marey (1830–1904) and his assistant, Georges Demeny (1850–1917), in France.

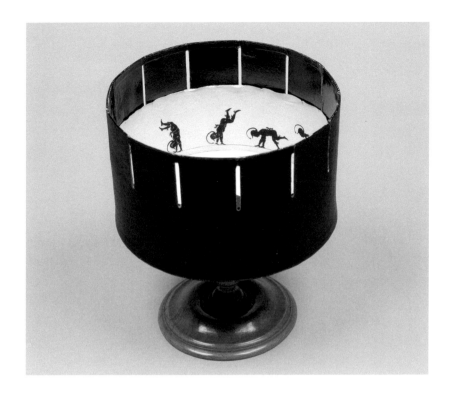

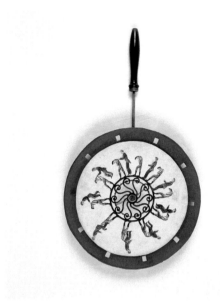

4 *(Left)*
**Phenakistoscope, UK, nineteenth century.
15 x 8 ¾ x 1 ¾ in. (38 x 22.2 x 4.5 cm).
© Hyōgo Prefectural Museum of History.**

5 *(Above)*
**Zoetrope, Japan, Meiji period. Tinplate,
wood, and paper, diam. 4 ½ in. (11.4 cm),
h. 374 in. (950 cm). © Hyōgo Prefectural
Museum of History.**

Then in 1876–77, Émile Reynaud (1844–1918) invented the praxinoscope—a device that gave the illusion of movement by substituting one image for another by means of prismatic mirrors. At the 1878 Universal Exposition in Paris, the press praised him and the jury awarded him a distinction for this toy, which also caught the public eye. Fine-tuning the process, he produced the projection praxinoscope, which he marketed from 1882 onward. In 1888, he took out a patent for his famous *Théâtre Optique* that was to be a big hit from 1892 to 1900 (12,800 shows with 500,000 spectators in attendance), with films such as *Pauvre Pierrot* (aka *Poor Pete*), or *Un bon boc* (aka *A Good Beer*). The Musée Grévin in Paris subsequently received his *pantomime lumineuse* projections.

It was in fact Émile Reynaud who created the cartoon, in that he had broken down movement into a series of drawings, which he then reconstructed as a whole, projecting them onto a screen. Yet his success was short-lived; the brilliant inventor, who destroyed most of his wonderful hand-painted films, died in poverty. A new invention was to take over, one that would invade screens the world over—the cinematograph.

6
Anorthoscope disk, Paris, c. 1836.
Oiled paper, print with color
highlights. Cinémathèque
Française – Conservatoire
des Techniques, Paris.

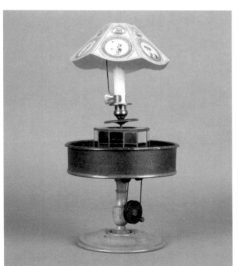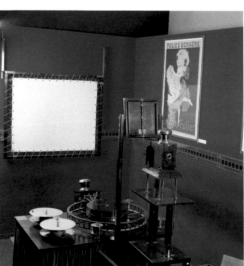

7 *(Far left)*
Émile Reynaud, Hand-cranked
praxinoscope, Paris, model
manufactured from 1879 onward.
Cinémathèque Française –
Conservatoire des Techniques,
Paris.

8 *(Left)*
Reconstruction of Émile Reynaud's
Théâtre Optique (1888), Paris.
Cinémathèque Française –
Conservatoire des Techniques,
Paris.

The emergence of cinema and cartoons

When the cinematograph reached Japan, it radically changed the world of imagery, as it had elsewhere. *Utsushi-e* performances became increasingly rare, and magic lanterns were soon confined to an educational role.

The cinematograph created by the Lumière brothers, Auguste (1862–1954) and Louis (1864–1948), first appeared in Japan in 1896, just one year after the first projections in France. The first imported movies—documentaries and fictional features made in Europe and the USA—sparked a craze that was never to die down. Shortly afterwards, four Japanese film companies came into being. In 1912 they merged to form Nikkatsu; two years later, several members of this company resigned to create Tenkatsu.

Imported from France, Britain, and the USA, cartoons made their first shy appearance in Japan in 1909. Japanese audiences were particularly fond of movies by James Stuart Blackton (1875–1941), the man behind the image-by-image cartoon technique. He created the first animated features in the history of cinema: *The Enchanted Drawing* (1900), *Humorous Phases of a Funny Face* (1906), and Fig. 9 *Fantasmagorie* (1908) by French caricaturist Émile Cohl (1857–1938).

In the 1920s, some fifty such films—known in Japan as *"dekoboko shingachō"* ("a series of random new images")—entertained Nipponese audiences, with an ever-increasing demand for images. Yet the Japanese were not going to be content with being mere spectators for long. As with painted scrolls, prints, and *utsushi-e*, they were soon to make this still-faltering technique their own.

9
Emile Cohl, *Fantasmagorie*, film, 1908.
Gaumont Production.

The pioneers of Japanese animation

It is astonishing to note that the three main pioneers to embark upon this great adventure—Shimokawa Hekoten, Kitayama Seitarō, and Kōuchi Sumikazu—did so independently, based on different techniques and with no prior cinematographic experience. This is probably why each laid claim to the title of "inventor of Japanese anime." The only thing they had in common was that all three of them had studied "Western-style" painting. In Japan, from the late nineteenth century on, two styles of painting could be distinguished: *nihonga**, literally "Japanese painting," which used diluted pigments on Japanese paper or silk, and *yōga*, or "Western-style" painting, which employed the mediums and pigments of Western painters. Indeed, though they knew nothing whatsoever about cartoon-making, their curiosity was unrivalled. Moreover, their backing came from film companies which, in the face of the success of Western cartoons, had commissioned these films from them. So everything was there to be invented.

The first attempt was ascribed to the caricaturist Shimokawa Ōten or Hekoten (1892–1973) in 1916. A student of the famous painter and *mangaka**, Kitazawa Rakuten (1876–1955), who first coined the term *"manga"* instead of *"ponchi-e**" to refer to caricatures and comics, Shimokawa was a regular contributor to the magazines *Tokyo Puck* and *Rakuten Puck* created by his master. From 1908 to 1912, he worked in the cartography office of the land army's topographical department, before working from 1913 to 1916 for the photographic department of Osaka's *Asahi* newspaper. With a talent for drawing, he published his first comic book, *Ponchi shōzō (Caricatures)* in 1916, making a name for himself in the field.

The Tenkatsu Company (Tennenshoku Katsudō Shashin, "Color Motion Pictures, Inc.") then asked him to create animated drawings. The word *"anime"* (as in the French *dessin animé*, "animated drawing" or cartoon) did not exist as such; neither did the terms *"manga eiga"* (manga movie) or *"dōga"* (motion pictures), which were coined subsequently.

After many months of trial and error, Shimokawa produced some attempts using chalk on black plates before opting to use white paint to draw on pre-printed grounds. He finally managed to create the first

Japanese animated feature film: *Imokawa Mukuzō genkanban no maki (The Story of the Concierge Mukuzō Imokawa)*. Its first public showing was in January 1917. In 1934, Shimokawa Hekoten acknowledged in an article entitled *"Nihon saisho no manga-eiga seisaku no omoide"* ("Memories of the Production of the First Japanese Manga Film"), published in the magazine *Eiga hyōron*, that everything he had done was quite rough, and that his characters did not walk but jumped like rabbits, which the audience found very funny. According to various books on cinema that were published in Japan, this film's hero would appear to have been the young student of his manga *Imokawa Mokuzo to buru (Imokawa Mokuzo and Buru)*, published in serial form in the magazine *Tokyo Puck*. Unfortunately the film no longer exists to confirm this hypothesis.

His second animated feature film, *Dekoboko Shingacho, Meian no shippai (Random New Images, a Great Idea Ending in Failure)* was presented the following month at the Asakusa cinema club.

After making five cartoons at the expense of his health—he suffered from eye problems as a result of drawing on brightly lit glass plates—Shimokawa Hekoten returned to manga, pursuing a brilliant career in various newspapers and magazines of the time. Tenkatsu then stopped working with animation.

Kitayama Seitarō (1888–1945) is considered to be the second pioneer of Japanese anime. An admirer of Western painting, he became a watercolor artist, after studying this technique with the painter Ōfuji Tōjirō (1870–1911). In 1912, he worked with the editorial department of the magazine *Mizue*, created by his master in 1905, to promote watercolors in Japan, before founding another art journal, *Gendai no yōga (Contemporary Western Painting)*. He organized painting exhibitions, which allowed artists such as Kishida Ryūsei (1891–1929) to present their works.

Filled with wonder at Western cartoon graphics, which he stumbled upon by chance in 1916, he set about studying their techniques. He presented his projects to the Nikkatsu Corporation (Nihon Katsudō Shashin), which recruited him for its Mukojima studio. Initially responsible for subtitling silent movies, he was then asked to design a typically Japanese series of cartoons. As he was a complete novice in this field, he had a very hard time making

10
Kitayama Seitarō, *Sarukani gassen (The War Between the Monkey and the Crab)*, film, 1917.
© Planetto Eiga Shiryō Toshokan.

Presented on May 20, 1917, in Tokyo, this film recounts the story of a monkey that exchanges his persimmon seeds for a crab's rice ball. The crab plants them; a tree grows and bears fruit. The wily monkey then offers to go and pick the fruit for the crab, but it eats the ripe persimmons and throws the rest on the unfortunate crab, killing him. The crab's children then decide to avenge their father's death.

11
Kitayama Seitarō, *Tarō no heitai (Tarō the Little Soldier)*, film, 1918.
© Planetto Eiga Shiryō Toshokan.

Sarukani gassen (The War Between the Monkey and the Crab), based Fig. 10 on a very well-known tale dating back to the fourteenth century.

Together with a team of young designers who, like himself, had studied painting, in 1917 he produced *Tarō no heitai (Tarō the Little Fig. 11 Soldier)* and ten other animated films, including the first advertising feature for the post office savings bank. The following year, he made ten more films, and set about producing a cartoon version of the legend of Momotarō, a boy born in a peach and endowed with extraordinary powers, who accomplished many amazing feats. This was the first Japanese animated movie to be subtitled for export. In 1921, he left Nikkatsu to found his own studio, the Kitayama Eiga Seisakusho (Kitayama Film Studio), where he created animated advertising features or educational films—a area in which he was an innovator. The 1923 Tokyo earthquake caused irreparable damage to his premises, forcing him to move to Osaka, where he produced documentaries for the *Mainichi* daily paper.

The third big name in early Japanese animation, Kōuchi Sumikazu (1886–1970), also trained in Western painting. He joined *Tokyo Puck* in 1907 and became a comic strip artist. His talent caught the eye of Kobayashi Kisaburō, who had quit Tenkatsu in 1916 to set up his own film production company, Kobayashi Shōkai. He entrusted Kōuchi Sumikazu with the creation of a cartoon, which was presented on June 30, 1917, five months after Shimokawa Hekoten's first film. His offering told of a samurai* who had been sold a poor quality sword. Narrated by a famous *benshi** (narrator), it was a huge hit. His second animated feature, *Chamebō kūki jū no maki (Story of a Mischievous Boy's Air Rifle)*, was banned on the grounds that it might incite children to get up to mischief. After his third animation, *Hanawa hekonai kappa matsuri (Hanawa Hekonai and the Kappa** Festival)*, the Kobayashi Shōkai company, fraught with financial difficulties, was forced to stop running. Kōuchi Sumikazu initially found a new job in a press office, before founding his own company, Sumikazu Eiga Sōsakusha, in 1923, and producing an animated publicity feature that recounted the life of the mayor of Tokyo, Gotō Shinpei, as well as other animated films for a political party. In 1930, he made a talking movie, *Chongire hebi (Chopped Snake)*, after the

work by his *mangaka* friend, Maekawa Chiho, before becoming a manga artist once more.

Thus Shimokawa Hekoten, Kitayama Seitarō, and Kōuchi Sumikazu opened up the way for the history of animation. Their enthusiasm, curiosity, and persistence allowed them to bring into being the first Japanese cartoons. Several of their followers—Yamamoto Sanae, Ōfuji Noburō, Murata Yasuji, or Masaoka Kenzō in particular—were to fine-tune the technique further.

Yamamoto Sanae (real name Seitarō; 1898–1981) was an artist of conventional training; little did he know that his meeting with Kitayama Seitarō would change his life completely. In 1918, Yamamoto became his assistant at Nikkatsu and helped to design several cartoons. He made his first film, *Usagi to kame (The Hare and the Tortoise),* in 1924. One year later, he set up his own studio, the Yamamoto Manga Seisakujo, and produced *Ubasute yama (The Mountain Where the Elderly Are Abandoned),* based on an originally Chinese custom that became a legend, whereby elderly people were abandoned in the mountains in times of famine, particularly in the Obasute-yama, a peak in the Nagano region. He then embarked upon a very different genre of animated films, such as *Nihon no Momotarō (Momotarō in Japan)* in 1928.

In his early days, he mainly worked on State commissions, particularly those of the Ministry of Education. During the war, he produced animated feature films for the Japanese army and navy. The Shin Nihon Dōgasha company, followed by Nihon Manga Eigasha (Yamamoto Sanae becoming its most important member), were established when the fighting was over. Yamamoto then went on to found Nihon Dōgashaien 1947, where he created a very popular animation feature film: *Suteneko Tora-chan (Abandoned Cat Little Tora).* Despite the film's success, his firm went bankrupt, subsequently to be bought up by the Tōei Company in 1956, with Yamamoto Sanae as its vice president.

The product of a wealthy background, Ōfuji Noburō (1900–1961) was trained by Kōuchi Sumikazu. He created his own studio, Jiyū Eiga Kenkyūsho, in 1925 and became an independent producer. His first film, *Bagudadu no Tōzoku (The Thief of Baghdad)*—a spoof on an

Fig. 12

Fig. 13

12
Yamamoto Sanae, *Usagi to kame (The Hare and the Tortoise),* film, 1924. © Planetto Eiga Shiryō Toshokan.

13
Yamamoto Sanae, *Nihon no Momotarō (Momotarō in Japan),* film, 1928. © Planetto Eiga Shiryō Toshokan.

14
Ōfuji Noburō Production, *Kirinuki Urashima (Excerpt from the Legend of Urashima)*, film, 1928.
© Collection of the National Film Center, The National Museum of Modern Art, Tokyo.

Here Ōfuji Noburō recounts the story of an actor by the name of Kuroda, who hopes to land the role of the hero Urashima Tarō in a film. In the end, the role goes to someone else, a fact that drives Kuroda to kidnap the young leading lady. Fortunately, the other actor rescues her, making for a happy ending.

15
Ōfuji Noburō, *Chiyogami (Work made from traditional chiyogami paper)*, c. 1926–30.
© Collection of the National Film Center, The National Museum of Modern Art, Tokyo.

American movie—was presented in 1926. Ōfuji was the first to cut his characters out of *chiyogami**, a type of traditional Japanese paper _{Fig. 15} decorated with various colorful motifs. He had it made to fit the sets he wished to create; his supplier was the specialist paper and craft store, Isetatsu. In various newspaper articles, he explained that the idea of using this paper had occurred to him while watching a *kami shibai** (literally "paper theater") performance. This form of travelling theater, designed for children, in which stories were related using a succession of different pictures inserted into a wooden frame, was very popular up until the end of World War II.

As Ōfuji Noburō's movies were in black and white, it is quite difficult to appreciate this paper's beauty. However, a few of his *chiyogami* models that have fortunately been preserved at the National Film Center bear witness to the delicate nature and minute detail of his characters, in which each part of the body and costumes take on different patterns. In the magnificent cartoon *Urashima* (1928), the *chiyogami* paper motifs are clearly visible in shades of gray.

In 1927, Ōfuji took advantage of the release of his film *Songokū monogatari (The Tale of Songokū),* to change his company's name to "Chiyo-gami Eiga-sha," (Chiyogami Motion Pictures Company).

Beguiled by the beauty of the silhouettes in the German animated film *Kalif Storch (Caliph Stork)* by the Diehl brothers and directed by E. M. Schumacher, which he had seen in 1924, he created the first shadow cartoon, *Kujira (The Whale),* in 1927. This animation, with a recorded soundtrack (record-style talkie), was exported to France.

Ever willing to experiment with new techniques, Ōfuji Noburō shot *Kogane no hana (A Golden Flower)* in 1929 in Cinecolor, but the film was projected in black and white. That same year, he turned to a new system of sound recording that synchronized image and music for his *Kuro nyago (The Black Cat),* based on a jazz record for children. He made a further eighteen movies up until the end of the war, when he adapted Akutagawa Ryūnosuke's novella *Kumo no ito (The Spider's Thread),* which was awarded first prize in the first Venezuela International Film Festival.

His subsequent works were mainly shadow movies, sometimes tackling religious themes, such as *Taisei Shakuson (The Venerable Sakyamuni,* Part I [1942] and Part II [1952]), or *Seisho gensōfu Adam to Eve (The Bible: The Fantastic Tale of Adam and Eve,* 1951). He produced a second version of *The Whale* in 1952, in Konicolor, using strips of colored cellophane paper styled on a church's stained-glass windows. In 1953, this remarkable film was selected in the Short Film category at the Cannes Film Festival. Though it did not win an award, Japanese film critics reported how Picasso had commended it at the time.

16
Ōfuji Noburō Production, *Kujira (The Whale),* film,1927. © Collection of the National Film Center, The National Museum of Modern Art, Tokyo.

A storm rages over the sea, causing the shipwreck of a boat that has aboard three men of different social classes—a sailor, a merchant, and a samurai—as well as a charming young lady. At daybreak, the four characters are safe and sound, but the three men begin to fight over the terror-stricken damsel. An enormous whale then appears and swallows the four of them whole. In the cetacean's stomach, the men put aside their fantasies to focus solely on their survival. The whale spits them out again and they find themselves on its back. Forgetting their fright, they start arguing once more about how to gain the young lady's favors. But the god of the ocean causes the men to sink, leaving the young woman in peace at last to go to sleep on the whale's back.

17
Ōfuji Noburō, Sankō Studio, *Kumo no ito (The Spider's Thread),* film, 1946. © Collection of the National Film Center, The National Museum of Modern Art, Tokyo.

18
Murata Yasuji, *Dōbutsu olimpikku taikai
(Animals at the Olympic Games)*, film, 1928.
© Planetto Eiga Shiryō Toshokan.

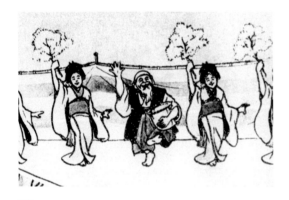

19
Murata Yasuji, *Hana saka jijii (The Old Man
Who Made Withered Trees Flower)*, film, 1928.
© Planetto Eiga Shiryō Toshokan.

This is the story of an old man who finds gold
thanks to his dog. A jealous neighbor kills the
hound and the poor man weeps as he buries it
beneath a tree that he then cuts down to make a
mortar. When he crushes rice in this vessel, the
grains change to gold. The neighbor sets light to
the mortar; but when the old man throws its ashes
on dead trees, they all come back to life and begin
to blossom.

In 1956, his shadow movie made in Fujicolor cellophane, *Yūreisen
(The Ghost Ship)* was awarded the Special Jury Prize in the Short Film
category at the Children's TV Film Festival in Venice. In it, Ōfuji
Noburō told the story of pirates who attacked a boat belonging to
aristocrats. Once they had killed all of the men, they seized the
women, some of whom committed suicide. A few months later, the
pirates saw a ghost ship loom up before them. Unable to win a battle
against the souls of their victims, they all perished.

Of exceptional artistic quality, Ōfuji Noburō's movies made a lasting
mark on the history of Japanese anime. Following his death, in
accordance with his wishes and through the efforts of his sister Yaé,
the *Mainichi* Eiga Konku-ru no Ōfuji shō (Ōfuji Award at the *Mainichi*
Film Concours) was created to recognize excellence in animation.

After the 1923 Tokyo earthquake, which dealt a terrible blow to
the film industry, new companies sprung up, including Yokohama
Cinema Shōkai, which specialized in the importing of movies
produced by the American Bray Pictures Corporation, where Murata
Yasuji (1896–1966) worked. Responsible for the graphics of the
intertitles of silent films imported from the USA, he also handled the
subtitling of educational films and cartoons for Bray Studios. This is
how he came to be interested in animation. He learned the
techniques from his childhood friend, Yamamoto Sanae, who then
worked for the Kitayama studio. In 1927, he made a new version of
The War Between the Monkey and the Crab and *Tako no hone (The
Octopus Bone)*, and the following year a large number of animated
features on sport, including *Dōbutsu olimpikku taikai (Animals at the* Fig. 18
Olympic Games) and *Hana saka jijii (The Old Man Who Made* Fig. 19
Withered Trees Flower).

Murata Yasuji was greatly instrumental in improving photographic
procedures by introducing various innovations. He became a master
in the art of paper cutouts, managing to produce movements that
were almost as fluid as those using cels. He would cut out each of his
characters, separating the body and the limbs, which he fixed at the
joints with pins in order to animate them. He would then set them
down to be filmed, image by image. This is how in 1934 he created

Tsukinomiya ōjosama (Princess Tsukinomiya), a masterpiece of its kind. The tale is set in the city of the squirrels, amid a field of flowers. Here, a grandmother squirrel brings up a little girl, whose background is unknown. A wicked frog kidnaps the child when out for a walk. When the squirrels go out to look for her, they learn that their protégée is the moon princess, whom the rabbit responsible for her safekeeping inadvertently let fall to earth. They rescue her and bid a wild goose take her back to her realm.

The same year, Murata produced *Osaru no taigyo (The Monkey and the School of Fish),* before orchestrating one of the most famous manga figures of the time—the black cat, Nora Kuro. In this cartoon, the cat stands before a peddler of *yakitori* (skewered chicken). He buys some to take home and, on the way, comes across two monkeys who have just been up to no good. He chases after them and, just as he is about to catch them, suddenly wakes up and realizes that although he does actually have the brochettes, the rest is nothing but a dream. Action and humor punctuate the entire film. A *benshi* (narrator) plays all of the roles, and much of his tale is written up between two of the film's scenes.

Murata Yasuji left the Yokohama Cinema Shōkai in 1937 and was recruited by various other film companies before founding his own, the Murata Seisakusho, in 1956, where he continued to produce a large number of advertising features in particular.

Masaoka Kenzō (1898–1988) turned to animation after studying Western painting at Kyoto University, and then with the master of Western-style painting, Kuroda Seiki (1866–1964). In 1925, he entered the Makino studio, before trying his hand four years later at the educational film department of Kyoto's Nikkatsu Uzumasa Corporation. He then produced his first film: *Nansensu monogatari, daippen, Sarugashima (Nonsense Story, Volume I: Monkey Island).*

In 1932, Masaoka Kenzō left Nikkatsu Uzumasa and founded the Masaoka Eiga Seisakusho studio in Kyoto. In the 1930s, audiences were no longer satisfied with seeing "moving pictures," but demanded talkies akin to the ones from the United States that they had discovered.

Fig. 21

20
Murata Yasuji, *Norakuro gochō (Corporal Gochō),* film, 1934. © Planetto Eiga Shiryō Toshokan.

21
Masaoka Kenzō, *Nansensu monogatari, daippen, Sarugashima (Nonsense Story, Volume I: Monkey Island),* film, 1930. © Planetto Eiga Shiryō Toshokan.

A couple and their baby are sailing along peacefully when a storm blows up. They put the child in a basket in the hope that he will survive, and let it drift away on the waves, despite the desperate nature of the situation. The little boy is washed up on an island inhabited by monkeys, which raise him. Little by little, they start to make fun of him because of his lack of a tail. The boy takes flight on a raft. This film was such a hit that Masaoka Kenzō produced a second episode of it two years later.

22

Masaoka Kenzō, *Chikara to onna no yo no naka (Within the World of Power and Women)*, film, 1933. © Planetto Eiga Shiryō Toshokan.

This comedy—intended for an adult audience—describes the family of an office worker, the father of four children, who is unfaithful to his wife with a typist. The wife flies into a terrible rage when she learns of her husband's infidelity. Famous actors of the time provided the characters' voice-overs.

23

Masaoka Kenzō, *Sakura (Cherry Blossom)*, film, 1946. © Planetto Eiga Shiryō Toshokan.

The particularly delicate nature of this film's graphics, in which the characters and butterflies have human features, is a throwback to Masaoka Kenzō's training as a painter.

Walt Disney (1901–1966) had launched his first talking cartoon in 1928. A talking movie was obviously much more expensive to make than a silent film, and took three times longer. In 1931, the Shochiku studio produced the first Japanese talkie: *Madamu to nyōbō (Madame and the Wife)*. Kido Shirō, head of Shochiku, wanted to focus on animated talkies from then on and hired Masaoka Kenzō with this aim. At the same time, a young man aged twenty, Seo Mitsuyo (born in 1911), came to see him to ask to be his student. Seeing how dynamic and keen he was, Masaoka realized that this would be the start of a successful collaboration. In April 1933, he completed his first cel animated talkie: *Chikara to onna no yo no naka (Within the* Fig. 22 *World of Power and Women)*.

Masaoka Kenzō invested a large sum of money to create a modern studio in Kyoto—the Masaoka Eiga Bijutsu Kenkyūjo. It was here that he produced *Chagama ondō (A Dance Song with a Kettle*, 1934), or *Mori no yōsei (Forest Fairy*, 1935), films on a par with those of Walt Disney in terms of quality. Masaoka then abandoned paper cutouts for highly expensive cels.

Patented in 1914 by the American Earl Hurd (1880–1940), the cel or celluloid was an instant success. The characters were drawn and painted on a transparent sheet of vegetable celluloid placed over a static background. The Canadian Raoul Barré's invention of a peg system that enabled the accurate positioning of successive drawings in relation to one another came to supplement this.

Despite the critics' praise, Masaoka Kenzō's films were deemed overly artistic and costly. He eventually fell into debt and his studio was bought up. In 1941, Shochiku opened the Dōga Kenkyūjo, with Masaoka as its production chief. He made an animated film after the famous manga *Fukuchan no kishu (Fukuchan's Surprise Attack)*, Fig. 24 followed by *Kumo to chūrippu (The Spider and the Tulip*, 1943), based Figs. 25; 27 on a scenario by the novelist Yokoyama Michiko.

Masaoka Kenzō explained that a chance discovery of an art book on the drawings of designer Léon Bakst sparked his passion for the work of Serge Diaghilev and the music of Igor Stravinsky. Setting himself the task of producing a high-quality movie, he commissioned the composer Hirota Ryūtarō to produce the music for *The Spider and the Tulip*. Masaoka asserted that animated films should be beautiful,

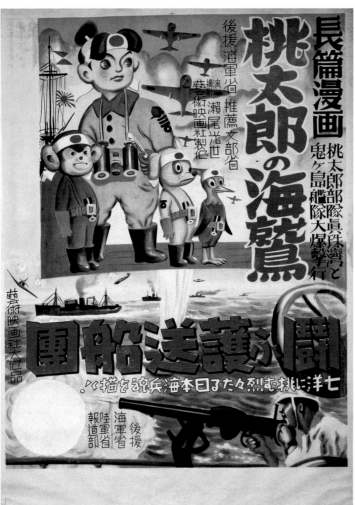

24 *(Above left)*
**Masaoka Kenzō, Shochiku Dōga Kenkyūjo, *Fukuchan
no kishu (Fukuchan's Surprise Attack)*, film, 1941.**
© Collection of the National Film Center, The National
Museum of Modern Art, Tokyo.

25 *(Above)*
**Masaoka Kenzō, *Kumo to chūrippu (The Spider and the Tulip)*,
film, 1943. Shōchiku Kabushikigaisha, Shochiku
Dōga Kenkyūjo.** © Collection of the National Film Center,
The National Museum of Modern Art, Tokyo.

The Spider and the Tulip tells the story of a male spider who tries
to seduce a ladybug to capture her. The ladybug then takes refuge
in the petals of a tulip, which offers her protection, making the
spider angry. The spider catches them. A storm then looms,
allowing the ladybug to be set free. When morning comes she
flies away happily and sings. There is a striking resemblance
between the face of the graceful ladybug and that of Walt Disney's
Snow White (1937).

26 *(Left)*
**Seo Mitsuyo, poster of *Momotarō no umiwashi
(Momotarō's Sea Eagles)*, film, 1942.**
© Hyōgo Prefectural Museum of History.

bright, and cheery, and that to achieve this, the animation, form, and music had to act as one. He pulled this off to perfection, as this film is a true masterpiece. After the war, he also produced *Sakura (Cherry Blossom,* 1946), a hymn to the beauty of Kyoto's flowering cherry trees. Like all cartoons of the time, Masaoka Kenzō's films always bore a moral intended for children. Fig. 23

Masaoka Kenzō played a decisive role in the history of animation. He was also the first to coin the term *"dōga"* (animated images), which was subsequently to be widely used in the field of animation. Until then, one would speak of *"senga dōga"* (line-drawn animated images), *"cartoon comedy,"* and *"manga dōga"* (animated manga). The history of manga experienced a similar phenomenon, as it was not until Kitazawa Rakuten that the term "manga" came into common usage.

At the origin of modern animation, all of the figures introduced in this chapter helped to shape talented cartoon producers, including Kumakawa Masao, Seo Mitsuyo, and Mori Yasuji. Their learning and passion would enable those who came after them to develop technical procedures and to create masterpieces.

27

Masaoka Kenzō, poster for *Kumo to chūrippu (The Spider and the Tulip)*, 1943. Shōchiku Kabushikigaisha, Shochiku Dōga Kenkyūjo. © Collection of the National Film Center, The National Museum of Modern Art, Tokyo.

This poster shows the two leading figures in *The Spider and the Tulip*. The title, *Kumo to chūrippu,* appears vertically, written in red characters that read from right to left.

THE BIG
PRODUCTION
COMPANIES

Tōei, a half-century of animated films, 1956–2006

Tōei—the beginnings

Just two months after the end of World War II, life resumed its course
and cartoonists joined Shin Nihon Dōgasha, a company that—one
month later—was to employ around a hundred salaried workers. It
was then that Nihon Manga Eigasha came into being. While its first
Fig. 23, p. 80 cartoon, *Sakura (Cherry Blossom)*—the story of a young girl and some
butterflies on the banks of a river lined with flowering cherry trees—
was completed in May 1946, it was not possible to show it. There was
still a shortage of everything at that time and the staff had to show
great ingenuity to obtain equipment. In August 1947, most of the
company's employees resigned to found the Nihon Dōgasha studio,
which became a limited company the following year—and the basis
of what is now Tōei.

The first work to be produced by Nihon Dōgasha was a tale set to
music, *Suteneko Tora-chan (Abandoned Cat Little Tora)*, shown from
August 25 through September 1947. The faces and bodies of all of the
characters (both human and animal) were entirely animated. Given
the film's success, others would follow with their own take on the cat
Tora-chan: *Tora-chan to Hanayome (Tora-chan and the Bride)* in 1948
and *Tora-chan no Kankan-mushi (Tora-chan's Ship Sweeper)* in 1950.

2

Okabe Kazuhiko, Yabushita Taiji, *Hakujaden (Tale of the White Serpent),* **film for big screen,** 1958 © TOEI Company Ltd.

This cartoon is based on a famous Chinese legend in which a young man falls in love with a white snake transformed into a ravishing young maiden. After a host of adventures, they end up together. With its allegorical musical accompaniment, this film is particularly successful in terms of its graphics.

In August 1952, Nihon Dōgasha merged with P.C.L. Manga-bu studios (which had been part of Tōhō before the war) and Tōhō Zukai Eiga-sha. The new company, Nichidō Eiga-sha, recruited staff, improved techniques, and created *Ari to Hato (The Ant and the Pigeon)* in August 1953, followed by *Kappa kawa to Tarō (Tarō and the Kappa)* in April 1954. It produced an average of three films a year, many of which were educational in nature, including *Ko usagi no monogatari (The Tale of a Little Rabbit,* 1954) and *Ukare vaiolin (The Merry Violin,* 1955, in color). In 1956, Tōei Company bought out Nichidō Eiga-sha, and the company became known as Tōei Dōga.

When Tōei Dōga was established (Tōei being originally a film studio), the talk was of *"manga eiga"* (manga movies) and not yet of "anime." Though the creative process had barely changed since the previous era, the Japanese were dreaming of making cartoons of similar quality to those made by Disney Studios. Ever since the launch of *Snow White* in Japan in September 1950, two full-length feature films by Walt Disney had been presented each year to Japanese audiences.

Tōei Dōga—the early years, 1956–62

The years 1956–62 marked the start of Tōei's golden age, with remarkable animated films for the big screen and then for television. The first cartoons initially drew on Chinese tales or Japanese legends, before turning to classics of world literature. The first full-length feature film was *Hakujaden (The Tale of the White Serpent)* in 1958, Fig. 2 which was awarded the Japan Ministry of Culture prize and the Blue Ribbon prize the following year, as well as an award in Venice.

This film marked the start of the use of cel paint and colored ink for the outlines. All of Tōei's full-length feature films were full animation*, meaning that they consisted of twenty-four drawings per second.

In 1959, Tōei produced *Shonen Sarutobi Sasuke* for the cinema, a title that was sold to MGM as *The Adventures of Little Samurai* or *The Magic Boy* and was awarded the Venice Grand Prix. The third full-length feature was *Saiyūki (Journey to the West)* based on Tezuka Fig. 3 Osamu's *Boku no songokū (My Songokū)*. Tōei asked Tezuka to join

the film crew in order to handle the storyboard* and the plot's development, but the famous *mangaka* had so much other work that Ishinomori Shōtaro and Tsukioka Sadao had to help him. Tezuka Osamu described this experience as follows:

> From start to finish, everyone got annoyed at me. Because I was behind schedule, because they said I lacked team spirit, etc.… I often felt like handing in my notice, but thanks to the director and the employees, I managed to fulfill my role in making this film. What I learned at Tōei was that the most important thing about an animation company was not the works, but the human relations. No other job requires this degree of mutual assistance between experts of each part, with the precision of clockwork. There is no place for a spirit of independence, the desire to get noticed, or the feeling of belonging to an elite. I also understood that the more brain-boxes and technicians required in an animated movie, the higher the risk of it losing its originality.[1]

In the end, Tezuka Osamu was relatively disappointed by the result, as he considered the film was not true to his work. The Tōei crew had indeed modified his manga, in its decision to let Rinrin (the little monkey in love with Songokū) live. Despite Tezuka Osamu's vexation, the film enjoyed considerable success. The film, which required 12,198 original drawings and 78,758 animated drawings, was shown in August 1960. The international rights were bought up immediately (it was entitled *Alakazam the Great* or *The Enchanted Monkey* in English) and it received the Venice Festival Prize. Tezuka Osamu would much later acknowledge that it was by virtue of this experience that he subsequently launched into animation.

Fig. 4 To celebrate its tenth anniversary, Tōei designed its fourth film, *Anju to Zushiōmaru (Anju and Zushiomaru),* after a novel by the famous writer Mori Ōgai (1862–1922), with sets in the style of traditional *nihonga* painting. It was the first time that transparent watercolors were used. Made up of 12,607 original drawings and 76,313 animated drawings, this full-length feature was launched on July 19, 1961; the following year it won a prize at the Rimini Festival.

3
Saiyūki (Journey to the West), **film for big screen, 1960.** © TOEI Company Ltd.

4
Anju to Zushiōmaru (Anju and Zushiomaru), **film for big screen, 1961.** © 1963 TOEI Company Ltd.

This story of two orphans takes place in medieval times; it has the graphic beauty of a scroll painting.

5
Ōkami shonen Ken (Ken the Wild Boy),
TV, November 25, 1963/July 12, 1965.
© 1963 TOEI Animation Co. Ltd.

6
Mahōtsukai Sally (Sally the Witch), TV,
December 5, 1966/December 30, 1968.
© Yokoyama Mitsuteru, TOEI Animation Co. Ltd.

Eiga Manga Matsuri, celebrating cartoons

In 1964, Tōei took the initiative of screening short- and medium-length feature films during the spring and summer vacations. This world-first endeavor of its kind enabled a large audience (including many children) to discover the cartoon and Tōei to glean a profit from its creations. In an age where color television, mobile phones, and computers were yet to exist, this cartoon festival, known as the Tōei Anime Fair from 1990 onward, was a particular success.

Animated films for television

With the boom in black and white television, the demand for animated movies continued to increase. Broadcast from January 1, 1963, *Astro Boy* opened up the way for televised cartoons. Realizing how much was at stake with this type of new media, Tōei decided to react quickly and produced its own animated films for television. *Ōkami shonen Ken (Ken the Wild Boy)* was shown for thirty Fig. 5 minutes each week from November 25, 1963, reaping great commercial success.

In March 1963, the full-length feature film *Wanpaku ōji no daija taiji (Little Prince and the Eight-Headed Dragon)* was made, based on a Japanese legend. Columbia Pictures bought the rights and distributed it in many countries. To counter this competition, Tōei brought out a new animated movie in June 1964: *Shōnen ninja fū no Fujimaru (A Little Ninja* Fujimaru)*.

In 1960, the onset of color television marked another turning point in the animation boom. Fifty thousand TV sets were sold in 1963 and the figure continually increased. Animated films soon appeared in color too, as in the case of *Mahōtsukai Sally (Sally the Witch)*, which Fig. 6 was originally in black and white and went over to color from the eighteenth episode. Tōei then revamped its studios and modernized its techniques. In 1964, a special English-brand copying machine for animation that Tōei called "xerography" was to revolutionize the process of tracing drawings onto celluloid.

For its tenth anniversary, Tōei made *Shōnen Jack to Mahōtsukai (Jack and the Witch)*, followed by *Ge Ge Ge no Kitarō (Cackling Kitarō)* Fig. 8

Fig. 9

in January 1968, based on the manga by Mizuki Shigeru, in black and white, which triggered the craze for *yōkai*.

Tōei went on making films regularly for both television and cinema. The new system of "xerography" was employed in *Taiyō no ōji Horus no daibōken* (*Little Norse Prince* or *Prince of the Sun: The Great Adventure of Horus*). Directed by Takahata Isao, one of the pillars of the Studio Ghibli today, this film was intended for an older audience than previous offerings. Using 50,000 original drawings and 159,000 animated drawings, this fourteenth full-length feature took three years to make; an effort rewarded by the Tashkent Festival Prize.

Worthy of mention, too, is the great TV success of *Tiger Mask*, in 1969. Tōei then went from full animation to limited animation* for films intended for television, thereby reducing production costs and enabling enhanced productivity. *Nagagutsu o haita neko* (*Puss in Boots*) presented at the Tōei Matsuri (Tōei Festival) in 1969 was awarded several prizes, including one from the Moscow International Film Festival. Its sequel was in 1972 was *Nagagutsu Sanjuushi* (*The Three Musketeers in Boots*), followed in 1976 by

7 *(Top left)*
Nagagutsu o haita neko, 80 nichikan sekai isshū *(Puss in Boots: Around the World in Eighty Days)*, **film for big screen, 1976.** © TOEI Company Ltd.

As an allusion to Charles Perrault, the author of the famous tale, the cartoon's hero is called "Pero." Wet and starving, he is helped by young Pierre, himself the target of his brothers' ill treatment. Pero becomes his friend and, as a token of his gratitude, makes him into the marquis of Carrabas so that he can marry the princess. Filled with humor and action, the film was a great commercial success.

8 *(Above, top)*
Ge Ge Ge no Kitarō (Cackling Kitaro), **TV, January 3, 1968/March 30, 1969.** © Mizuki Shigeru, TOEI Animation Co. Ltd.

9 *(Above)*
Taiyō no ōji Horus no daibōken (The Little Norse Prince [or *Norse Prince Valiant*]. *Prince of the Sun: The Great Adventure of Horus),* **film for big screen, 1968.** © TOEI Company Ltd.

10 *(Above)*
After Akatsuka Fujio, *Himitsu no Akkochan* (*The Secrets of Akko-chan*), TV, January 6, 1969/October 26, 1970.
© TOEI Animation Co. Ltd.

11 *(Above, right)*
After Akatsuka Fujio, *Dōbutsu takarajima* (*Treasure Island*), film for big screen, 1971.
© TOEI Company Ltd.

12 *(Above, far right)*
After Akatsuka Fujio, *Mōretsu Atarō*.
© Fujio Productions.

13 *(Right)*
Akatsuka Fujio, *Himitsu no Akkochan* (*The Secrets of Akkochan*), n.d. Extract from printed manga. © Fujio Productions.

Nagagutsu o haita neko, 80 nichikan sekai isshū (Puss in Boots: Fig. 7
Around the World in Eighty Days).

Other animated films that were popular with audiences included
Himitsu no Akkochan (The Secrets of Akko-chan) in 1969, based on the Fig. 10
manga by the late Akatsuka Fujio, nicknamed the "King of Gags," who
remains today one of the most popular *mangaka* in Japan, or *Dōbutsu* Fig. 11
takarajima (Animal Treasure Island) in 1971.

The early days of "anime business," 1972–80
In 1972, several industrial disputes occurred, disrupting Tōei's
operations. Many of its employees left the studio to join another one.

That year, *Mazinger Z* enthralled audiences, marking the start of
the age of giant robots with the ability to transform themselves. A few
movies on this theme were marketed abroad.

Harlock travels all over the universe to defend the oppressed. Just like Matsumoto Leiji's original manga, this television series was a great success.

16
Wakakusa monogatari (Little Women), TVSP,
1980. © 1980 TOEI Animation Co. Ltd.

17
Jan Barujan monogatari (Les Misérables),
TVSP, 1979. © 1979 TOEI Animation Co. Ltd.

Between 1972 and 1980, cartoon production was prolific. *Lalabel* or *Cuty Honey* were among those particularly popular with little girls, while *Candy Candy* remains the most famous, with a reputation that spread far beyond the Japanese archipelago. *Devil Man, Ikkyū san*, or the *Andersen Stories*, produced in 1972, were designed more for boys.

The 1970s generation, who had seen *The White Serpent* in their youth, enjoyed the animated films designed for adults. In 1977, *Space Battleship Yamato*, based on the manga by Matsumoto Leiji, was a real hit. The following year, *Ginga Tetsudō 999 (Galaxy Express 999)* and Fig. 18 *Uchū Kaizoku Captain Harlock (Space Pirate, Captain Harlock)*, by the Fig. 15 same author, became a huge TV success.

Since the Meiji period, the Japanese had also shown great interest in the classics of world literature. These novels were translated and then often adapted in the form of manga, followed by cartoons. For example, *Les Misérables* by Victor Hugo, and the novel by American Fig. 17 writer Louisa May Alcott (1832–1888), *Little Women*, published in 1868–69, gave rise to various versions, including from Tōei.

18
After Matsumoto Leiji, *Ginga Tetsudō 999*
(Galaxy Express 999), TV, September 14, 1978/March 26, 1981.
© 1978 TOEI Animation Co. Ltd.

INTERVIEW
WITH WATANABE YOSHINORI (RYŌTOKU)

Former vice president of Tōei

Alongside his wife, Hiroko, and their son, Hajime, an engraver and medalist, Watanabe Yoshinori (Ryōtoku) gave me a great deal of sound advice and let me interview him about his career. In his beautiful home, where sophistication is the watchword, two insect masks appear to loom up from some futuristic age.

"They are the *Kamen Rider* masks I had made specially," explains Mr. Watanabe.

There is no doubt that I am in the home of an aesthete, but it is also that of the man who was Tōei's vice president around a decade ago. A book by Ohshita Eiji entitled *Japanese hīrō wa sekai o seisu (Japanese Heroes Get Established Around the World)* retraces Watanabe Yoshinori's career, which spanned Tōei's golden age.

Mr. Watanabe entered Tōei in 1952, just after graduating from university. He started out in the marketing department, and with his intransigence and business acumen soon worked his way up. His audacity earned him the nickname "the bulldozer," "the gang," or "the *daimyo*" (feudal lord). A few years later, his boss asked him to work on project sales for television. Erudite, curious, and interested in all manner of things, Mr. Watanabe then immersed himself in many novels, both Japanese and foreign, went to see all kinds of shows (even traditional performances such as *kabuki* and *noh*), and thought about potential projects. He talked to the greatest contemporary writers, whose works were adapted for cinema or television.

Brigitte Koyama-Richard:
Mr. Watanabe, you have personally experienced the golden age of manga, the cinema of animation, and cinema itself. Could you tell me about your work at Tōei?

Watanabe Yoshinori Ryōtoku: I have dabbled in everything and have met all sorts of people in the course of my career.

B. K.-R.: It seems that you had an enormous workload?

W. R.: Yes, and of course I had more and more as the years went by. It was not like today where everything is divided up. I would have to manage the launch of a cartoon as well as a film with actors. I contacted them to offer them roles; I handled the music, and much more besides. In the mornings and afternoons I would work at the office and in the evenings, often until the middle of the night, I was to be found in restaurants and bars with filmmakers, *mangaka*, actors, and writers to talk shop. As you know, important decisions are always taken in the evening over a drink!

B. K.-R.: You survived on very little sleep. Where did you get all that energy?

Watanabe Hiroko: Many artists sent their manuscripts to my husband, who would use his days off and sleeping time to study them in full.

W. R.: My job was my passion and that seemed only natural for me.

B. K.-R.: The *mangaka* and the professional animators* I have met all say the same thing: "We only get a few hours' sleep a night but we love what we do."

W. R.: Yes, it is a choice. In my particular case, I was responsible for several TV, cinema, and theater programs at once, and needed to multitask. Yet each time made for a new creation and a new adventure. I would have to select an actor or an actress for a specific role, a *mangaka* for a particular subject, etc.

Watanabe Hajime: When I was a child, my father was very much taken up by his work, but many guests would come round in the evenings to discuss things. *Mangaka* and artists would stay to chat or to play mah-jongg deep into the night. I knew them all very well. When I was little, I would get first pick at the very first toys from the cartoon series that my father and his team produced. My friends in our neighborhood loved coming round to play with these magic weapons or belts. One day, when they needed a child in an advertisement, I even posed for a poster and appeared in an advertising feature. It all seems a far cry from the austere world of engraving in which I find myself today. But when I think back to my father's work at the time, he seems to me to have been a kind of twentieth-century Tsutaya Jūzaburō. Tsutaya Jūzaburō was editor and adviser to the greatest Japanese printmakers, such as Hokusai and Utamaro. My father likewise selected and advised *mangaka* and artists. I remember the warm atmosphere that reigned in this house.

B. K.-R.: The book that retraces your career opens with the creation of *Kamen Rider*, in 1970.

W. R.: Yes, we needed to find a program for the Saturday 7.30 p.m. to 8 p.m. slot that would attract a large number of viewers, so we created this series. I suggested using heroes on motorbikes and having them wear this grasshopper mask. We asked Ishinomori Shōtarō, who to my mind was one of the greatest *mangaka*. He could draw anything, in very different genres, which is extremely rare indeed.

B. K.-R.: In your opinion, what was new about this series and what sparked the craze we have known in both Japan and abroad?

W. R.: I would say that it is the way the characters metamorphose. It was the first time that a hero could be transformed. I had the idea when looking at books on a shelf. Kafka's work, *Metamorphosis*, caught my eye and I realized that this would be the perfect solution. I then thought that to make the metamorphosis more spectacular, the heroes would need some kind of gesture that would stick in people's minds. I therefore suggested styling this on the gestures of a kabuki actor when he comes onstage after crossing the *hanamichi* [flower way]. He performs what is known as *"roppō,"* which is a kind of dance, by making large movements with his arms and legs. For greater impact, I asked the actors to shout *"Henshin!"* ["Metamorphosis!"] when they carried out these actions. This became immediately popular with children and they all began to imitate their heroes.

B. K.-R.: It was around this time that the "media mix"* [media franchises] started to develop?

W. R.: Yes, I saw to the development of media mixes. I took care of everything, from start to finish, selecting the publishers and handing out the work. For *Kamen Rider*, I chose the publishing house Kōdansha and the manga magazine *Shūkan Shōnen Magazine*. The sponsor who marketed the merchandise was Bandai. I also had to find record companies for each film and agencies to distribute them, etc.

B. K.-R.: So a lot of goodies and super-hero outfits were on sale at the time?

W. R.: Yes. Among them was the film's famous hero belt with a revolving buckle. Unfortunately, when they bought it, children realized that it didn't revolve. We solved this problem by producing a more expensive product that really did revolve and it was snapped up as soon as it came out in the shops.

B. K.-R.: You had a big hand in the development of robot toys with subsequent works such as *Matzinger Z*, known as *Tranzor Z* in the United States?

W. R.: Yes. Nagai Go enjoyed great success with his manga *Harenchi gakuen (Shameless School?)*. In 1972, he published *Matzinger Z [Tranzor Z]* in the magazine *Shūkan Shōnen Jump*; Tōei made it into an anime that was an international hit, as was the film's lead song. Toys based on the *Tranzor Z* series became increasingly expensive and complex, but sold very well. This was not limited to films for boys. The merchandising then spread to cartoons such as *Sally the Witch, Candy Candy, Attack No. 1*, etc.

B. K.-R.: Could you tell me about some of the success stories you enjoyed with your Tōei team?

W. R.: A work's success often depends on a title or some accessory. In *Himitsu no Akkochan [The Secrets of Akko-chan]* by the late Akatsuka Fujio, we decided to change not the title but the accessory. In the manga version of her metamorphosis, the little girl uses a freestanding mirror, which would have been too big to make into a toy. In the cartoon, with the author's consent, we used a pocket mirror; children could then buy a toy version, to their great delight.

B. K.-R.: Tōei has enjoyed great success at both national and international level, such as with the works of Matsumoto Leiji. Series like *Power Ranger, Saint Seiya [Knights of the Zodiac]*, and *Sailor Moon* are known throughout the world, and children from many countries have played at disguising and transforming themselves like their heroes.

W. R.: Yes, in the course of my career I have witnessed the evolution of Japanese animation, which has extended the world over—something that no one had envisaged in the early days.

B. K.-R.: You seem passionate when talking about your work.

W. R.: It's true, I was terribly busy, but I found that only natural. As general producer, I had to think about all those people I had working for me.

Before I left, Mrs. Watanabe showed me the album of photos and drawings created in honor of her husband's sixtieth birthday. All four of us looked at this real treasure trove, complete with autographs and drawings by the most famous *mangaka*.

– June 2009 –

The age of "media mix," 1981–94

Between 1981 and 1994, Tōei continued to produce animated movies whose success went beyond the nation's borders: *Sally the Witch, Dr Slump Arale, Hokutō no ken (Fist of the North Star), Dragon Ball Z, Sailor Moon, Kinnikuman (Muscleman).* Today many of them are the subject of cinematograph remakes or reruns.

As early as 1990, a server was set up on the Internet to present Tōei and its products. In 1998, Tōei Animation (formerly Tōei Dōga) began to use a digital system.

Figs. 19–21 The 1990s were a booming decade, with works such as *Slam Dunk,* based on the manga by Inoue Takehiko, which sparked an unprecedented interest in basketball, *Oja majō Dorémi (Magical Doremi), Dijimon Adventure,* and *One Piece.* Since 2004, the *Pretty Cure* phenomenon has thrilled young girls. It contains all the ingredients for the success of these films—metamorphosis, courage, honesty, the fight for good, and *kawaii* * (cute) graphics. In addition, since the 1983 opening of its gallery, Tōei has organized exhibitions on its animated movies, to the delight of young viewers.

Due to its success in both Japan and abroad, Tōei now has several branches across the world and remains one of the pillars of Japanese animation.

20
Fresh Purikyua (Fresh Pretty Cure),
TV, February 1, 2009/January 31, 2010.
© 2009 TOEI Animation Co. Ltd.

21
Futari wa Purikyua (Pretty Cure),
TV, February 1, 2004/January 30, 2005.
© 2005 TOEI Animation Co. Ltd.

Stages of Production in 1956

(First column, top to bottom)

22
Project brainstorming meeting: choosing the subject, examining documents, and drafting the synopsis.

23
Preparatory meeting for the film.

24
Manufacturing figurines of the characters.

(Second column, top to bottom)

25
Clarifying the drawings.

26
Checking the drawings.

27
Hand trace.

28 *(Far left)*
Applying color to the drawings.

29 *(Above left)*
Final check.

30 *(Above)*
Producing backgrounds.

31 *(Far left)*
Preliminary shots.

32 *(Left)*
Production, recording of actors' voice-overs, and sound effects coordinated with the image, followed by the final image and sound recording for the screening of the film.

33
Script of the film
*Anju to Zushiomaru
(The Orphan Brother).*

34
Storyboard.

35
Choosing characters and making sketches of them.

Stages of Production Today

All images on pages 102–103 © TOEI Animation Co. Ltd.

36 *(Top left)*
Script.

37 *(Top middle)*
Storyboard.

38 *(Above)*
Document positioning.

39 *(Top right)*
Applying color to the drawings.

40 *(Above right)*
Special effects.

41 *(Above)*
Graphics tablet (producing drawings to be inserted between key images).

42 *(Top left)*
Producing backgrounds.

43-44 *(Left)*
3-DCG.

45 *(Below)*
Off-line editing.

46 *(Above)*
Recording of actors' voice-overs and sound effects coordinated with the image.

A Tōei great: *Ge Ge Ge no Kitarō*

Mizuki Shigeru's famous manga was made into several TV series, as well as being adapted for the big screen and using actors. Here are some photographs of Tōei's versions produced for television.

47

After Mizuki Shigeru, *Ge Ge Ge no Kitarō 2*, TV, October 7, 1971/September 28, 1972. © 1971 TOEI Animation Co. Ltd.

48

After Mizuki Shigeru, *Ge Ge Ge no Kitarō 4*, TV, January 7, 1996/March 29, 1998. © 1996 TOEI Animation Co. Ltd.

49

After Mizuki Shigeru, *Ge Ge Ge no Kitarō 3*, TV, October 12, 1985/March 21, 1988. © 1985 TOEI Animation Co. Ltd.

50

After Mizuki Shigeru *Ge Ge Ge no Kitarō Yokai Japan Rally 3-D*, July 12, 2008/ currently screening in cinemas. © 2008 TOEI Animation Co. Ltd.

51
After Mizuki Shigeru, *Ge Ge Ge no Kitarō 5*, TV, April 1, 2007/ March 29, 2009.
© 2007 TOEI Animation Co. Ltd.

INTERVIEW WITH SHIMIZU SHINJI

Director of Tōei's Planning Department

Shimizu Shinji, who has directed many of Tōei's anime, *Ge Ge Ge no Kitarō* in particular, was kind enough to answer my questions.

Brigitte Koyama-Richard: Why did you choose to join Tōei?

Shimizu Shinji: When I was a student, I got a passion for cinema and decided that this was the area in which I absolutely wanted to work. I was hoping to become a producer, but there was no work in that domain. However, there were openings in the field of anime. I thought that by joining Tōei, I would probably be able to go from animated films to movies using actors. For me, Tōei was the company that made *Saiyūki (Journey to the West)* or *The Adventures of Sinbad.*

B. K.-R.: What did your work entail?

S. S.: Initially, I was an editor working on cartoons such as *Candy Candy, Galaxy Express,* the third version of *Ge Ge Ge no Kitarō, Hokutō no ken [Fist of the North Star], Himitsu no Akkochan [The Secrets of Akko-chan].* Next I worked on the promotion of videos and other products. Then I went back to anime production on projects such as *Arare chan, Dr Slump Arale,* and *Kinnikuman [Muscleman];* I've now been working as a producer for the company for over fifteen years.

B. K.-R.: Which works have you produced?

S. S.: I'll name a few for you: *Aoki densetsu Shūto, Shoot, Galiba-Boy [Gulliver Boy], Sekai meisaku Dōwa* (series), *Ge Ge Ge no Kitarō, Kindaichi shōnen no jiken bo [The File of Young Kindaichi], Ginga Tetsudō 999 [Galaxy Express 999], Tales from Around the World, Intāsutera 5555 [Interstella 5555], One Piece, Futari wa Purikyūa [Pretty Cure],* etc.

B. K.-R.: Tōei has also produced many cartoons that are very popular abroad. Among them, could you tell me something about Mizuki Shigeru's *Ge Ge Ge no Kitarō?*

S. S.: There are two ways of defining *yōkai:* firstly, they are very ancient supernatural beings; secondly, *yōkai* are very Japanese. All Japanese people, young or old, love Kitarō. It's something that is beyond explanation. We have some common element in our DNA that endears this character and the other *yōkai* to us. Nonetheless, Kitarō is a young one-eyed boy and his father is a *yōkai* with the appearance of an eye. All *yōkai* are weird and all come in strange forms. The story begins in a cemetery and is really unusual! Yet we find Kitarō appealing. It is as if he had some magical power that he transmits to whoever looks at him. My job was therefore to communicate this interest for the character, not only in Japan but also throughout the world.

B. K.-R.: This film was originally entitled *Hakaba no Kitarō [Kitarō of the Graveyard]*. Why did you change the title to *Ge Ge Ge no Kitarō*?

S. S.: The work was originally intended for *kami shibai* (small street theater), and then for rental books *(kashibon*)*.[2] After being published in the *Shūkan Shōnen Magazine*, it was made into an anime. We therefore decided to give it a more suitable title.

B. K.-R.: How do the versions of this cartoon differ?

S. S.: The first version is the most faithful to the original work and is in black and white. The second is in color and very close to what would become the anime model. The third is very funny. The fourth is more like the original work once more. The fifth shows a Pokémon-style Kitarō.

B. K.-R.: The current version is not at all frightening, is it? The characters are verging on the *kawaii* (cute). Did you take your decisions after discussing it with Mr. Mizuki?

S. S.: Mr. Mizuki gave us a free hand. Our producer, with the staff's agreement, decided on the current version. You're right; it is not frightening for viewers as the characters are likeable.

B. K.-R.: Does the same go for the screenplay?

S. S.: Yes, Mr. Mizuki didn't intervene; he trusted us completely.

B. K.-R.: Research into *yōkai* has greatly progressed, thanks to Mizuki Shigeru. This adventure also provides the opportunity to plunge back into the roots of Japanese art and culture, doesn't it?

S. S.: I completely agree. It is fascinating; it is not simply a question of folklore, but of the foundations of our country's art and culture.

B. K.-R.: Interest overseas in Japanese animation is continually on the increase, and it also influences the cartoons and films of various nations. In your opinion, how is Japanese animation set to evolve?

S. S.: I hear that all animation in the USA will be in three dimensions from now on. I suppose that Japan will follow the same path, but I don't think that two-dimensional animation will die out here. Japan has quite a specific situation, unlike that of the United States, where animation is considered to be an industry. From Japan emerged Japanese prints that contradict perspective. And I think that we can create increasingly beautiful works in two dimensions.

– June 2009 –

52
Mizuki Shigeru, *Yōkai Ryūgūjō (Yōkai in Ryūgū Castle)*. Original drawing published on August 4, 1968 in *Shūkan Shōnen Magazine*, Kōdansha.
© Mizuki Shigeru Production Inc.

Ryūgū Castle is located on the seabed and is the home of the dragon king.

53
Ge Ge Ge no Kitarō dai shingeki (Kitarō in Full Action). Original drawing, *Ge Ge Ge no Kitarō Anime centoraru ban reko-do jaketto/Anime-ju reko-do*, 1985.
© Mizuki Shigeru Production Inc.

Mizuki Shigeru, the great *yōkai* master

You only need look at the different versions of *Ge Ge Ge no Kitarō* to realize how unchanging the work actually is. Now aged over eighty, Mizuki Shigeru still has the appetite for life and the fertile imagination that allowed him to bring into being an impressive number of all kinds of drawings and manga. Today he is one of the manga artists most in demand in Japan. I have been lucky enough to meet him on several occasions and to admire a large number of his original drawings. All are incredibly beautiful in terms of graphics, and the richness and delicacy of the gradation of their brush-applied color are quite remarkable. To recount his life story, this brilliant artist has chosen a manga format. But he has also used another method—the painted scroll—so as to show the main events of his existence as in a movie.

INTERVIEW WITH MIZUKI SHIGERU

Mangaka

Brigitte Koyama-Richard: Mr. Mizuki, my sincere thanks for granting me this time to answer my questions. It's a great pleasure for me every time I meet you. I would like you to tell me about your childhood and this woman, NonNonbā, who had a determining role in your life.

Mizuki Shigeru: NonNonbā was a simple and very kind woman. She had a wonderful talent for telling *yōkai* stories.

B. K.-R.: Didn't these stories scare you?

M. S.: Of course they did—but I loved it. In those days there were only kerosene lamps, not electric lighting like today. The shadowy light and atmosphere were very conducive to stories of *yōkai*.

B. K.-R.: As a child, you also enjoyed going to a nearby temple to admire paintings of the Buddhist vision of hell, didn't you?

M. S.: Yes, I loved looking at those scary paintings, even if it terrified me.

B. K.-R.: Your works are very popular in the West. Thanks to you, *yōkai* are now famous. And you also made them fashionable in Japan. What did you style your designs on?

M. S.: I took my inspiration from the *yōkai* of times past, particularly those of *ukiyo-e* artist Toriyama Sekien (1712–1788). In my opinion, his were the finest *yōkai* representations.

B. K.-R.: What do you think of Katsushika Hokusai and Kawanabe Kyōsai?

M. S.: They are two very interesting artists. I like Kyōsai's prints and painted scrolls, such as the ones that depict farts. They are very funny. But for me the paragon of *yōkai* will always be Toriyama Sekien.

B. K.-R.: During the war, you experienced some very difficult times. You were sent to Rabaul, an island in Papua New Guinea. After being injured and losing an arm, you found solace and friendship with the local people there, didn't you?

M. S.: Yes, I got along well with them. They are very simple and very human. A smile is enough to communicate. They had nothing to live on, but were extremely welcoming and generous. We managed to communicate with a few gestures and words. They gave me green bananas that they grilled. They were good, not sweet, but with a taste like bread. They also grilled sweet potatoes and ate coconuts, which they shared with me. Very tasty!

B. K.-R.: You were the only Japanese person to go to see these local people?

M. S.: Yes, the others held them in a sort of contempt. Personally, I experienced a sincere sense of friendship with them. As I was the only one in my regiment not to have lost weight, my superiors soon began to suspect that I was leaving the camp to see the locals who had befriended me. I was admonished, and they even considered putting me in the clink. But I was uncontrollable and didn't behave like the others. In the end they just let me go my own way.

B. K.-R.: It must have been hard for you to leave your friends when the war was over?

M. S.: Oh yes! I wanted to stay there and spend my life there. My superiors had a hard time persuading me to return to Japan. I had every reason to be happy there—friends, fields to till, food, and even a lovely local fiancée. In that part of the world, the climate is pleasant and there is no winter. Heavenly indeed!

B. K.-R.: Did you go back to see them after the war?

M. S.: Yes, I returned twenty-six years later.

B. K.-R.: They must have been happy to see you again.

M. S.: Yes, but sadly many of them, including my friend Topetoro, had died. They don't live to a ripe old age, as they are in a completely natural environment with no system of medical care. Moreover, in those regions, malaria is common and claims many victims. I caught it myself and I can tell you that you are never completely cured.

B. K.-R.: On your return to Japan you took classes in drawing and painting in a university in Tokyo. You also had a number of different jobs.

M. S.: Yes. I found life in Japan very hard compared with that in New Guinea. To earn a living I did umpteen jobs that had nothing to do with drawing. I drew for the *kami shibai*, and then created manga for magazines.

B. K.-R.: Which is your favorite among your many works?

M. S.: I like them all, though I'm particularly fond of Kitarō *(Ge Ge Ge no Kitarō)*.

B. K.-R.: You have produced many drawings for a wide variety of works. How were you able to create so many *yōkai*?

M. S.: It came quite naturally to me. I loved to draw those characters.

B. K.-R.: You have also described your life story in the form of a painted scroll. It's a very original idea.

M. S.: Yes, I had been thinking about it for a long time.

B. K.-R.: This painted scroll is a particularly amusing and interesting way to find out about your life. *Ge Ge Ge no Kitarō* has become a very popular animated film. The *yōkai* in it are really sweet and not at all scary.

M. S.: Yes, I am glad that people like this work.

B. K.-R.: What is your dearest wish now?

M. S.: To live as long as possible. Ever since I was born, I have loved taking my time and sleeping. That is why I didn't go to kindergarten and why I was a year later than everyone else in entering primary school. And even then, I would only go once I had finished a leisurely breakfast, which meant I missed all the arithmetic lessons! When I was writing for several magazines at the same time, including the *Shūkan Shōnen Magazine* and *Sunday*, the hardest thing for me was not getting enough sleep. I therefore hope to live as long as possible in a very peaceful manner.

B. K.-R.: Your wife's fascinating autobiography *Gegege no nyōbo (Spooky Wife)*, will be aired in serial form every morning for fifteen minutes on the national NHK channel from spring 2010. I can't wait to see this film.

M. S.: We are all looking forward to seeing the serial.

I take my leave of the artist, whose apartment is full of *yōkai* of all shapes and sizes. It is a magical place where at any time you expect one of them to come to life.

– June 2009 –

54
Mizuki Shigeru, *Jinsei emaki (Painted scroll of the life of Mizuki Shigeru)*. © Mizuki Shigeru Production Inc., and with our thanks to Yanoman Corporation.

This scroll measuring 32 ft. 9 in. (10 m) in length and 16 in. (40 cm) in width was on show during the exhibition *Dai Mizuki Shigeru Ten* ("Great Mizuki Shigeru Exhibition"), held from April 29, 2004 to September 25, 2005 at the Tottori Prefectural Museum by the Asahi Shinbun-sha.

* When looking at the scroll from right to left, we see Mizuki Shigeru (his real name, Mura Shigeru), born in Osaka on March 8, 1922. His family moved to Tottori Prefecture when he was one month old. At the age of three, his favorite toy was a horse-shaped pushchair.

* He loved eating and was convinced that everything was edible. He even went as far as tasting the golden knob on the top of a Japanese flagstick and got a touch of food poisoning!

* NonNonbā—the nickname of the woman who helped the Mizuki family with their daily chores—often took him to a temple to look at *rokudō-e*, paintings representing "the six paths" of reincarnation in Buddhist cosmogony, with terrifying sections representing the descent to hell. For him it was quite a revelation.

* In the evenings, the five year-old boy liked to listen to the *yōkai* stories that NonNonbā told so well.

* He started school at the age of seven, but would continue to enjoy a leisurely breakfast and frequently arrived late. He was unable to pronounce his first name, Shigeru, correctly, and said that his name was Gegeru. This is how he came by the nickname "Gege."

* When he went out for a walk in the evenings with his brother, he always felt that he was being followed. "It is the *yōkai* Betobeto," NonNonbā would say.

* He learned life's rules through being rowdy with the other children.

* He loved drawing and collecting insects.

* NonNonbā died of tuberculosis after caring for a girl with the same ailment.

* He drew all the time, particularly the foreign boats that arrived in the port.

* One day he was starving hungry. He found out that it was because of a *yōkai* up to no good!

* At junior high school, he appeared in the great daily *Mainichi* paper as an artist of genius.

* In 1940 (then aged eighteen), he delivered newspapers to earn money. His portliness meant that he was often clumsy, and consequently he lost his job.

* He developed a passion for Goethe.

* In 1941, he entered an art school, where he attended evening classes and did odd jobs during the day.

* In 1943, he was called to the front. He joined the Tottori infantry regiment, where his job was to play the bugle; he was unable to produce a sound. He asked to change jobs and found himself transferred to Rabaul, in New Guinea. He had a very hard time there, being unable to get used to army regulations. Just as the war reached its height, he was sent to the front line as a lookout. In one attack he was the only survivor. He roamed the jungle before going back to the army, caught malaria, and lost his left arm in a bomb attack.

* Yet this didn't curb his appetite. He went to find food with the local people, with whom he got on well.

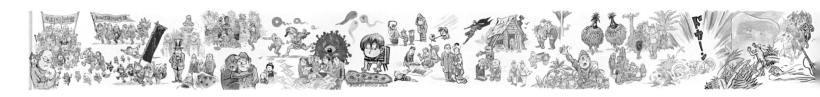

55
Mizuki Shigeru, *Jinsei emaki (Painted scroll of the life of Mizuki Shigeru)*. With our thanks to Yanoman Corporation.
© Mizuki Shigeru Production Inc.

* When the war was over, all he wanted was to stay and share the life of his local friends. The army medical officer had trouble persuading him to go back to Japan. He promised to come back and see them in seven years. He was to keep his promise twenty-six years later.

* He arrived in Japan in March 1946, had another operation on his arm, and remained hospitalized for almost a year. He then decided to go to Tokyo, where he began to draw for the *kami shibai* (street theater), and then for rental books *(kashibon).*

* In 1950, he bought a one-story building in Kobe, made up of ten small apartments and located in Mizuki Street. He would sell it three years later to buy a house, but "Mizuki" became his stage name.

* In 1954, Suzuki Katsumaru, famous for his *kami shibai* performances, introduced him to a peculiar work by Itō Masami, entitled *Hakaba no Kitarō (Kitarō of the Graveyard).* He used this as inspiration for what was to be a hugely successful manga.

* In 1958, he published his first work, *Roketto Man* [Rocket Man].

* In 1961, he was married ten days after meeting the girl that his parents introduced to him. He created his most famous characters, including Kappa no Sanpei, Kitarō, and Nezumi Otoko.

* His first daughter was born on December 24, 1962.

* In 1965, his manga *Terebi kun (Little Terebi)*, published as a serial in the *Bessatsu Shōnen Magazine*, won the Kōdansha Prize.

* He became famous and got busier and busier. He took on some assistants and founded Mizuki Production.

* His second daughter was born on December 24, 1966.

* Twenty-six years after the end of the war, he went back to New Guinea, where he met one of the friends he had made during the war, now the village chief.

* In 1984, his father died.

* In 1991, he was awarded the "purple ribbon" *(Shijū Hōshō)* (a decoration corresponding to the French Legion of Honor or the American Medal of Honor).

* In 1993, the Sakai Minato shopping street was renamed the "Mizuki Shigeru Road." Many *yōkai* are to be found there.

* In 2002, a museum devoted to Mizuki Shigeru opened in Sakai Minato.

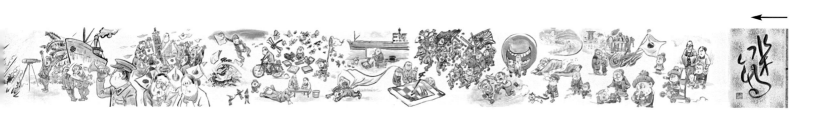

56
Tezuka Osamu.

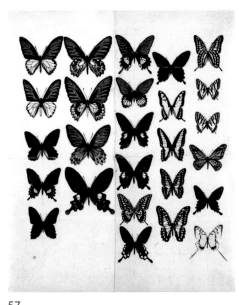

57
Tezuka Osamu, *Chō (Butterflies)*, crayon drawing.
© Tezuka Productions.

Tezuka Osamu (1928–1989), god of manga and father of TV anime

Takadanobaba station, on Tokyo's railway loop, reverberates with nostalgic music—that of the animated film, *Astro Boy*. In fact Tezuka Productions is about a fifteen-minute walk away from this station. The two-story building stands in a very quiet residential district, seemingly far from the bustle of Shinjuku, though actually very near. Astro Boy, or rather a large figurine of this famous character, welcomes visitors at the entrance. In 2009, Tezuka Productions celebrated the eightieth anniversary of the birth of the late Tezuka Osamu (1928–1989). Eighty events, exhibitions, lectures, film screenings, and special TV broadcasts were planned throughout the year. What's more, an *Astro Boy* remake, produced in the USA, was released in October 2009.

When we read about the master or visit an exhibition on his life and career, such as the large retrospective held at the Edo-Tokyo Museum from April to June 2009, we are surprised at the prolific nature of his work. We wonder how, as a child, he was able to observe and draw so attentively the insects around him, and create manga of this quality for his schoolmates. We wonder too how, as a young man, he was able to complete his studies of medicine, and graduate, while at the same time publishing manga. And how this "god of manga" came to be a figure that cannot be ignored on the Japanese animation scene. He would appear to have lived three lives at once. Fortunately, the many interviews on film and his myriad publications are a way of better understanding this exceptional character.

Tezuka Osamu was lucky enough to be born into a family where manga, far from being outlawed as was often the case at the time, were highly regarded. His mother was probably greatly to thank, as she was the first to read them to him. And his father, a fan of cinema and animation, bought a camera and film projector, a rarity at the time when such objects were very expensive. Tezuka Osamu grew up in a very warm-hearted household and, though he claimed to have been the target of his schoolmates' mockery on account of his puny appearance and his insect-like face, he nonetheless soon managed to fit in. As early as primary school, his gift for observation and drawing

were astonishing. His first manga, designed to entertain his class-mates, already gave an inkling of his talent in the field. He was only twelve when he drew *Rokunen kan o kaerimite* (*Looking Back on the Last Six Years*), which shows amazing maturity.

Fig. 58

The book *Tezuka Osamu Gekijō* (*The Animation Filmography of Tezuka Osamu*, Tokyo, Tezuka Productions, 1997) includes the speech made by the master on February 13, 1988, when he received the Asahi Prize (awarded by the *Asahi Shinbun*, Japan's largest daily newspaper) in Tokyo. He tells how, at the age of five or six years, he would watch films like *Felix the Cat*, and how a large portion of his father's salary went on buying films and manga: "I grew up watching these movies and it made me realize just how interesting it was to make an image move, and how animation had incredible potential in relation to manga. I then said to myself that, at least once in my life, I would have to make an animated film. I produced my first attempt when I was in junior high school; it was then that I was hooked."

As a boy, Tezuka Osamu was passionately interested in music, classical styles in particular; in fact, Mussorgsky and Tchaikovsky were much in evidence in several of his films. A lover of literature since his childhood, he also enjoyed frequent trips to the theater, particularly Takarazuka (the stage for musicals in which all roles are played by females). Drawn to all forms of art, he was eventually to hone his talent through manga.

His first manga, *Mā-chan no nikkichō* (*Diary of Mā-chan*), appeared in a youth magazine that was part of the *Mainichi Shinbun* daily paper. Yet in parallel with this activity, he embarked upon the study of medicine, as had some of his family before him. His student workbooks have been preserved, revealing his taste for precision and surprising realism. The drawings of human anatomy that he reproduced in his manga *Black Jack* are indeed the work of an "artist-doctor."

In 1953, he rented a room in Tokiwasō, where he would stay for just over a year. Many young *mangaka* came to live there after him. These occupants included figures as famous as Ishinomori Shōtarō, Akatsuka Fujio, Fujimoto Hiroshi and Motō Abiko (who went by

58
Tezuka Osamu, *Rokunen kan o kaerimite (Looking back on the Last Six Years)*, crayon drawing. © **Tezuka Productions.**

Here Tezuka Osamu depicts the key events of his school life. At junior high school his natural science drawings were admired for their degree of precision. The butterflies that he collected are reproduced with astonishing realism.

59
Tezuka Osamu, *Ribon no kishi (Princess Knight),* film,
1967. © Tezuka Productions, Mushi Production.

60
Tezuka Osamu, *Janguru Taitei (Jungle Emperor),* film,
1966. © Tezuka Productions, Mushi Production.

61
Tezuka Osamu, *Dororo,* film, 1969.
© Tezuka Productions, Mushi Production.

the joint name of "Fujiko Fujio"), or Suzuki Shin.ichi (now head of the Animation Museum in Tokyo's Suginami district). While continuing to publish successful manga such as *Ribon no kishi* ^{Fig. 59} *(Princess Knight)* or *Janguru Taitei (Jungle Emperor* or *Kimba the* ^{Fig. 60} *White Lion),* Tezuka Osamu completed his thesis and graduated as a medical doctor in 1961.

His collaboration with Tōei for the adaptation of his manga *Boku no songokū (My Songokū),* between 1958 and 1960, as well as the deep admiration he had for Walt Disney (whose influence is clearly apparent in the character Astro Boy), incited him to design his own animated films. He embarked upon the adventure in 1961, not without having warned his wife of the financial difficulties it might entail. He put together a team and worked on his first anime, *Aru machi kado no Monogatari (Tales of the Street Corner),* which he completed in November 1962. To cut costs in this experimental middle-length feature, he wanted "the images to move slightly": "Making an experimental film is very entertaining. As we know, in any case, that it will earn no money, this only serves to hone the desire to create of those involved."[3] Against all expectations, *Tales of the Street Corner* won several prizes.

Tezuka Osamu could not be content with experimental films that were so unlucrative, however. He had to pay his assistants who, incidentally, had turned down offers in advertising features to work with him, but wanted to be able to make a living. One day Tezuka said to them: "Well, let's make cartoons for television. In the future, I'm sure that they'll be in huge demand."[4] When his assistants said that it was impossible, he replied that they needed to find a way of reducing the number of drawings and including "images that don't move" in the scenario in order to cut down on production costs. "In that case, it won't be animation but theater," countered his assistants. But Tezuka Osamu then managed to convince them with his surprising retort that "television is nothing more than electric theater!"[5] He decided to adapt *Tetsuwan Atomu (Astro Boy),* already published as a ^{Fig. 62} manga. Thus emerged the first real animated film created in serial form for television.

In actual fact, there had been another one, *History Calendar,* launched on May 1, 1961. Broadcast daily on weekdays, this cartoon—

lasting for one minute—retraced a historical event that had taken place in Japan or elsewhere—the construction of the Empire State Building, for instance. The *mangaka* Yokoyama Ryūichi and his team produced this series. Three hundred and sixty-five films were made, each by a different author, which made for a different style of drawing every day. The series was broadcast for less than a year.

Despite his difficult beginnings, the character of Astro Boy became famous throughout the world.

> When I began to draw *Astro Boy* in 1951–52, I received harsh criticism from educators and parents, who angrily claimed that "there will never be a high-speed train or freeway in Japan" or that "robots are impossible to make"; they dubbed it "extravagant," saying that "Tezuka is drawing ridiculous things, he is the children's enemy!" If I continued to draw, despite such virulent criticism, it is because I wanted to show that the theme of these fighting robots was actually that of "respecting life," which is rooted in nature.[6]

Tezuka Osamu added that, as he had portrayed the society of the future in his manga, many saw *Astro Boy* as his major work, and believed that he was praising the forthcoming techological revolution, whereas he was refuting all of that:

> It was nothing of the sort. I hoped to show that if science aimed only for progress, forgetting nature and human beings, it would be able to create only a society of deep cracks, contradictions, and discrimination, doing nothing but cruelly hurting humans and all living beings.... What I hoped to portray in *Astro Boy* was the lack of communication between science and man.... He explained further why he believes it is a misconception: "Astro Boy is able to think for himself; he is a robot with feelings. He wants to be like human beings. I drew him at school, but he has the ability to solve any calculation in a fraction of a second, and his mobility is incomparable. He therefore experiences a deep sense of alienation and sorrow, which I attempted to render when he was sitting atop a building. No one has mentioned this. People merely focus on the power of science.[7]

62
Tezuka Osamu, *Astro Boy*, film.
© Tezuka Productions.

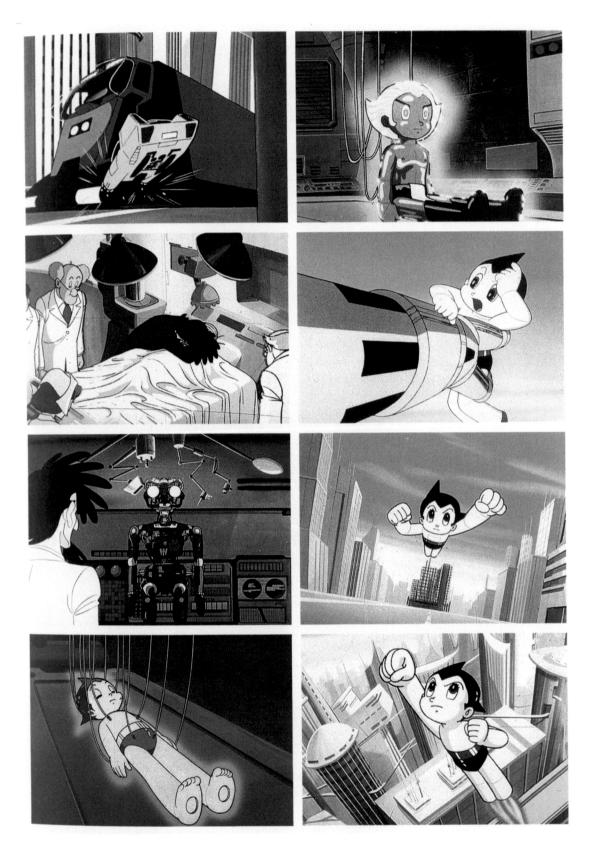

63
Tezuka Osamu, *Astro Boy*, film. © Tezuka Productions.

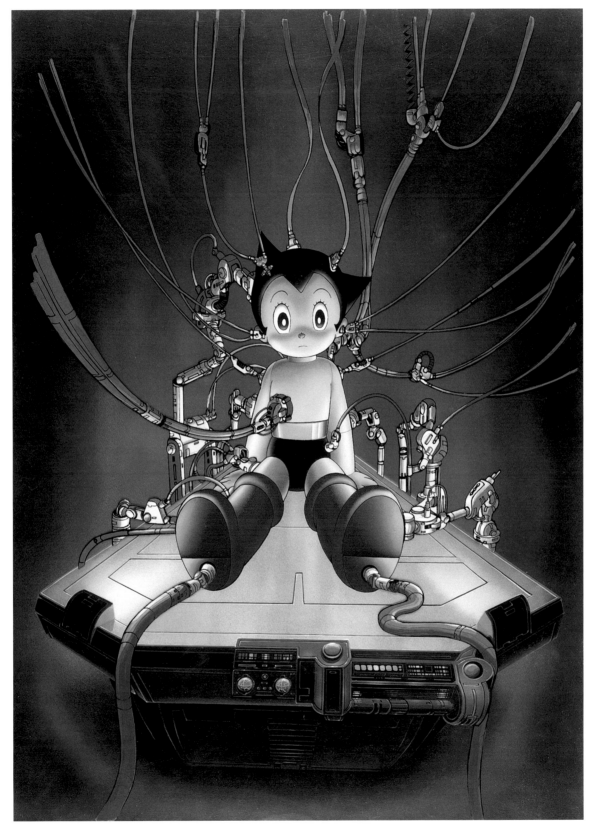

64
Tezuka Osamu, *Astro Boy*, film. © Tezuka Productions.

65
Walt Disney (Walter Elias Disney, 1901–1966),
American producer, director, scriptwriter,
and cartoon animator. © Costa/Leemage.

This much disparaged and subsequently much adulated manga character thus became the hero of an animated film. Yet in order to be able to bring out one film a week, Tezuka, who had agreed to produce them for the derisory sum of 550,000 yen at the time, saw his assistants drop from exhaustion one by one, despite the ingenious system he had advocated: the "bank system" and "limited animation."

An archive documentary, presented as part of the Tezuka Osamu exhibition at the Edo-Tokyo Museum, shows the shelves where his assistants filed images that they used on several occasions. Tezuka Osamu himself described this system:

> For an animated film designed for television we draw twelve images per second; in Japan, however, we draw only eight (this is what is known as "limited animation"). Each movement is drawn as elegantly as possible and in the best posture because if the result is second-rate the image needs to be reworked during the rush—which means a lot of work and time wasted— we might go over the deadline.[8]

In this way, the cartoons were produced more quickly, but the fewer the images the less the character appeared to move. Several cels were superimposed for the mouth and limbs to give a more fluid movement. Some character or background cels were also kept and reused in similar scenes (what is known as the "bank system").

Despite the small number of images used for *Astro Boy*, in two or three months the media response had gathered pace, and each film (which lasted for thirty minutes with ten minutes of ads) was a huge hit with children.

Though Tezuka Osamu was well aware that he was losing money with his anime, he wanted to follow his passion through to its conclusion and continued to create a wealth of manga to cover his deficit.

He described the first *Astro Boy* broadcast with great emotion:

> On January 1st, 1963, *Tetsuwan Atomu [Astro Boy]* was broadcast for the first time. Never, in the whole of my life, will I be able to forget how I felt then. I was like a father looking lovingly at his child who got to be on television.[9]

Tezuka Osamu went on to produce many other animations based on his manga: *Ribbon no kishi (Princess Knight)*, *Dororo*, and *Janguru Taitei (Jungle Emperor)*. His fascination with experimental cinema continued and he made four short films, including *Memory* or *Mermaid*. He then turned to manga aimed more at adults, before founding a monthly journal entitled *COM* on December 25, 1966, in which he started to publish *Hi no tori (Phoenix)*. The adult anime that he went on to make—*Sen ya ichi ya monogatari (A Thousand and One Nights)* or *Kureopatura (Cleopatra)*, for instance—did not enjoy the success hoped for.

However, Tezuka did not admit defeat for all that, and went on to design his magnificent film *Tenrankai no e (Pictures at an Exhibition)*, which was much admired by Disney, among others. Despite unanimous praise from the critics, this anime was a financial disaster and Tezuka resigned from Mushi Productions, one of the three companies he had created. This company produced televised series of other *mangaka*; it went bankrupt in 1973, as did his other company, Mushi Pro Shōji. He then devoted himself to manga at Tezuka Productions.

He was, however, to return to animation in 1978 with *Hi no tori (Phoenix)*—his life work and without a doubt his favorite film, which

68
Tezuka Osamu, *Jumping*, film, 1984.
© Tezuka Productions, Mushi Production.

In this film, one of a kind, Tezuka Osamu allows the viewer to embody a character. He walks, jumps, strides over cities and forests, appears to cross countries in times of peace and war, dives off the top of buildings, and moves through a universe that shifts from reality to unreality.

The master explained that the idea for this film occurred to him while watching a three-minute-long Hungarian animation in which the viewer saw the world through the eyes of a fly. This short film was Ferenc Rófusz's *The Fly/A Légy* (1980).

gave a glimpse of his philosophy and humanism. He produced another remake of *Astro Boy* (1980), while at the same time continuing to pursue experimental animation, before creating *Jumping* (1984), which won the Grand Prize at the festivals of Zagreb and Valladolid.

In a filmed interview, Tezuka Osamu explained how happy he was still to be alive after having known the war, and that he wanted at all costs to do what he loved until he died. Through animation, he sought to give life to his manga characters. He was aware of the constant pressure of time, as he had to draw numerous manga to finance his

69
Tezuka Osamu, *Aoi Burinku (Blue Blink),* **film, 1989.**
© **Tezuka Productions.**

This film takes the viewer into a dreamlike world. A little
boy meets a blue horse and they have many adventures
together as they learn the meaning of friendship, life, and
good. Not until the very last episode does Tezuka reveal
that it is just a dream.

70
Tezuka Osamu, Storyboard from *Aoi Burinku (Blue Blink),*
1988–89. © **Tezuka Productions.**

71–73

Tezuka Osamu, *Onboro firumu (Broken-down Film)*, film, 1985. © Tezuka Productions.

A veiled reference to Westerns, this film required considerable work, as Tezuka was looking to reproduce the grain of an old roll of spotted film on which a hair appears throughout.

films, but admitted that he loved to design and produce the majority of his projects on his own. What he found most beguiling was the way he could metamorphose his characters; he made the drawings for his films himself, which is extremely rare. He worked for two years and five months on *Jumping*, which required 3,959 cels.

Fig. 68

In 1985, he was awarded the Grand Prize at the first Hiroshima International Animation Festival and at the International Festival of Varna for *Onboro firumu (Broken-Down Film*, 1985). Two years later, Figs. 71–73 he designed *Mori no densetsu (Legend of the Forest)* based on Tchaikovsky's first and fourth movements.

In 1988, despite the serious illness afflicting him, Tezuka Osamu continued to draw, and embarked upon the direction of two animation series: *Leo the Lion* and *Aoi Burinku (Blue Blink)*. Fig. 69

The trauma of war, the fear of death, and the will to preserve life and nature pervaded Tezuka Osamu's entire oeuvre. The art of animation enabled him to be a giver of life. In this respect, he declared:

> Animation cinema is a kind of movement, and at the same time, the art of giving life. In making something move, we are breathing life into it—this is what is known as "animism," the notion that leads us to believe that every object has a soul. In this sense, animation is very much a kind of animism.[10]

Having traveled endlessly across the globe ever since the mid-1970s to take part in festivals, Tezuka Osamu passed away on September 2, 1989, leaving behind him thousands of manga drawings and a host of animated films.

Tezuka Productions now manages the publication of the master's works in Japan and abroad. It also authorizes remakes of some of them. It has its own studios in China, sells licenses to other companies for character merchandising, and runs its store. It also organizes various events, exhibitions, seminars, and TV programs related to Tezuka's work.

What is surprising about Tezuka Productions is not only the warmth of the welcome, but also the way that the employees strive to perpetuate the ideas of its founder, Tezuka Osamu.

INTERVIEW
WITH MATSUTANI TAKAYUKI

President of Tezuka Productions

Brigitte Koyama-Richard: Mr. Matsutani, thank you for meeting me today. I would like, if I may, to talk about your career at Tezuka Productions. When you did join this company and in which context?

Matsutani Takayuki: After studying law, I did various odd jobs before finding work with the Jitsugyō no Nihonsha publishing house, which brought out the *Manga Sunday* magazine for adults. My job was to deal with Tezuka Osamu's manga, which is how I had the opportunity to make his acquaintance. The following year, he offered me a post in one of his three companies. At the time he owned Mushi Productions, Mushi Pro Shōji (which handled merchandising and the journal *COM*), and Tezuka Productions. As the first two had fallen into great financial difficulty, Tezuka Osamu now worked only for the latter, which was the studio where he created his manga.

B. K.-R.: So you were no manga expert?

M. T.: Not at all. But when Tezuka Osamu offered to take me on board in his company, I really wanted to work for him, as he was a real genius.

B. K.-R.: When we look at documentaries from this period, we get the impression that he was forever writing and drawing. Were all of his employees as busy as he was?

M. T.: Yes, it was awful! We slept on the premises and never managed to get home more than twice a week. Three publishers were there constantly, each waiting for his manga, and they also ate and spent the night at the offices. Sometimes Tezuka Osamu would write a page for each of the three manga at the same time. There was no day or night, Saturday or Sunday. We always had to be ready to fulfill all of his demands. He worked constantly and was always stressed by time. Just think how he created almost six hundred pages of manga a month in 1975–76— some twenty pages a day is staggering!

B. K.-R.: What did your work entail, exactly?

M. T.: I had to manage the master's schedule—which was very complicated—take care of the meals, and find assistants when there were not enough of them. As he was always snowed under with work, he would take his pencils and papers with him in taxis or planes when he was traveling. We would make reservations on every flight as we never knew what time he would be able to board. As the publishers would be waiting, when we arrived at our destination we would even ask the pilot and crew to send them the drawings as soon as they got back to Tokyo. When they heard Tezuka Osamu's name, they were all very happy to do so.

B. K.-R.: This year, many events are held to celebrate the eightieth anniversary of Tezuka Osamu's birth. There are numerous TV broadcasts and a magnificent exhibition devoted to his life and work at the Edo-Tokyo Museum. What was your greatest wish when organizing these various tributes?

M. T.: In all of his manga and anime, Tezuka Osamu wanted to convey to children a message of peace, love, and respect for life. Our greatest wish is therefore to perpetuate this message for future generations through these events and new editions of his manga.

B. K.-R.: The Edo-Tokyo Museum sees many foreign visitors. Tezuka Osamu's philosophical message is understood the world over, isn't it?

M. T.: Yes, the themes he tackled are timeless and meaningful for everyone. He was a pioneer in this and a whole generation of budding *mangaka* has followed him, looking to produce quality manga. In fact, Japan is an exceptional country in that large publishing houses publish both literary or artistic works as well as manga. They included manga in their magazines and then created actual magazines dedicated to them. For years there has been great freedom of expression in this area; this has allowed manga to develop and evolve. It is something quite specific to Japan, and is found nowhere else.

B. K.-R.: Tezuka Osamu was also a pioneer in the sense that he was one of the first to take part in festivals such as the Angoulême International Comics Festival?

M. T.: That's right. He did his utmost to promote manga and animated pictures, and to convey his message. His experimental films and the various prizes he received in many countries were highly instrumental in making his name and his works like *Astro Boy* known abroad.

B. K.-R.: This year a remake of *Astro Boy* comes out in Japan, the USA, and in Europe. It is a good opportunity for young people to discover this hero, but isn't there a danger of the film and its characters straying far from the original?

M. T.: No, because we were monitoring them. However, the character had to be modified to appear in 3D; we hope that viewers will like him. Some heroes need to be modernized to appeal to today's audiences. In Japan, we are also working on remakes of other works such as *Buddha*.

B. K.-R.: What would you like to say to the new generation of *mangaka*?

M. T.: Today there are manga schools or courses at universities. This is excellent, but these young people must not content themselves with simply learning drawing techniques. General education is the most important thing. To design interesting manga, you need to read widely, see a lot of movies at the cinema, go to the theater often, and cultivate your mind. Since his childhood, Tezuka Osamu had a very rich personal store of knowledge that allowed him to create all of these stories.

B. K.-R.: What is your dearest wish?

M. T.: For us, the most important thing is to continue to pass on Tezuka Osamu's message, striving to make his manga and animated films known and loved by future generations.

– June 2009 –

INTERVIEW WITH KOTOKU MINORU

Production manager at Tezuka Productions

Ever since I started work on my previous book, *One Thousand Years of Manga*, Kotoku Minoru has provided me with a wealth of information and showed me documents that have been invaluable for my research. Each of our meetings has given me the opportunity to learn more about Tezuka Osamu.

Brigitte Koyama-Richard: When did you start working at Tezuka Productions?

Kotoku Minoru: I entered the company by chance in 1978. A friend had suggested I take a part-time job there. The following year I became a full-time salaried employee.

B. K.-R.: What was your job?

K. M.: I managed Tezuka Osamu's schedule, just as Matsutani Takayuki had done before me. I had to organize the master's day around his work to be submitted to the publishers, order meals, reserve flights when he went off to conferences, and so on. The editors from the publishing houses were a permanent fixture, sometimes for four days at a time. There were times when we wouldn't leave the studio for more than five days. We had to be in constant attendance to Tezuka Osamu, as he was always late with his deadlines. He worked for several publications at the same time and had to write several hundreds of pages a month. He also had lectures and interviews to prepare, as well as his animated films.

B. K.-R.: How did you deal with the various publishing houses?

K. M.: It wasn't easy as we had to keep everyone satisfied.

B. K.-R.: How was Tezuka Osamu able to do so many things at once?

K. M.: He was a true genius. He managed to work on virtually no sleep. His mind was full of drawings, finished and in color. He was therefore able to work on several projects at the same time and could draw his figures starting from any part of the body.

B. K.-R.: He had assistants, didn't he?

K. M.: Yes, constantly throughout the day; around six p.m. we would ask him how many assistants he needed for the night. The assistants took over from one another twenty-four hours a day. They all shared the same bases for applying color, etc. The master had arranged things so that all of his assistants could work in exactly the same manner.

B. K.-R.: All of those who worked with Tezuka Osamu say that it was very hard—yet all of them continued. Why?

K. M.: I think that it was down to Tezuka Osamu himself. We were proud to assist him and we respected him. He knew how to talk to people and how to behave with them.

He himself chose what he wanted to work on, and even if we told him that it was impossible for some reason or other, he would do it anyway, asking us which of all of the jobs should come first. He was very exacting with himself, always exerting himself to the full—and expected us to do likewise.

B. K.-R.: How long has the music from *Astro Boy* been playing at Takadanobaba Station?

K. M.: In the manga, Astro Boy was born at Takadanobaba in 2003. This is why JR (Japan Railway) agreed to play the *Astro Boy* music from that year onward.

B. K.-R.: Everyone is extremely cooperative at Tezuka Productions. It is really important for researchers who want to study Tezuka Osamu.

K. M.: That is how Tezuka Osamu was himself; we want his philosophy and work to live on.

B. K.-R.: His works have been translated into many languages, haven't they?

K. M.: Yes, over a dozen.

B. K.-R.: What is your dearest wish for Tezuka's work?

K. M.: We want the young generation to know about it and hope that today's children will read his manga.

B. K.-R.: In your opinion, what is the most important message that Tezuka Osamu wanted to convey?

K. M.: Respect for life. Next, I would say that it was his desire for peace. The themes that he worked on in his productions are timeless; this is why his works are very popular abroad.

– June 2009 –

INTERVIEW WITH SHIMIZU YOSHIHIRO

Rights manager at Tezuka Productions

A remake of *Astro Boy* is to be launched this year in the US and many other countries. I wanted to talk about this new version with Shimizu Yoshihiro.

Brigitte Koyama-Richard: You have an exciting job within Tezuka Productions. Can you tell me about your career and your relationship with the master, whom you knew very well?

Shimizu Yoshihiro: I started to work at Tezuka Productions in 1978. At the time, it was just a student job, but when I graduated from university I was lucky enough to be recruited. I've now been here for over thirty years.

B. K.-R.: Were you hired as a cartoonist?

S. Y.: Not at all—I can't draw. I asked to work in the production department. I specialized in things like reproduction rights, which meant that I got to meet people from all backgrounds. Tezuka Osamu's first readers are now all around seventy years old. It is always a great pleasure to talk to them, just as it is with the younger generations of fans.

B. K.-R.: What does your job actually consist of?

S. Y.: I am responsible for organizing exhibitions, exhibition venues, TV programs, and managing the licensing rights for mascots and figurines.

B. K.-R.: Tell me about Tezuka Osamu. How did he relate to the people who worked for him?

S. Y.: He was a man of great simplicity and humanity in his relationships with others. A tireless worker, he was able to draw several projects at once. He would ask for some surprising things at strange times—chocolate, or pencils, in the middle of the night, when all the stores were closed! He would often test his assistants to see what they were capable of.

B. K.-R.: In the Western world, *Astro Boy* is his best-known work. Yet he wrote many other manga. Why is that, do you think?

S. Y.: Yes, *Astro Boy* is internationally famous. It is true that there was something for everyone in his prolific output. But at that time, in the West there were no manga as long as Tezuka's and his manga had yet to be translated. It was therefore the cartoon *Astro Boy* that made him known abroad. But I wonder to what extent, as many people were familiar with *Astro Boy* but didn't know the name of his creator.

B. K.-R.: Why weren't his manga translated at the time?

S. Y.: Manga are read from right to left. Western readers at that time were not used to reading manga in that order. We would have had to reverse the order and it would have

been very time-consuming to check everything. Tezuka preferred to focus on production in Japan.

B. K.-R.: That has changed a lot. Today young people in the West have no qualms about reading manga in the Japanese order.

S. Y.: That's right. The same goes for film subtitles, which they have no problems reading while listening to the original version.

B. K.-R.: Tezuka Osamu was very interested in new technology, wasn't he?

S. Y.: Yes. He made experimental cartoons and was a pioneer in experimenting with many amusing devices in his other films. In *Cleopatra*, a film intended for adults, he used actors for the body and cartoons for the faces. He did likewise in *Vampire*. He liked it when viewers wondered how he made his productions.

B. K.-R.: A new version of *Astro Boy* is due for launch shortly in the US. Did you work with the American studios?

S. Y.: We approved the screenplay, checked the broad outline, and asked for a few changes in the hero's graphics. The American studios conducted a survey among young viewers, who found Tezuka's character too childish. The master's idea was a little boy of about seven, but American children thought that he was only four! They wanted an older hero, who would look around twelve or thirteen years old. So the studio redesigned an older version. When I saw his new face, it looked to me like that of a thirty-five-year-old man! We asked for more changes and ended up with the present character, a youth aged around twelve, and we were happy with this. Criteria vary greatly from one culture to another. As the film was produced in the US and intended for both Western and Japanese viewers, we had to appreciate this and yield to the desires of the American audience if we wanted the movie to be a success.

B. K.-R.: In your opinion, what is the difference between Japanese anime and American cartoons?

S. Y.: In the United States, movement is the most important thing, whereas in Japan it is the story. When Americans and Japanese watch the same cartoon they never laugh at the same time. For Americans, animated films are for children. *Astro Boy, Jungle Emperor*, and *Mac Go Go Go [Speed Racer]* were the only animated films to make it to the US in the 1960s. A couple of decades later, other Japanese animations arrived in video form. In these films, the characters found themselves up against the same problems as the teenagers who became carried away with Japanese animation. They began dressing up as their favorite heroes—leading to the phenomenon of cosplay*, which has been taken up by Japanese youth. The success of Tezuka Osamu's animated films was at the root of remakes

using actors. Now we hope that the fans of his anime will want to discover his manga.

B. K.-R.: In your opinion, where will animation go from here?

S. Y.: There will be many changes as Asian countries have studied Japanese techniques. We will work increasingly with these countries for things like color application. We work in cooperation with them, but have never seen the faces of the people we are dealing with. On the other hand, there are employees of all nationalities in the American studios. We are going to find ourselves before a new world of animation.

– Spring 2009 –

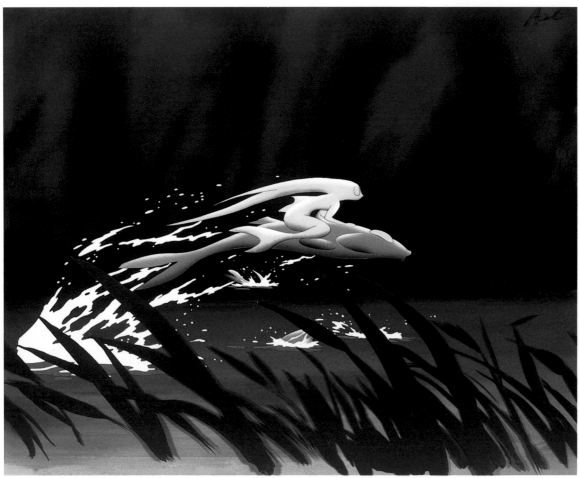

74
Tezuka Osamu, *Mori no densetsu (Legend of the Forest),* **draft drawing for the film, 1987. © Tezuka Productions.**
This masterpiece with its magnificent graphics—which unfortunately remained unfinished—recounts the history of animation, referring to its pioneers, Walt Disney in particular. Tezuka goes back to his favorite themes here: protecting life of every form and nature.

75–78
Astro Boy. © 2009 Imagi Capital Limited Original
Manga; © Tezuka Productions.

A new version of *Astro Boy*

In this new version, the young super-power robot is on a quest for identity. Presented by Imagi Studios, *Astro Boy* is directed by David Figs. 75–78 Bowers (*Flushed Away*). Freddie Highmore, Kristen Bell, Nathan Lane, Eugene Levy, Matt Lucas, Bill Nighy, Donald Sutherland, Samuel L. Jackson, and Nicolas Cage in the role of Doctor Tenma supply the voices. Based on the manga by Tezuka Osamu, this picture is produced by Maryann Garger (*Flushed Away*), Cecil Kramer, Ken Tsumura, Paul Wang, and Francis Kao. Music is by John Ottman.

Yokoyama Ryūichi and the Otogi Studio

Alongside Tōei and Tezuka Osamu's films, which occupied a central place in the history of Japanese anime from the mid-twentieth century, a few other big production companies emerged. One of these was the Otogi Studio, founded by the famous *mangaka* Yokoyama Ryūichi (1909–2001).

Yokoyama Ryūichi discovered animation's charm through Walt Disney's movie *The Skeleton Dance* (1929), which came out in Japan in 1930. In 1932, prior to the founding of Tōhō, he joined the PCL (Photo-Chemical-Laboratory) Studio, working in its research department. In 1936, he made a series of cartoons for the Tokyo edition of the great daily *Asahi* newspaper, *Edokko Kenchan*. However, seeing the popularity of Fukuchan, one of his secondary characters, he decided to make him into a hero. This comic strip changed its title several times and appeared in the *Mainichi* newspaper in 1956.

In 1951, on a reporter's mission to the USA for *Mainichi*, he visited the Disney Studios and met Walt Disney himself. In 1955, he converted the second floor of his house into a studio to produce his first 16-mm motion picture: *Onbu obake** (*Piggyback Ghost*). It was presented to the Bunshun Club literary circle in December of the same year and attracted many celebrities from the world of letters, such as Osaragi Jirō (1897–1973) and Mishima Yukio (1925–1970). The film was subsequently readapted for television.

In 1956, his studio became known as Otogi Productions, and Yokoyama Ryūichi produced *Fukusuke* (*The Top-heavy Frog*). Fig. 82

79–80
Yokoyama Ryūichi, *Hyōtan suzume*
***(The Sparrow in the Empty Pumpkin)*, film**
for big screen, 1959. © Yokoyama Takao.

In a peaceful village of amphibians there is a
gourd endowed with magic powers that is
home to some sparrows. A wicked frog even-
tually makes himself king of the village and
begins a reign of terror over the inhabitants.
No longer able to bear his vile deeds, the other
frogs rise up in rebellion and the magic gourd
goes off in pursuit of the dictator, driving him
away forever.

81
Yokoyama Ryūichi,
Otogi no sekai ryokō
(Otogi's Voyage
***around the World)*,**
film for big screen,
1962. © Yokoyama
Takao.

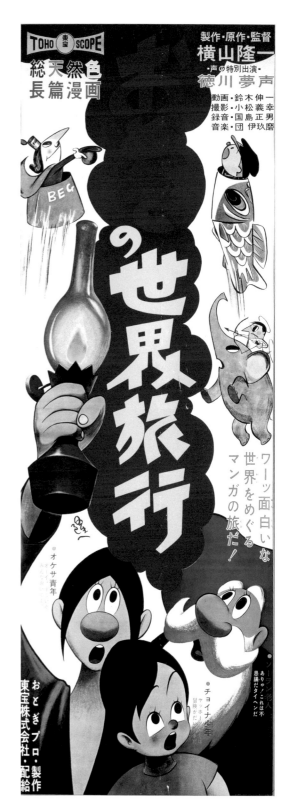

82
Yokoyama Ryūichi, *Fukusuke (The Top-heavy Frog)*, film for big screen, 1957. © Yokoyama Takao.

This story's heroine is a little hydrocephalic frog who is forced to live upside down. Her adoring parents try all means to let her live a normal life and make her some very heavy shoes so that she can keep her feet on the ground. A demon then abducts her. Her father rushes to her aid and spirits away an instrument essential to the demon. He promises to return it if his child can be restored to health. The demon complies and the frog can then live like all of her fellow creatures.

This very human film was awarded two prizes the following year: the *Mainichi* Educational Culture Prize and the special Blue Ribbon Prize. Two years later, he adapted the children's story *Fushigi na hyōtan (A Strange Gourd)*, which became *Hyōtan suzume (The Sparrow in the Empty Pumpkin)*. In 1962, he also designed *Otogi no sekai ryokō (Otogi's Voyage Around the World)*. Figs. 79–80 Fig. 81

Yokoyama Ryūichi also produced numerous animated publicity features, which won him prizes on several occasions. He officially resigned from the studio in 1972 and helped many talented youngsters on the road to animation, Suzuki Shin.ichi and Yamamoto Eiichi in particular.

Tatsunoko Production

Tatsunoko Production was one of the animation studios that developed after the war, and whose influence extended to the West in the 1960s, even having a profound impact on contemporary cinema.

Behind the genesis of this production company were three brothers: Yoshida Tatsuo, born in 1932; Kenji, born in 1935; and Toyoharu (who was to go by the pseudonym "Kuri Ippei"), born in 1940.

83
Mach GoGoGo (Speed Racer), TV, June 1966/
May 1968. © Tatsunoko Production.

This story's young hero, Go Mifune (aka Speed
Racer), drives a high-powered racing car on the
world's greatest circuits. He goes in search of his
brother, an unparalleled racer, who has disap-
peared. With the help of his family, girlfriend, and
a mysterious man, he too gradually learns to
become an excellent racing driver.

84
*Konchū Monogatari Minashigo Hachi
(The Adventures of Hutch the Honeybee)*,
TV, April 7, 1970/September 8, 1971.
© Tatsunoko Production.

One day, the peaceful realm of the bees is attacked
and destroyed by wasps. One little bee is the sole
survivor. When he learns the secret of his birth, he
decides to go in search of his mother, and on the
way has many encounters. This story of filial love
touched the hearts of many TV viewers.

85
*Kerokko Demetan (Demetan Croaker, The Boy
Frog aka The Brave Frog)*, TV, January 2,
1973/September 25, 1973. © Tatsunoko
Production.

Following an attack by some dangerous Tritons, a
group of tree frogs (including Demetan) take
refuge in a pond. Here, young Demetan, who
comes from a poor background, meets Ranatan,
the lovely daughter of a lord. He falls in love with
her but cannot live by her side without the permis-
sion of a powerful frog. Shy and fearful, Demetan
will find courage, and fights for peace to prevail in
the pond.

86
Uchū e-su (Space Ace), TV,
March 8, 1965/April 28, 1966.
© Tatsunoko Production.

The inhabitants of the planet Parlum, forced to leave, go in search of another area where they can live in peace. The hero, Ace, son of the president of Parlum, loses his way and finds himself in the twenty-first century on Earth. Befriended by Doctor Tatsunoko and his daughter Asari, Ace has no qualms about using his super-human powers to brave anyone trying to stir up ill-feeling. The Fuji TV channel broadcast this series of fifty-two episodes in black and white.

87
Kagaku Ninja gun Gatchaman (Science Ninja Team Gatchaman), TV, October 1, 1972/September 29, 1974. © Tatsunoko Production.

After losing their mother when the youngest sibling was only one year old—and in the absence of their father, who had gone up to the front— the three children were raised by their grandmother. Like many children of this generation, they experienced some difficult years, even if their father returned safe and sound from the war. The eldest boy, who dreamed of becoming an artist, attended classes in a school and worked for the *kami shibai* to earn a little money. His younger brother subsequently joined him. Tatsuo then left to work for a magazine in Tokyo. His meeting with Sasagawa Hiroshi, Tezuka Osamu's assistant, who suggested that he try his hand at animation, was to change his life completely. In 1962, he founded the Kabushiki Gaisha Tatsunoko Purodakushon, Tatsunoko Production Co., Ltd. *"Tatsunoko"* means "little dragon" (or "seahorse"), which accounts for the famous logo depicting a stylized version of this creature.

The studio specialized in cartoons for television; in 1965 it presented its first film, *Uchū e-su (Space Ace),* inspired by *Z Boy,* Fig. 86

a manga by Kuri Ippei. In those days, motion pictures had little regard for reality; however, Tatsunoko Production made its heroes grow older over the course of the episodes, so that children could identify with them more readily.

Two years later, in 1967, the company embarked upon various studies in order to use animation to represent the movement and speed of a racing car. These studies would result in the film, *Mach GoGoGo (Speed Racer)*, which won fame the following year in the United States. In 2008, the Americans even produced a remake of this story using actors.

The 1970s marked the beginning of Japanese economic expansion and the rapacious development of studying. Wanting to own their own homes, many Japanese people started to work long hours, leaving their children as "latchkey kids." A new expression— "*kaggikko**" (latchkey child)—was coined, symbolizing this generation of children who returned from school to an empty house, and the domestic conflicts that ensued. Tatsunoko Production then decided to make an animated film on this social phenomenon and chose to use insects as the characters. This appealing project gave rise to *Konchū Monogatari Minashigo Hachi (The Adventures of Hutch the Honeybee)*.

With *Kagaku Ninja gun Gatchaman (Science Ninja Team Gatchaman)* in 1972, Tatsunoko Production became one of the most important studios of the time. The following year, in a completely different register, the little frog in *Kerokko Demetan (Demetan Croaker, The Boy Frog)* would melt the hearts of both parents and children.

Yoshida Tatsuo passed away in 1977; his brother Kenji replaced him at the helm of the studio. In 1987, it was Toyoharu's turn to occupy this position. A subsidiary of Tatsunoko Production became independent under the name of "I.G. Tatsunoko" and went on to buy out the I.G. Studio. Kenji took over the reins once again in 1995, before making way for Narushima Kōki in 2005. Today the Japanese toy company Tomy is the majority shareholder.

Tatsunoko Production is currently enjoying great success with its television series *Yattāman (Yatterman)*, a remake of an animated film dating from 1977.

INTERVIEW WITH NARUSHIMA KŌKI

President and CEO of Tatsunoko Production

Narushima Kōki kindly answered my questions and showed me around the studios of Tatsunoko Production, which is located in the Kokubunji district, outside of central Tokyo.

Brigitte Koyama-Richard: Could you tell me about the history of Tatsunoko Production, please?

Narushima Kōki: This company was founded by three brothers, Yoshida Tatsuo, Kenji, and Toyoharu. Yoshida Tatsuo was a *mangaka* and Kenji followed in his footsteps. Like Tezuka Osamu, they wanted to see their drawings move.

B. K.-R.: That was the beginning of animation, wasn't it?

N. K.: Absolutely. It was a task for pioneers. Everything was waiting to be invented, and Walt Disney was of course the model. Limited animations had to be produced on very slim budgets. But they were young and had the energy to achieve what they wanted to.

B. K.-R.: How many people made up Tatsunoko Production in its early days?

N. K.: About ten. They were all friends of the three brothers. Then the production went on to recruit as many as three hundred people.

B. K.-R.: What is special about Tatsunoko Production?

N. K.: I think that it is the main heroes created by the Yoshida brothers, and the psychological make-up of these characters. As orphans, the three brothers suffered greatly and had a difficult childhood. Their anime clearly reflect their feelings and vision of life. Their stories are about fraternity, mutual aid, and solidarity.

B. K.-R.: Yes, their works are very moving.

N. K.: But the films were more popular in some countries and cultures than others. For example, in the US they were not able to understand the melancholic sentiment that prevails in some of them; they found the plots too complicated—for them, cartoons are first and foremost a form of children's entertainment. However, in Europe—first in Italy and then in France—the works went down very well.

B. K.-R.: What is the reason for this, do you think?

N. K.: I don't think that Americans and Europeans interpret cartoons in the same way as the Japanese do. For us, in terms of marketing, it is very important to understand these different forms of interpretation.

B. K.-R.: How do you feel about the current globalization of anime? Don't you think that Japanese production might lose its originality?

N. K.: Yes, I share your concern. But I feel that the problem lies in the fact that many people are unaware of this. Initially, Japanese designers—the founders of Tatsunoko Production in particular—paid no heed to foreign audiences at all. They produced the works that they wanted to create. They were artists. Today all production companies must, of course, consider the international market. But it is important for Japanese anime to preserve the specific features that made them so original. For Americans, limited animations (cartoons for television made up of few images per second) are not real animations. Of course, they are different from full animation movies such as those by Walt Disney. Yet managing to convey emotion in a character that does not move very much was a very difficult undertaking. I think that limited animation was an enormous contribution to the advancement of anime. Today, with the widespread use of computers, what remains is the cartoon's meaning and original idea.

B. K.-R.: In the early days, Disney influenced Japanese designers, but nowadays it is they who influence American cartoons and cinema. What do you think of this? Your anime, *Speed Racer*, for example, was the subject of a remake, wasn't it?

N. K.: Yes, it's true that Japanese anime are now a source of inspiration for some foreign designers. We are pleased about this, but must not become vain, as self-satisfaction is a veil to seeing things with perspicacity and limits creativity. In the past, we considered jointly producing five films with Italy. After several years, three have come into being: *Robin Hood [Robin na daiboken], Cinderella [Monagatori]*, and *Snow White [Shirayuki Hime no Densetsu]*. In *Robin Hood*, the Italians thought that our characters' eyes were too big and that there was a lot of violence. We decided to change nothing and produced the film in Japan. In the case of the other two, we complied with their instructions, but these films lacked the hallmark of Tatsunoko Production. In the end, *Robin Hood* was the most successful anime—and remains so today. The other two are hybrid versions and were not the successes we hoped for.

B. K.-R.: Your anime *Yattāman*, broadcast on TV, was a great hit. This summer, you are also going to bring out a version of this film for the big screen.

N. K.: Yes, we are delighted. We also want to be able to embark on some new projects. This presents a great financial risk, and animation needs sponsors to revitalize it. But Tatsunoko Production is ready to take this risk to bring audiences new and original offerings.

– June 2009 –

88 *(Below right)*
Ie Naki Ko (Nobody's Boy—Remi), TV, 1977–78.
© TMS Entertainment.

This adaptation of the famous novel *Sans Famille* by Hector Malot (1830–1907) is very true to the original text. Raised by the good foster mother Barberin, the young orphan Remi then takes to the road with Signor Vitalis, a traveling musician. After many adventures, the child succeeds in finding his real parents.

89 *(Middle right)*
Mei Tantei Holmes (Sherlock Hound), 1984–85.
© RAI/TMS.

A free adaptation of Sir Arthur Conan Doyle's adventures of Sherlock Holmes, here the famous detective is a dog, Sherlock Hound, accompanied by his dear Dr. Watson. Both have a new riddle to solve on a night of thick fog.

90 *(Far right)*
Lupin III (Lupin the Third), **after the original comic book created by Monkey Punch. Part I (1971–72), Part II (1977–80), Part III (1984–85).**
© Monkey Punch; © TMS Entertainment.

Lupin III (Lupin the Third) is one of the most famous TV series in Japan. Based on Maurice Leblanc's novel *Arsène Lupin,* it recounts the adventures of the grandson of the famous gentleman thief. The young man chalks up conquests and solves problems with disarming simplicity. Along with his three stooges, Jigen, Goemon, and the *femme fatale* Fujiko, he tries to outwit Detective Zenigata, who is forever on their tail. Miyazaki Hayao worked on this series. Two hundred and twenty-eight episodes have been shown on TV and were highly successful—as was the manga they came from.

TMS Entertainment

Founded in 1946, the TMS Entertainment company created its animation studio in 1964. The many cartoons that it produced were often taken from great literary or comic strip classics. We should not forget that, if Japanese animation enjoyed such a postwar boom and sparked such a strong craze, it is also largely due to the talent of the *mangaka* and the publishers who spurred them on.

91 *(Above)*
Botchan, **1980.** © **TMS Entertainment.**

Botchan, one of the most famous novels by the great Japanese writer Natsume Sōseki (1867–1916), published in 1906, offers an image of Meiji-period Japan, when the country was opening up to the West and was faced with great upheaval. The hero, a young math teacher, is sent to the provinces for his first appointment. There he becomes the target of his students' mockery and his colleagues' harassment—a misfit in provincial shackles.

Here Nemo sets off for Slumberland in the company of his new friend, Professor Genius, and his favorite animal, Icarus the squirrel. In this utopian land, where everyone is living in harmony, Nemo meets the king. The latter decides to adopt him and gives him a key, making him promise never to open the door that it fits. Nemo doesn't keep his promise and frees a terrible demon that invades Slumberland.

Winsor McCay (1869–1934), a graphic artist turned cartoonist for newspapers, first published *Little Nemo* in 1905 in the *New York Herald* supplement. His tale took the reader into a carefree dream world where everything was possible; time no longer existed and imagination had no bounds. Little Nemo traveled in his bed and always woke up when he fell out of it. The graphics and colors of these comic strips are remarkable and have lost none of their charm. *Little Nemo* remains a great classic of its kind.

95 (Above)
Sonic X, **based on the Sega video game, 2003–05.**
© Sonic Project.

This animated film recounts the battles between Sonic, who found himself on Earth after his planet exploded, and the terrible Dr. Eggman (Robotnik) and his gang, who have decided to conquer the world. Sonic makes some friends, a young earthling by the name of Christopher (Chris) in particular. Chris helps him to battle against the forces of evil. To do so, Sonic has to find the Chaos Emeralds.

96 (Top right)
Galaxy High School, **TV, September 13, 1986/ December 6, 1986. © TMS Entertainment.**

This funny anime recounts the adventures of the first two students—an earthling and a girl from another planet—to change places. It also touches on more serious subjects, particularly the battle against drugs. TMS Entertainment produced this series for the US CBS Network, based on an original idea by Chris Columbus (*Harry Potter and the Chamber of Secrets, Home Alone,* etc.) and with a soundtrack by Don Felder (The Eagles).

97 (Above)
Takarajima, (Treasure Island), **film, 1978–79. © TMS Entertainment.**

Adapted from Robert Louis Stevenson's famous novel *Treasure Island,* this anime is a chance for those who have yet to read the book to discover this exciting adventure.

98

Anpanman, TV, 1988/currently showing. © Takashi Yanase/Anpanman Project.

Created in 1968 by Yanase Takashi, Anpanman is a very famous character in Japan. His round face is a bread bun filled with the red bean paste *(anpan)* used in traditional Japanese cakes. All of his friends are named after some foodstuff—Uncle Jam, for example. Anpanman and his friends protect people from the awful Baikin Man ("Germ Man"). They always emerge victorious from their adventures, to the great delight of Japanese youngsters, who are always keen to get tie-in merchandise. This series celebrated its twentieth anniversary in October 2008. The one thousandth episode was broadcast during summer 2009.

99–100
Fukuchan, TV, 1982–83. © Yokoyama
Ryūichi/Shin-ei Animation.

101
Kureyon Shinchan (Crayon Shin-chan),
April 13, 1992/currently showing.
© Usui-Yoshito/Futabasya/Shin-ei Animation/
TV-Asahi. ADK.

Shin-Ei Dōga

The Shin-Ei Dōga production company made a great contribution to the international success of Japanese animation. Founded in 1976 by the late Kusube Daikichirō, it is now managed by his brother, Sankichirō, who opened its doors to me and explained that Shin-Ei Dōga's greatest wish is to create anime that children like; consequently there is humor, but no violence. Among the many anime the company has produced—some of which have delighted Japanese audiences for three decades—the best known are *Fukuchan*, after the manga by Yokoyama Ryūichi, which was broadcast on television from 1982 to 1984, and *Obake no Qtarō (Ghost Qtarō)*. And the more recent Fig. 102 *Kureyon Shinchan (Crayon Shin-chan)*, also very popular outside of Fig. 101 Japan, still appears every week on television. Yet it is the highly celebrated Doraemon who is the symbol of Shin-Ei Dōga, where a figure of him stands in pride of place at the entrance. Whether on the big screen or television, the adventures of this sweet little manga character show no signs of becoming stale.

102
Obake no Qtarō (Ghost Qtarō), TV, 29 August 1965/26 March 1967.
© Fujiko-Pro/Fujiko Studio/Shin-ei Animation.

これを 表紙にする

ドラえもん キャラクター表

103–104
Doraemon, April 2, 1979/March 25, 2005.
© Fujiko-Pro/Shogakukan/TV-Asahi/Shin-ei/ADK.

105–106
Kappa no kū to natsu yasumi (Summer Days with Coo).
© Masao Koyute.

107 *(Top left)*
Oshii Mamoru (director), *Innocence (Ghost in the Shell 2),* film for big screen, 2004. © 2004 Shirow Masamune–Production I.G./KODANSHA.

108 *(Top right)*
Kamiyama Kenji, *Sutando Arón Konpurekkusu (Ghost in the Shell–Stand Alone Complex),* film for big screen, 2002. © 2002 Shirow Masamune–Production I.G./KODANSHA.

109 *(Above)*
Oshii Mamoru (director), *The Sky Crawlers,* film for big screen, 2008. © MH/NI, BWDVYHDYCH.

Production I.G.

Production I.G. Tatsunoko was founded in 1987 and became Production I.G. in 1993—"I.G." being the initials of its two cofounders: Ishikawa Mitsuhisa, the company's president, and Goto Takayuki, in charge of the artistic design. The company soon became involved in the production of OAV* (Original Animation Video) and video games, as well as TV series. In 1995, its collaboration with Oshii Mamoru gave rise to a magnificent cartoon: *Kōkaku kidōtai (Ghost in the Shell).* In 2003, the studio handled the animation sequences in the American movie *Kill Bill.* The following year, *Innocence (Ghost in the Shell 2),* also by Oshii Mamoru, was selected to compete for the Palme d'Or at the Cannes Festival. In 2008, Oshii created the cartoon *The Sky Crawlers* and, the following year, an animation documentary *Miyamoto Musashi.* Figs. 112–115 Fig. 111

For the 2009 summer season, Production I.G. brought out a remarkable 3D film, *Hottarake no shima Haruka to mahō no kagami (Oblivion Island and the Magic Mirror),* a kind of moving and action-packed modern-day *Alice in Wonderland,* with some splendid special effects.

In the wake of the popularity of robots with audiences in the 1960s, through *Astro Boy* and *Gigantor,* appeared *the mecha** in the 1970s, with *Mazinger Z, Gundam,* or the famous *Yūfo Robo Gurendaizā (UFO Robot Grendizer).* The cyborgs and other robots[12]—particularly in Oshii Mamoru's *Ghost in the Shell*—heralded a new genre, marking a real turning point in cartoon history. Kamiyama Kenji created a series of animated films for television, based on *Ghost in the Shell* and broadcast in 2002: *Stand Alone Complex* (known by its English title Figs. 108; 11 even in Japan, or rather *Sutando Arón Konpurekkusu*), followed by *Stand Alone Complex 2nd Gig,* in 2005, which in turn gave rise to a third movie, *Stand Alone Complex—Solid State Society* in 2006.

110
Kamiyama Kenji, *Sutando Arón Konpurekkusu*
(Ghost in the Shell–Stand Alone Complex),
film for big screen, 2002. © 2002 Shirow Masamune
–Production I.G./KODANSHA.

Ghost in the Shell is a complex, sophisticated tale. The viewer is drawn into a futuristic society where information technology and the virtual predominate. The heroes are human beings, though there is nothing to distinguish them physically from cyborgs. Human beings and cyborgs come together and play a role in this society where the watchword is terror. The new Public Security Section 9 is an antiterrorist squad. A lot is at stake as the planet's survival is hanging by a thread. The lovely cyborg Kusayanagi Motoko, the "Major" in charge of a team that specializes in electronic piracy, understands the extent to which human brains can be infiltrated or hacked by unscrupulous individuals. Yet, like most of her friends, she is aware that she is only a cyborg. Her physical ability far surpasses that of a human being. Only her soul (or "ghost" which, as the title *Ghost in the Shell* suggests, takes cover in a shell) has been preserved, thus presenting her with a serious dilemma. She ponders over things, trying to find the answers to her existential questions. This police thriller alternates short violent scenes with philosophical moments of great graphic beauty. It contains many allusions to literary works, as does the sequel, *Innocence.* This full-length feature film, and the TV series that ensued, inspired several foreign filmmakers.

111
Oshii Mamoru (director), *The Sky Crawlers,* **film for big screen,**
2008. © MH/NI, BWDVYHDYCH.

The movie *The Sky Crawlers,* based on the novel by Mori Hiroshi, immerses the viewer in a virtual world, where men amused themselves by dreaming up air battles to be broadcast on TV or appear in the newspapers. The pilots of these fighter planes are humanoids, the Kildren, created to confront one another. Doomed to remain eternal adolescents, they are granted death only during these battles. The viewer must provide his own interpretation of the film's ending, somewhere between love stories and metaphysical questions. The art nouveau-style interior decorations and the beauty of the landscapes, such as the one reproduced here, are in stark contrast to the movie's oppressive atmosphere.

112–115
Oshii Mamoru (director), *Innocence (Ghost in the Shell 2)*, **film for big screen, 2004**
© 2004 Shirow Masamune–Production I.G./KODANSHA.

Here, one of the protagonists, Batou, a member of Public Security Section 9, is in pursuit of a female android who has just killed two police officers. This series of four images depicts the scene in which Batou catches her. She is a fragile little android; her porcelain complexion and jet black hair are the perfect foil to the beauty of her big sky-blue eyes and full red lips. Despite the force that dwells within her, she is unable to overcome Batou; in a childlike voice she asks him for help: *"Tasukete"* ("Help me"). At that very moment she disintegrates and we see her beautiful face crack and break up, taking on a monstrous appearance.

116 *(Left)*
Hottarake no shima Haruka to mahō no kagami (Oblivion Island and the Magic Mirror), **film for big screen, 2009.** © 2009 FUJI TELEVISION/ Production I.G./Dentsu/ Pony Canyon.

117–121 *(Above far left and facing page)*
Nishikubo Mizuho (director), *Miyamoto Musashi sōken ni haseru yume (Musashi, The Dream of the Last Samurai)*, **film for big screen, 2009.** © 2009, Production I.G. Mushashi Production Committee.

Nishikubo Mizuho directed this film, which had a screenplay by Oshii Mamoru. The bill states that it is a documentary animation. With two 3-dimensional puppets—one of which looks like Oshii Mamoru—taking it in turns to provide the explanations, this film recounts the life of the national hero, Miyamoto Musashi, as well as the history of Japan.[13] While Oshii Mamoru and Nishikubo Mizuho focus particularly on his swordsmanship, Miyamoto Musashi's artistic career is also very much in evidence. This remarkable film is a way for Japanese youth to rediscover a part of their past and for foreigners to learn about this legendary figure.

INTERVIEW WITH ISHIKAWA MITSUHISA

President and CEO of Production I.G.

Ishikawa Mitsuhisa welcomed me in a very down-to-earth manner in the offices of Production I.G.. His youthful appearance and the way he looks at whoever he is speaking to with candor and assurance were what first struck me. He described his work with much enthusiasm. A book entitled *Zassōdamashi (Spirit Weed)* charts his exceptional career. In it, he describes his agricultural origins, his family who provided his moral force, and his passion for *kuruma ningyō* (a traditional puppet theater similar to *bunraku*). Then he recounts his many travels in India, Thailand, Africa, USSR, or other countries until he happened to get a student job at Tatsunoko Production, where he married one of the founder's daughters. His anti-establishment free spirit led him to create the I.G. Tatsunoko production company in 1987 with his friend Goto Takayuki; in 1993, it was to become Production I.G. From its initial five members, the company now employs almost three hundred people. It is very famous not only in Japan, but also in the United States, Europe, and Asia. In 2004, Ishikawa Mitsuhisa was named "Entrepreneur of the Year" in Japan.

Brigitte Koyama-Richard: Many thanks for agreeing to see me. I would like you to talk about your production company and its specific features.

Ishikawa Mitsuhisa: There were five of us initially; some twenty years on, there are almost three hundred of us. I would never have dared envisage such success at the time.

B. K.-R.: This remarkable success is far from being confined to Japan. What is so special about Production I.G.?

I. M.: We make the films that we really want to make. The most important thing is to establish firm human relations and to create an environment conducive to producing the anime that we want to make. Animation is a buoyant market and we need to be aware of this. We can't merely follow the wishes of the artists. We have to take into account the demands of the audience. I wanted this company to provide a kind of fusion between the artists and the producers.

B. K.-R.: You have produced a wide variety of works, many of which have become cult pictures abroad. What kind of animations would you like to work on from now on?

I. M.: Profit is not the most important criterion for us. We want to make novel works that focus on remarkable aspects of Japanese culture, music, or the quality of the animation. For example, we want to highlight the beauty of the Clamp anime group's drawings in their manga *xxxHoLic*.

This summer we are going to launch a 3-D anime. To do so, we had to study carefully how to render the character's movements. The heroine is a schoolgirl. She is dragged into a magical world with many references to traditional Japanese culture. We want to create typically Japanese works.

B. K.-R.: What do you think of the influence of cartoons on international cinema?

I. M.: French cinema has had a profound influence on most directors, Oshii Mamoru and a host of others. This is probably why these anime are such a hit in France. I also think that the quality of the manga has greatly evolved because readers are more demanding, which means that the anime also have to be of a superlative level to fulfill their expectations. There are a very large number of Japanese animations as compared with those of other countries, and many are of high quality. It is these that now influence filmmakers in America and elsewhere.

B. K.-R.: Don't you think that Japanese anime are often created with the international market in mind?

I. M.: No, I honestly think that this is not the case. The Japanese don't create these films to suit foreign tastes, but for Japanese audiences. And when the film goes down well here, we present it in other countries.

B. K.-R.: Aren't you afraid that, with today's globalization, Japanese anime will lose some of their originality?

I. M.: Yes, of course. This is why we have to be vigilant and choose our producers, artists, and directors with care. We cannot work only for the Japanese market. But it is by aiming for quality films that we will be able to make them known abroad.

B. K.-R.: Your production company has created a very large number of films. Yet I think that many people associate the name Production I.G. mainly with Oshii Mamoru?

I. M.: Yes, his talent has made it possible to bring out some successful works. We have also worked with other brilliant producers and directors. It is important to be among talented people who know how to work together, even if they don't always agree with each other. This is probably one of the qualities of the Japanese.

B. K.-R.: What is your dream?

I. M.: I don't have one for myself. I have objectives that I strive to attain to please my family and to satisfy the members of this company. I want all of those who live or work with me to feel good, to enjoy their job, and therefore create original works. We are getting ready to bring out a 3-D film this summer, *Oblivion Island and the Magic Mirror*, which we have been working on very hard for several years. We are also going to be presenting our new anime *Miyamoto Musashi sōken ni haseru yume [Miyamoto Musashi, The Dream of the Last Samurai]* at La Maison de la Culture du Japon in Paris, as part of the Japan Expo.

B. K.-R.: Your new film *Miyamoto Musashi* is truly unique within your company, I think. I like this anime's educational aspect, and it is also very dynamic.

I. M.: We hope that Japanese and foreign audiences will like it too.

– June 2009 –

122
Shinzaki Mamoru, *Hadashi no Gen (Barefoot Gen)* (based on the manga by Nakazawa Kenji), film for big screen, 1983.
© Gen Production.

This film, directed by Shinzaki Mamoru in 1983 and awarded the *Mainichi* Ōfuji Noburō Prize, recounts the dramatic history of the Nakaoka family a few days before and after the bombing of the city of Hiroshima on August 6, 1945. The author draws upon his own experience and provides a virulent criticism of the imperialist regime at that time and of the American Occupation, emphasizing the need for self-reconstruction after a tragedy.

123
Galaxy Angel. © Broccoli. Bandai Visual.

124
Hosoda Mamoru, *Summer Wars,* film for big screen, 2009. © 2009 Summer Wars Film Partners.

After the great success of the 2006 film, *Toki o kakeru shōjo (The Girl Who Leapt Through Time)*, Hosoda Mamoru brought out *Summer Wars* in August 2009. Its heroine is a shy high school student who takes refuge in a virtual universe that she has to learn to leave by trusting others.

Madhouse

Not far from the Animation Museum, in Tokyo's Suginami district, is one of the most important animation studios in Japan—Madhouse. Though it is generally not very easy to gain access to such a company, I received a very kind welcome from Maruyama Masao, one of its founders. He showed me around his ultramodern premises and introduced me to a number of his colleagues. Working in every type of genre, Madhouse Studios produces animated films for both children and adults, and for TV and cinema alike.

Madhouse Studios was founded in 1972 by former employees of Mushi Productions, including Maruyama Masao, Dezaki Osamu, and Kawajiri Yoshiaki. It has some of the most illustrious directors and producers in its ranks. Many of this studio's anime productions— *Unico: To the Magic Island, Hadashi no Gen (Barefoot Gen), Azuki-* Fig. 122 *chan (Azuki), Metropolis, Paprika, Galaxy Angel,* and *Summer Wars* Figs. 125–126 in particular—have been international successes.

125–126
Rintarō, *Metropolis,* film for big screen, 2001.
© 2001 Tezuka Productions / Metropolis Committee.

This work by Rintarō, a harmonious blend of traditional animation and 3-D, is a tribute to Tezuka Osamu's famous manga. In the futuristic city of Metropolis, humans coexist with robots. The towering skyscraper, Ziggurat, is home to the society's elite, while the poor and the robots are doomed to live underground. A private detective and his nephew, Ken.ichi, are investigating a case of the illegal trafficking of human organs. They meet Dr. Laughton, a mad scientist who has designed a new type of android, Tima. This wonderful girl, who beguiles viewers with her beauty and tragic destiny, is fated to sit enthroned atop Ziggurat.

127
Red Line. © 2009, Katsuhito Ishii, GASTONIA, MADHOUSE, REDLINE Partners.

INTERVIEW
WITH MARUYAMA MASAO

Chief creative officer at Madhouse

Brigitte Koyama-Richard: Mr. Maruyama, thank you for showing me around. I would like you to tell me about your career. You have been in the animation field for a long time, haven't you?

Maruyama Masao: Yes, I started out with Tezuka Osamu, to whom we are all indebted. This man of great generosity has left behind a huge corpus of work. He worked incessantly and was interested in every new technical development. He slept very little and would write several books at a time. Yet he always agreed to be interviewed and endeavored to make himself available.

B. K.-R.: Did you have a specific job?

M. M.: We all had to multitask and were very busy. Sometimes we would hardly sleep for a week! But Tezuka Osamu's huge output has given rise to contemporary animation. He was the first to create cartoon series for television and his Astro Boy character has subsequently become famous, outside of Japan as well.

B. K.-R.: You created Madhouse in 1972. Can you tell me about your studio?

M. M.: When Tezuka Osamu's studio, Mushi Productions, went bankrupt, several of us (who were his assistants)

decided to create a new company; this is how Madhouse appeared. I then started working on the film *Ashita no Joe [Tomorrow's Joe]*, which holds many marvelous memories for me, tinged with nostalgia. I met the author of this manga, Chiba Tetsuya, on several occasions. He is a remarkable man, full of humanity, and he has created some very exciting works. I even kept a cel from this film as a souvenir. Look how lovely that is!

B. K.-R.: Is it still possible to keep souvenirs like that of animated motion pictures today?

M. M.: Unfortunately, modern techniques have put a stop to much of that.

B. K.-R.: You have created many films. Are they all original works?

M. M.: Some were taken from manga; others, like *Perfect Blue*, are entirely original works.

B. K.-R.: Can you explain to me what you mean by an "original work" and tell me how you go about making this type of film?

M. M.: We draft a project and screenplay, and then we decide how we are going to film it.

B. K.-R.: I would like you to tell me about the wonderful animated film, *Metropolis*, which has been a great success both in Japan and abroad.

M. M.: This film is a tribute to the work of my master, Tezuka Osamu. He drew the manga, but never made it into an animated picture. I wanted to try to understand how he would have staged and filmed this work if he had had the opportunity. My friend Rintarō, well known for his many films—*Ginga Tetsudō 999 [Galaxy Express 999]* in particular—directed it, and we used the most modern techniques at that time. Tezuka was fascinated by modern technology, which is why I opted for 3-D.

B. K.-R.: The special effects are astonishing. I particularly like the main character, Tima, whose face is different from that of Tezuka Osamu's manga figure. Which films are you working on at the moment?

M. M.: We have several projects under way. Our work is very eclectic and our films are intended for a wide audience. However, the big-screen picture that we are working on for Christmas 2009, again directed by Rintarō, is one of our current priorities. It will be called *Yona Yona Penguin*. A French studio will also be part of this adventure. I wanted to produce a film that is different to American movies— one that is beautiful, with a little European twist.

B. K.-R.: You lead a very busy life!

M. M.: It's true that we get by on little sleep in our job.

B. K.-R.: What are your hopes for Madhouse?

M. M.: We hope above all that audiences will continue to like our films.

– Fall 2008 –

INTERVIEW
WITH RINTARŌ

Director and producer at Madhouse

Hoping to find out a little more about the new film *Yona Yona Penguin*, produced by Madhouse, I wanted to meet one of the legends of animation, the director and producer of many cartoons, Mr. Rintarō (his real name is Hayashi Shigeyuki). All fans of Japanese animation, both at home and abroad, know his name. Rintarō represents the history of Japanese anime from the late 1950s to the present. Since his productions for Tōei, then at Mushi Productions, and up to his work for Madhouse today, he has never stopped creating and innovating; his most recent film, *Yona Yona Penguin*, goes to prove that he is one of the undisputed masters of contemporary Japanese animation. He took time out to tell me about his exceptional career.

Brigitte Koyama-Richard: I would like you to give a brief account of your career. You started in this profession in the late 1950s. What made you want to go into animation?

Rintarō: I had no intention at all of working in this field. I loved drawing manga in the *gekiga** style, but my sights were set more on becoming a director. I joined Tōei because of its cinema studio. I thought that I might have the chance of learning how to become a director there. At that time, the manager of Tōei longed to make cartoons on a par with Walt Disney's in terms of quality. I was asked to work on the film *The White Serpent* and I began by applying color to drawings or cels. I then became an animator.

B. K.-R.: Your name is a stage name, isn't it?

R.: Yes, it is a nickname given to me by a colleague.

B. K.-R.: You then entered Mushi Productions and worked with Tezuka Osamu?

R.: Yes, I worked on several films—*Astro Boy, Jungle Emperor, Moomin*, etc.

B. K.-R.: Then you came to Madhouse in the early 1970s.

R.: Yes. A few of my friends founded Madhouse Studios and I made many films independently for them, while also working for other productions. But I like the spirit of freedom and adventure that reigns here; I would never have been able to embark on such a novel film as *Yona Yona Penguin* in another production company.

B. K.-R.: Since you started out, you have gone from cels to 3-D. Has your work changed very much?

R.: Not really, apart from the evolution in techniques. Initially I was not particularly interested in 3-D, even if I admired the remarkable work of the Pixar Studios. One day I said to myself that we too could do a new kind of CG*

(computer graphics) animation. The problem with CG is that the system is designed particularly for rendering movement, but not expressions and sentiment. It was precisely this that I wanted to remedy by making *Yona Yona Penguin*—and I think we have succeeded.

B. K.-R.: What does your job as producer and director of this film entail?

R.: The job is the same as in cinema. A studio chooses the producer, who writes the screenplay (or has it written).

B. K.-R.: You wrote it for *Yona Yona Penguin*, didn't you?

R.: Yes. I then designed the storyboard. We select the team of animators and those responsible for the artistic side of things, the background images, etc. The director checks each image and sends back any that don't suit him to be redrawn. He gives directions about lighting, color, design, and is responsible for the whole of the film, including the cutting and editing and the musical elements.

[Mr. Rintarō shows me a clip from *Yona Yona Penguin*. The graphics, fluidity of movement, and expression are remarkable.]

B. K.-R.: How many years have you worked on this film?

R.: I've been on this project now for seven years. I was preparing it for three years before we started work with the French team, and we have just finished it. [M. Rintarō shows me a part of his storyboard, a bulky file full of annotated drawings. It is a masterpiece in its own right and an invaluable document for animators to come.]

We wanted to distinguish ourselves from Pixar's work. I knew exactly the result I wanted to achieve, but it was not always easy to make my team understand what I was thinking, as it was really quite novel in technical terms.

B. K.-R.: Out of all of your films, one of my favorites is *Metropolis*. Maruyama Masao told me that it is a tribute to Tezuka Osamu. I find the main character, Tima, much more beautiful than that of the original manga.

R.: Tezuka Osamu meant a lot to all of us and his work is very dear to us. *Metropolis* is a manga from his early days and the characters in it are roughly drawn. It was like a draft for his future manga. We decided to make the characters more attractive, but were anxious to preserve the spirit of the work.

B. K.-R.: Don't you feel that the Japanese animation market is heading toward globalization, meeting the demands of the American market?

R.: The Europeans would like us to make more typically Japanese films. Unfortunately, business is now a key factor and the best part of Japanese animation now has to meet the demands of the American market.

B. K.-R.: Aren't you afraid that by dint of wanting to satisfy the international market, Japanese animation will fall into a state of collapse?

R.: For me, Japanese animation reached its peak in the 1970s and 1980s. Designing new, quality works is a matter of urgency if we are to remain in this field. We have to preserve the originality of Japanese animated films.

B. K.-R.: In your opinion, what constitutes the originality of such films?

R.: They have a different timing and rhythm; this comes through quite clearly when we work with foreign teams. Our graphics are also born of our cultural tradition, albeit subconsciously. Illuminated scrolls, such as *Chōjū jinbutsu giga* [Scrolls of Frolicking Animals and Humans]*, are at the root of our animated pictures, and the master Japanese printmakers have influenced our graphics. I like Hokusai of course, but have a preference for Kuniyoshi. All of the works by these artists are in our genes and are part of our DNA, even if we are unaware of it.

B. K.-R.: What is your dream now?

R.: I like new ideas and going from one film to another. I always have several projects on my mind. So I would say that my dream is to make a new animated film using Full 3-DCG (three-dimensional animation produced entirely by computers).

B. K.-R.: Thank you very much. I wish you all the best for *Yona Yona Penguin.*

– Fall 2008 –

128
Rintarō, *Yona Yona Penguin,* film for big screen, 2009. © 2009 Rintarō + Madhouse/Yona Yona Penguin Film Partners+DFP.

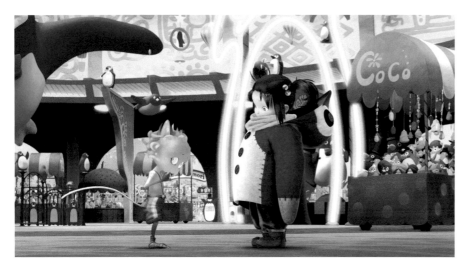

129–132

Rintarō, *Yona Yona Penguin*, film for big screen, 2009. © 2009 Rintarō + Madhouse/Yona Yona Penguin Film Partners+DFP.

Wearing a coat that makes her looks like a penguin—a precious gift from her father before he died—the little heroine, Coco, gains access to an enchanted world. Her father told her that she would be able to fly with this coat. Chaley, a supernatural goblin, whisks her away to his country, whose inhabitants had been suffering ever since a monster plunged them into darkness. Zammie, a fallen angel banished from heaven, is in the monster's service, strewing terror in the village. Coco and Chaley convince the penguin that the monster is using her to her own detriment, that she should trust them, and that selfless friendship does exist. From one adventure to another, Coco finds the strength within her to allow her to fly, in order to vanquish the monster and to bring aid to her friends. Coco and Chaley help Zammie to return to heaven, after being put back on the right track. Friendship and moral values are the watchwords of this superb Franco-Japanese anime, which contains symbols from various religions, such as the seven lucky gods and angels. The graphics and color palette are stunning. Never before had 3-DCG Japanese animation attained such fluidity of movement and such delicacy of facial expression.

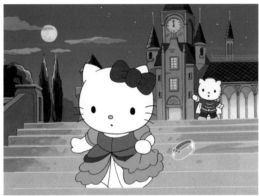

133
Hello Kitty no Cinderella (Hello Kitty's Cinderella),
film, 1989. © '76, '10 SANRIO CO. Ltd.

134
Hello Kitty: Ringo no Mori no Fantasy (Hello Kitty:
The Fantasy of the Apple Forest), TV, 2006.
© '76, '10 SANRIO CO. Ltd.

Hello Kitty, one of Japanese animation's stars

Hello Kitty is a delightful cat, the darling of little girls and young women, not only in Japan but also in all Asian countries, the United States, and Europe. She is the star of the company Sanrio, the creator of a host of branded merchandise and the emblem of all that is *kawaii* (cute), so popular today throughout the world. Kitty has a quite specific identity; her name is "Kitty White," she was born on November 1, and lives in the suburbs of London with her parents and twin sister Mimmy. The name "Kitty" was taken from the cat that appears in Lewis Carroll's *Through the Looking Glass.*

Kitty, or Hello Kitty, was originally a little female cat born in 1974, with a face ringed in black and depicted in a seated position. In 1976 she was standing up, and as of 1982 appeared with no outline around her face. She evolved over time, aimed at a varied audience of young children, schoolgirls, and adults, and wore different outfits according to the season and fashion. Forever young and lovely, Kitty charmed both little girls and their mothers, who had known the character in her early days. She appeared on such an impressive range of merchandise and was so successful that the Sanrio company decided to make her into a cartoon character. Unlike most Japanese anime, which are often inspired by a manga or literary work, Kitty became the heroine of a host of cartoons after gaining popularity simply as a character on a postcard or on fancy goods. These anime are just like Kitty herself—delightful and designed for a very young audience, basically aged from three to six years.

Hello Kitty initially appeared as an animated doll in a film, followed by cartoons. She played the role of Cinderella, or appeared Fig. 133 in original works along with her friends. The most recent offerings include *Ringo no Mori no Fantasy (The Fantasy of the Apple Forest),* Fig. 134 which was a TV series of thirteen 7-minute episodes in 2006. Kitty was also the heroine of several films, marketed as DVDs, that adapted famous tales from around the world—*Hello Kitty Shirayuki hime (Hello Kitty Snow White)* for example—as well as a series of very short educational cartoons, including *Hello Kitty to issho ha migakimashōne*

(Let's Brush Our Teeth with Hello Kitty), a practical guide for children, or *Hello Kitty Magikaru A,I,U,E,O (Hello Kitty Magical A,I,U,E,O)*. All of these Kitty films take children on wonderful adventures, whisking them into a dream world and delighting all who watch them.

The evolution of Japanese animation

In the wake of the great production houses (Mushi Productions, Tezuka Productions, Tōei, Tatsunoko Production, Madhouse, etc.), animation has continued to evolve. In the 1970s, famous directors such as Rintarō, Miyazaki Hayao, or Takahata Isao participated in the design of many anime. Then, with video recorders becoming less expensive over the following decade, these films started being recorded. It also marked the start of the first OVA* (original video animation), which largely contributed to the success of some animated films. The first OVA was Ishii Mamoru's *Darosu* (Dallos) in 1983.

Whether intended for television or the big screen, retailed in OVA format or watched on a computer or cell phone, the majority of cartoons are now produced in CG or 3-DCG. Of course, there are some exceptions, as in Miyazaki Hayao's latest film, *Ponyo*, in which he chose to have everything drawn by hand.

Unfortunately I failed to obtain the Studio Ghibli's authorization to reproduce their images and my request to interview its members was to no avail. The studio staff is now too busy to grant researchers any interviews or reproduction rights. Yet the great animation studios mentioned earlier most generously opened their doors to me.

Detail of fig. 21. © 2008 Kohji Kumeta/Kōdansha.

THE EMPIRE OF MANGA AND ANIMATION: THE ROLE OF THE BIG PUBLISHERS

All of the key figures I met from the world of animation and publishing stressed one feature found in Japan as opposed to other countries—the importance of manga magazines. Not only did they allow budding talents to blossom and flourish, but they gave rise to a host of successful manga that were subsequently made into animated films, many of which are the subject of remakes today.

The year 2009 marked the fiftieth anniversary of two of the main Japanese manga magazines: Kōdansha's *Shōnen Magazine* and Shogakukan's *Shōnen Sunday* came into being on March 17, 1959. This is, of course, no coincidence. At a time when the Japanese were just emerging from the horrors of war, young people had few other forms of entertainment than manga, which were available both as books for loan *(kashibon)* and very bulky monthly magazines that contained a large number of supplements. Given the growing popularity of these magazines, the publishing house Shogakukan, shortly followed by Kōdansha, decided to launch a weekly manga magazine. As neither publisher was originally specialized in this area, this was well and truly a great adventure.

1
Akatsuka Fujio, *Osomatsu-kun.*
© Fujio Productions Ltd.

These two prestigious publishing houses thus embarked upon a frantic race to find the best *mangaka*; this rivalry, which was sometimes the opportunity to form strong friendships, fostered the emergence of quality manga that will be forever etched into the history of Japanese comics.

Shogakukan's *Shōnen Sunday* managed to enlist the collaboration of the master Tezuka Osamu. Its first issue, with Nagashima Shigeo—a famous player of baseball, the most popular sport in Japan—gracing its cover, contained fifteen pages of a manga by Tezuka, *Suriru Hakushi (Doctor Suriru)*, as well as Fujiko Fujio's *Umi no ōji (Prince of the Sea)* and Terada Hiroo's *Supōtsuman Kintarō (Sportsman Kintarō)* among others. Three hundred thousand copies of the new magazine were produced at launch, each retailing at thirty yen.

The first issue of *Shōnen Magazine* came out the same day, with Asashio, a famous sumo wrestler on its cover. It contained articles on sport, Tezuka Osamu, and five manga, including Itō Akio's *Monkichi kun (Little Monkichi)* and Endō Seiji's *Bōken senchō (The Adventurous Ship's Captain)*. It had a run of 205,000 copies with a price set at forty yen.

The editors of both magazines then needed to show great ingenuity to attract readers. *Shōnen Magazine* asked Chiba Tetsuya to write a manga about baseball. It was his publisher who introduced Chiba to this sport (about which he knew very little); at the time he drew mainly manga for girls. His manga, *Chikai no makyū (The Promised Pitch)*, with its completely innovative graphics, went down very well with readers.

Seeing this success, the heads of Shogakukan reacted by increasing the number of pages of their magazine—which went from eighty-four to five hundred and twenty today—and appealing to Yokoyama Mitsuteru, who created a *ninja* story, *Iga no Kagemaru (Kagemaru of the Iga Clan)*, that was to go on for six years! They then enlisted the talents of the greatest gag drawer, Akatsuka Fujio, who contributed *Osomatsu-kun*. With this author a new style was born, popular with Fig. 1 all Japanese people.

Shōnen Sunday looked to the world of ghosts *(obake)*. Its editor asked Fujiko Fujio to produce a manga on this subject, requesting that

the main character be a ghost who appears not only in summer, as was usual in Japan, but also during the other seasons. Fujiko Fujio A (the name "Fujiko Fujio" referred to a *mangaka* duo who worked together; "Fujiko Fujio A" became the signature after one of them died) describes how, when looking for an original name for his main character, he came across a page in a novel by Abe Kōbō (1924–1993) containing the letter Q. As he liked the form of this letter, he named his hero "Obake no Qtarō." This friendly ghost, which appears in this book (p. 148), was very popular among young readers.

Kōdansha retaliated in 1964 with *Ultra Q*, which brought monster stories into vogue. Then *Hoshi no kyojin (Star of the Giants)*, a fine story about a father-son relationship against a baseball backdrop, drawn by Kawasaki Noboru and written by Kashiwara Ikki, came out in 1966. In 1967 the magazine managed to enlist the talents of Akatsuka Fujio and went on to publish one of the most famous gag manga in Japan, *Tensai Bakabon (Genius Bakabon)*. A few years later, Shogakukan regained its favorite *mangaka*, to the despair of the editors of Kōdansha's *Shōnen Magazine*, and carried on publishing this cult manga in its pages.

The issue of January 1, 1968 saw the first episode of a work that was to provide its author with lasting fame, *Ashita no Joe (Tomorrow's Joe)*, based on a story by Takamori Asao, with drawings by Chiba Tetsuya. This tale of boxing heroes appeared in the magazine until May 13, 1973. When one of the two heroes died, an official funeral ceremony was organized on the Kōdansha premises, attracting crowds of fans.

Given the huge success of these magazines among the younger generation, parent-teacher associations expressed their concern and became highly critical. They lashed out at manga, which they maintained (without ever having read them) were bad for the eyes, for the mind, and prevented children from studying. Similar reactions were to be found in other Western countries—but this did not stop young people from reading them.

In an attempt to revamp its style, *Shōnen Sunday* then turned to love stories. Takahashi Rumiko, one of the most brilliant *mangaka*, came up with *Ranma 1/2*, whose fame spread well beyond the archipelago's borders.

Fig. 2

2
Akatsuka Fujio, *Tensai Bakabon.*
© Fujio Productions Ltd.

3
A series of stamps for *Shōnen Magazine*.

4
A series of stamps for *Shōnen Sunday*.

Two series of commemorative stamps were issued in 2009 to celebrate the golden jubilee of these two illustrious publishing houses.

5
Case Closed. © Gōshō Aoyama / 1996, 2010 Shogakukan, YTV, TMS.

Aoyama Gōshō's *Case Closed*, aka *Meitantei Conan (Detective Conan)*, is one of the manga published by Shogakukan that has become a very popular anime. Its hero, Conan, is a high school student with the appearance of a seven-year-old child after being made to drink poison. He lives with a private detective whom he helps to solve cases using hypnosis. The scenarios, a blend of humor, intrigue, action, and love, fascinate both viewers and readers of all ages.

6
© Gōshō Aoyama/Shogakukan.

The 50th Anniversary of Japanese weekly comic books for boys
週刊少年漫画５０周年Ⅱ ＜週刊少年マガジン＞

The 50th Anniversary of Japanese weekly comic books for boys
週刊少年漫画５０周年Ⅱ ＜週刊少年サンデー＞

In March 2009 the two rival magazines jointly celebrated their half-century, in the company of the editors who had been involved over these fifty years, and the *mangaka* and authors who contributed to their success. The manga they introduced were at the root of many animated films.

INTERVIEW WITH KUBO MASAKAZU

Producer and editor in chief at Shogakukan

Ōga Masahiro, the president of Shogakukan, was interested in my research and introduced me to Kubo Masakazu, who was behind Pokémon's success in the bookstores, and then in the field of animation.

Brigitte Koyama-Richard: When you joined Shogakukan, did you hope to work in the field of manga or animation?

Kubo Masakazu: That was my intention when I joined, but in the early days I started out in a department responsible for finding documents and information for publications or videos. That is where I learned about the cost of manufacturing various products. This experience was extremely useful when I had to make anime myself.

B. K.-R.: What did you do within this great publishing house?

K. M.: After spending two years in the same department, I was assigned to the monthly magazine *Terebikun*, aimed at five- to eight-year-old children, and articles about the heroes of *Power Rangers, Kamen Rider*, etc. There I learned the ropes of magazine manufacture. Two and a half years later, I was put in charge of the monthly newsletter on *Korokoromikusu* manga. Aimed at the six- to thirteen-year-old age group, this successful magazine ran to as many as two million copies. I then participated in the development of Bikkurimanchoko stickers, the manga *Obacchama-kun*, the success of Mini yonku model racing cars, and Pokémon.

B. K.-R.: You were largely to thank for the Pokémon success, weren't you?

K. M.: The Pokémon success is down to a joint effort and to children the world over. It is the result of a brilliant creator [Satoshi Tajiri] and his team. It is not always easy to work with an artist with a strong personality, but in the case of Pokémon, we had all gotten along exceedingly well for over thirteen years, thanks to the president of the Pokémon Company, Ishihara Tsunekazu. It was during the winter of 1995 that I worked on Pokémon for the first time. I was then working for the *Korokoromikusu* magazine; the Nintendo Company asked me to come and see the Pokémon game (*Poketto Monsta-aka.midori* in Japan, known as Pokémon Red and Blue abroad). I only had a very short time to try it out and was unable to grasp its overall depth, but my first impression was that it was a game of quality, well tuned to the world of children. I found the Pokémon exchange system particularly fascinating. Nintendo then asked me to help them in promoting this game; on February 28, 1996, the day it was launched for sale, we brought out a special issue of *Korokoromikusu*, as well as a manga whose main character was Pippi, one of the main Pokémon figures. Three months after the game was launched, Mr. Ishihara told me that they had "a ghost Pokémon." This is how he introduced me to Myu [Mew]. In fact, Mew didn't appear in the games, but greatly fueled children's conversations. I then decided to give away twenty Mews to the readers of *Korokoromikusu*. We got eighty thousand requests! It was then that the editorial staff and

myself understood how important the Pokémon were. On October 15, 2006, five days before the magazine was due out, we included extra pages carrying Pokémon playing cards, and offered a mail-order version of the new Pokémon game: *Poketto monsuta ao* [Pocket Monsters Blue]. *Korokoromikusu* had a print run of two million copies. At the time there were about four million children aged between two and twelve. One out of every two children read our magazine. I remember that the editorial office telephone would never stop ringing and that we had to ask colleagues from other departments to help us. This is how we were able to carry this project through. That summer, I had planned to make a cartoon for television. I went to Kyoto to the original Nintendo headquarters and showed some images to those in charge. I pointed out that when a cartoon was a hit on television, we immediately made it into an animated film for the big screen. The people in charge at Nintendo feared that if we made a TV anime the success would only be short-lived—yet for over twenty years Shogakukan had been in the habit of screening a *Doraemon* film for cinema. I explained to them that I wanted to nurture and raise a timeless character like *Doraemon*, and finally got them to accept my project. We also introduced Pokémon games in the magazine. Most of the readers thought that it was a game aimed mainly at boys. But as all the Pokémon in it were delightful, I realized that the TV cartoon version was also sure to appeal to girls. So I put the director Yuyama Kunihiko, who has created many cartoons for girls, in charge of it. Shogakukan Production [now Shogakukan-Shūeisha Production] and OLM produced this film. For the main character, I wanted to use a particularly appealing Pokémon among the one hundred fifty then in existence, so I chose Pikachu. On April 1, 1997, the anime

was first broadcast on television. Pikachu was immediately a huge success and we shot to the top of the audiometer. In April 1998, we brought out *Myūtsu no gyakushū (Pokémon: Mewtwo Returns)*, for cinema, followed by *Rugiya bakutan [Pokémon the Movie 2000: The Power of One]* the following year. Both went down very well with audiences. I have worked as executive producer since the first film and hope to continue to do so as long as my physical and mental health will allow me.

B. K.-R.: You have written a very interesting book about Pokémon. In your opinion, why are these characters so popular?

K. M.: The subjects that come up in Pokémon correspond exactly to the lives children lead. They go fishing, ride their bicycles, visit caves, go shopping, etc. The Pokémon games feature virtually every pastime of interest to children. At present there are around five hundred Pokémon so everyone is able to find one they like. There is fighting in Pokémon, but nobody dies. After each battle, like in sport, the opponents respect one another and talk happily with one another. The Pokémon are also characters that appeal to parents, and their stories make sense the world over. As proof of this, one third of viewers are adults, and each year we achieve a satisfaction rating of 95 percent. The Pokémon have captured the hearts of parents and children alike, which is also what makes them so delightful.

B. K.-R.: The Pokémon have become an international hit. Do you think that anime are universal?

K. M.: Yes, they are increasingly becoming so. Throughout the world 3-D cartoons such as those by Pixar are a great

success, but I think that in terms of expressing emotion, two-dimensional ones still have a bright future ahead of them. Each year Japan creates a large number of animated films on a wide variety of subjects for every age group. I think that, with the joint effect of manga, there are ever-greater numbers of fans everywhere. But there is an increasing amount of illegal hacking on the Internet, which is very harmful to cartoonists. If we manage to solve this problem, the future of anime will be secure.

B. K.-R.: What are your recent creations?

K. M.: We are working on an anime project for the big screen, *Layton kyōju to eien no utahime [Professor Layton and the Eternal Diva]*, due for launch in December 2009. It is based on a game that has sold over five million copies throughout the world, in Great Britain in particular. We have high hopes for this film. For television, I am busy with *Inazuma eleven*, a cartoon about the soccer of the future. I am also responsible for the scheduling of a children's news program, *Oha-Studio*, which has already enjoyed over two thousand five hundred broadcasts, and is still running.

B. K.-R.: In your opinion, what is so specific about Japanese anime?

K. M.: Sixty percent of Japanese anime are taken from a manga. It is therefore no overstatement to stress their importance, both in terms of quality and quantity. Let's take the example of a manga published in a weekly specialist magazine. The story runs to eighteen or twenty pages in each issue, and the last page should make the reader want to buy the following issue to find out what happens next. This manga is then made into a cartoon and we also work to encourage the viewer to want to see the next installment. To produce an anime from a manga we use the latter's basic drawing and storyboard. We therefore save time and achieve a work of better quality, as the characters are reproduced faithfully. While readers follow the manga, we obtain licenses from toy manufacturers so as to be able to market tie-in merchandise as soon as the anime is broadcast. The relationships between manga and animated films are therefore one of the great particularities of Japanese production.

B. K.-R.: Japanese anime are partly made abroad. Aren't you afraid of globalization?

K. M.: Globalization seems to me something that cannot be avoided in the age of the Internet. But Japan has the least restricted environment for designing cartoons—and a wealth of artists. The Pokémon have been an international success for twelve years now. Yet every time a rival appeared, it came from Japan. As long as there remains the will to create quality films in our country, we will see the emergence of works that will thrill the world, regardless of globalization. In any case, that is what I hope.

B. K.-R.: What do you think of the fascination with anime in the United States, Europe, and Asia?

K. M.: It makes me very happy. We produce these works for audiences awaiting them the world over. It is not for money or for ourselves.

B. K.-R.: Which works would you like to handle now?

K. M.: The Pokémon are far from being over. I want to make many more surprising films.

B. K.-R.: What is your dream now?

K. M.: Pikachu goes by the same name in every country. The voice is also the same. The Pokémon became a hit in 1999 at the same time throughout the world. The young generation of twenty year-olds today laughed or cried through the adventures of Pikachu and all his friends. I would like this shared international experience to become a common international language. If, during a meeting at the UN or UNESCO, the question arose of what one was doing when Pikachu was in fashion, it would make me very happy!

– June 2009 –

7
Myūtsu no gyakushū. © Nintendo.Creatures.GAME FREAK.
TV Tokyo.ShoPro. JR Kikaku. © Pokémon.
© 1998 Pikachū Project.

8
Rugiya bakutan (Revelation Lugia). © Nintendo.Creatures.
GAME FREAK.TV Tokyo.ShoPro. JR Kikaku. © Pokémon.
© 1999 Pikachū Project.

9
Ashita no Joe (Tomorrow's Joe), TV, April 1, 1970/September 21, 1971.
© Chiba Tetsuya. © Mushi Productions.

An animated film based on Chiba Tetsuya's famous manga.

A great manga figure: Chiba Tetsuya

Chiba Tetsuya is one of the most inventive *mangaka* of his generation. His fame is now absolutely assured and his work, *Tomorrow's Joe,* one of the best known in the history of manga in Japan, has just been given a new lease of life as it has been republished in Kōdansha's weekly magazine, *Shūkan Gendai,* since March 2009.

Figs. 10–11

Chiba Tetsuya also recounted a crucial phase in his life in a manga that came out in late 2008 in *Young Magazine* entitled *Tomogaki (Friendly Links).* In it, he describes an accident he had when he was young, in his early days as a *mangaka.* The editor of his publishing house had come to talk about his work when, as they were fooling around, Chiba Tetsuya was inadvertently thrown through a window and had to undergo serious surgery to remove the various shards of glass from his face and body. Very upset by the consequences of his inadvertent action, the editor wanted to make amends by getting other artists to draw the manga's following episodes. He went to seek help in the renowned Tokiwasō house, where Tezuka Osamu had

Figs. 13–14

10–11
Excerpt from the manga *Ashita no Joe (Tomorrow's Joe)* in the magazine *Shūkan Gendai,* Kōdansha, March 2009. © ASAO TAKAMORI.TETSUYA CHIBA/KODANSHA.

12
Shūkan Gendai
magazine cover,
Kōdansha,
March 2009.
© Chiba Tetsuya.

been the first *mangaka* to rent a room, shortly followed by a host of other young artists. At the time Tokiwasō was home to figures who were to become that generation's most illustrious *mangaka*, namely Ishinomori Shōtarō, Akatsuka Fujio, and Fujiko A. While they had all heard of Chiba Tetsuya and his work, they had never met him in person. Yet when they learned of his misadventure and his inability to follow through the manga he had started, they all agreed to help him. This was the beginning of a firm friendship. Decades have gone by and many artists from the time of Tokiwasō are no longer with us. It is with nostalgia and emotion that Chiba Tetsuya talks about his friends and describes this period of his life in *Tomogaki*.

Fig. 13–14

13
Tomogaki, 2009. © Chiba Tetsuya.

Tokiwasō house.

14
Tomogaki, 2009. © Chiba Tetsuya.

Tomogaki ends with the artist's silhouette as he bids farewell to his friends who have passed away.

INTERVIEW WITH CHIBA TETSUYA

Mangaka

Despite his great fame, Chiba Tetsuya, in the company of his wife, welcomed me to his home in a very open and generous manner. Far from the traffic and crowds of Tokyo's central districts, their house stands next to a Shinto shrine, where the surrounding peace and quiet is broken only by birdsong.

Brigitte Koyama-Richard: I would like you to talk about *Tomogaki*, this moving episode in your career which makes us aware just how important friendship is to you. This fascinating story involves the most famous *mangaka*, whom you respected and knew so well.

Chiba Tetsuya: Thank you for reading and admiring my account. I wanted to leave a reminder of this period of my life when I met all of these men who shared my passion and became real friends. Many of them died too soon, swept away by the hectic life of a *mangaka*, always taken up by the impressive number of pages they have to submit to a publisher. A *mangaka*'s job is exciting, but very hard, as stress is part of our daily life. Tezuka Osamu, who was a model for us all, himself passed on much too soon.

B. K.-R.: What can you tell us about that period?

C. T.: It was a time when we all stood by one another. We shared a natural team spirit and liked to get together for a drink, to play golf, and to chat—things that the current generation of *mangaka* don't do, as they are much more independent. I am still very happy when I meet my *mangaka* friends.

B. K.-R.: Did you always want to become a *mangaka*, ever since early childhood?

C. T.: No way. At that time, manga had a bad reputation. My parents, like most people of their age, thought that manga prevented children from studying, and there were none of them at my house. However, the house was full of books, children's stories, and Japanese and foreign novels. I was a huge reader when young and dreamed of becoming a writer or poet. Then, when I discovered the fascinating world of art and music, I wanted to be a musician and then a painter—as you can see, anything but a *mangaka*, for the simple reason that I had yet to read a manga. But when I did come across one, I can say that it was a true revelation. I understood that, through manga, I could convey the writer's, painter's and, even perhaps, the musician's emotions. Unbeknown to my parents, I started to do my first drawings.

B. K.-R.: What do you want to express through manga?

C. T.: Like a stage director, I always try to use emotion to convey a story. Thus, in *Tomogaki* we have nostalgia, sorrow, and friendship.

B. K.-R.: What have been your sources of inspiration?

C. T.: I taught myself to draw and was then inspired by the work of Tezuka Osamu, followed by cinema, which occupied a very important place in Japanese people's lives at that time.

B. K.-R.: Do you think that traditional Japanese art—painted scrolls in particular—influenced you?

C. T.: Without having studied them in particular, I think that all of the works we have seen in our schoolbooks are a part of us. Painted scrolls seem to me to be one of the main sources of manga and anime. The finest literary works, beginning with *Genji Monogatari (The Tale of Genji)*, were subsequently illustrated in other forms, including the magnificent painted scrolls. In manga, as in a scroll, the story unfolds from right to left, and the text is also read from top to bottom and from right to left. All Japanese people are indirectly influenced by these works from their past.

B. K.-R.: *Tomorrow's Joe* has enjoyed huge success in Japan and other countries. We are delighted to see that this work has been republished, as of early March 2009, in the magazine *Shūkan Gendai*. I think that it will therefore reach the younger generation. You must be very pleased about this.

C. T.: Yes, for sure. I created it when I was twenty-eight and I am happy that today's young people will discover it.

B. K.-R.: This manga was also made into a successful anime. Is it still broadcast on television?

C. T.: Yes, it regularly appears on local channels.

B. K.-R.: Aside from your *mangaka* activity, you now also run courses at university. What do you want to teach and pass on to these young people?

C. T.: I am particularly careful to answer the questions of my students who dream of becoming *mangaka*. Though I was never taught to draw myself, I explain to them how to present themselves in manga form, and how to draw a manga based on something that happens during the day or a fable such as *The Hare and the Tortoise*. I show them how to make the tale unfold, and advise them. I also invite many *mangaka* to take part in our classes, so that students have access to all form of manga.

B. K.-R.: What are your future projects?

C. T.: I hope to write a sequel to *Tomogaki*, but I would also like to produce a manga about all those people who went to Manchuria with their families, their experience of warfare and the difficulty of their existence on their return.

B. K.-R.: We are all looking forward very much to your next works. Thank you for answering my questions. I wish you great success in your future projects.

Chiba Tetsuya then took me to a large room in which his works are filed—an impressive number of volumes. It was here that he used to work with his many assistants. His most famous manga include *Chikai no makyū [The Promised Pitch*, 1961], *Harisu no kaze [Harris' Whirlwind*, 1965], *Tomorrow's Joe* (1968–73), *Notari Matsutarō* (1973–93), and *Ashita Tenki ni naare [May Tomorrow Be Fine*, 1981–91]. Chiba Tetsuya now works alone; he has just brought out a magnificent collection of his latest creations and previously unpublished works. His youthful spirit and curiosity about the world are a hint that this erudite man still has some fine surprises in store for us. Several of his manga, including *Akane-chan (Little Akane)* and *Tomorrow's Joe*, have been adapted as anime for the big screen.

– June 2009 –

INTERVIEW WITH IGARASHI TAKAO

Vice president at Kōdansha

While a *mangaka*'s success is, of course, down to his talent, the role of the editor who advises and encourages him through the creative process is far from insignificant. This is why I wanted to talk to several editors. Kōdansha opened its doors to me. One of its directors, Igarashi Takao, gave me a warm welcome. After showing me around the offices bustling with editors working on the many magazines published by Kōdansha, he took me to a quiet floor, where paintings by Signac and Valotton grace the wood-paneled walls.

Brigitte Koyama-Richard: Mr. Igarashi, thank you for taking some time out to see me. I would like you to talk about your career and your future projects.

Igarashi Takao: I have spent virtually all of my career at *Shōnen Magazine*, followed by *Gekkan Shōnen Magazine*, which is very rare, as most of us move around a great variety of fields. When I started work here in 1966, Kōdansha was mainly known for its women's press or cultural books, rather than for manga. We had to make up for much lost time as compared with Shogakukan or Shūeisha. The latter, with their magazine *Shūkan Shōnen Jump*,[1] were beating all the records. I was assigned to the weekly *Shōnen Magazine* as vice editor-in-chief in 1978. I was appointed editor-in-chief of the monthly in 1981, and then of the weekly magazine in 1986.

B. K.-R.: You became Kōdansha's managing director in 2008, after being appointed director in 1997.

I. T.: That's right. Throughout my career, I have striven to make the magazines in my charge popular with readers through the quality of their content.

B. K.-R.: You take part in many TV shows about manga; it appears that you have met and guided a large number of *mangaka*, haven't you?

I. T.: Yes, and I chose to produce works that went on to become very successful, such as Chiba Tetsuya's *Ashita Tenki ni naare [May Tomorrow Be Fine]*, Shirato Sanpei's *Watari*, Akatsuka Fujio's *Tensai Bakabon [Genius Bakabon]*, and many others besides.

B. K.-R.: You directed and encouraged these artists?

I. T.: Exactly. Our role consists of advising *mangaka* in order to make their work as interesting as possible for the reader. Then, as editor-in-chief, I worked on a host of manga, such as, say, *GTO [Great Teacher Onizuka]*.

B. K.-R.: How would you define the magazines that you have worked on?

I. T.: They are magazines for a male readership, read by young people up to about the age of twenty. I have never worked in the women's press.

B. K.-R.: You quickly rose to the level of editor-in-chief. What changes did this make to your work?

I. T.: As editor-in-chief, it is of course necessary to supervise and liaise on a daily basis with the other editors to know how the ongoing manga are progressing. *Mangaka* often hesitate about how to end their stories. We put our heads together to decide what the best solution would be. Discussion and advice therefore make things go forward.

B. K.-R.: What are the links with animation?

I. T.: The editor-in-chief determines the choice of production studio when making a manga into an anime. It is therefore a big responsibility. Many of our manga have been made into anime or films with actors.

B. K.-R.: Manga sales in general have dropped in Japan. What is the reason for this, do you think?

I. T.: It is not because the manga are not as good, but because young people have a different lifestyle now. They spend much more time on SMS text messaging from their cell phones than they do reading manga. Statistics have shown that they spend an average of three hours a day tapping on their telephones!

B. K.-R.: In that case, do you think that more people will read manga on their mobile phones?

I. T.: I don't think so. Manga are made to be read on paper. The manga images presented on a mobile are extremely limited and lose their power and interest. In the 1990s we read too many manga. We knew that it wouldn't last. I think that balance is necessary and that diversity is important. We need people who read manga and those who read novels, people who listen to music, etc.

B. K.-R.: What do you recommend to maintain your magazines' sales figures?

I. T.: At all costs we need to maintain the level by offering works of quality. There is no point in bringing out more magazines and creating new ones. We need to keep those we have alive and to give young *mangaka* the opportunity to start out. It takes a long time for a *mangaka* to become well known through a magazine and to develop a loyal readership. Moreover, it takes three to five years for a magazine to really exist. *Shōnen Magazine* is now celebrating its fiftieth birthday! It is the oldest one.

– June 2009 –

INTERVIEW WITH ISHII TŌRU

Editor-in-chief at Kōdansha

Ishii Tōru has been working at Kōdansha for over twenty-five years. Passionate about his job as an editor—he loves to recount with humor and modesty some of the most striking episodes—and a discoverer of new talents, he has been a judicious adviser to many *mangaka*. He has rubbed shoulders with the most famous among them. It was he, for example, who suggested to Chiba Tetsuya the idea of telling his magnificent life story in manga, resulting in *Tomogaki*. Ishii Tōru always makes time for his authors and gives many lectures. In November 2008, he met me in the huge office, bustling with the editorial staff of *Young Magazine*, of which he is now one of the directors.

Brigitte Koyama-Richard: When did you join Kōdansha and what are the various positions you have held up to now?

Ishii Tōru: I joined *Young Magazine*'s editorial team in 1982, then in 1986 worked on the boys' magazine *Shōnen Magazine* and, in 1995, *Mister Magazine* (a magazine that ceased to exist in the year 2000). In 2000, I handled the monthly *Shōnen Magazine*, then, in 2005, *Young Magazine*. Ever since I have been at Kōdansha, I have worked only on manga and male magazines. As an editor, my aim has been to try to improve the content of these magazines so as to increase the sales figures; most successful manga make for sales of between one hundred and fifty thousand and five hundred thousand copies.

B. K.-R.: An editor's job seems very exciting to me. What does it entail exactly?

I. T.: I can compare what we do with the world of theater. The *mangaka* creates the roles and we become the actors. We often initiate a framework and sometimes write the screenplay, which is the most difficult. We meet the *mangaka*, mainly to talk about the story and have him write the storyboard. We check each panel and try to improve the content or to supply changes. The most important thing is the drawing of the storyboard (done in pencil, it is quite different from that of an animated film). Ninety percent of the manga's interest will come from that. We are familiar with each *mangaka*'s drawing style and can easily envisage what the finished work will look like. When we watch films on television that show editors at work, we have the impression that they merely go and fetch the manuscripts from the *mangaka* and go drinking with them. That is pure fiction; if things were like that a long time ago, it is certainly no longer the case today.

B. K.-R.: I think that the editor's presence is absolutely indispensable. He establishes a relationship of trust, advises his author, and encourages him to follow his manga through to its logical conclusion. It is a job with a lot of responsibility, isn't it?

I. T.: There are all sorts of editors. In my case, I like to gloss over the flaws and always look for the positive aspect, especially in young people just starting out in this

profession. No work by a novice can be of a very high level, or particularly interesting. Sometimes I ask a *mangaka* to change the main character and to replace him with one of the other characters in his manga who have real presence or a stronger personality. It is surprising, but the *mangaka* are quite often unaware of the interest inherent in some of their characters. I sometimes feel as if I am a baseball or soccer coach urging his players on. I talk with the authors a lot about things like their family or their youth, as this may provide a very valuable source of inspiration. I cannot advise them without knowing something about their personality, their habits, and their cultural background.

B. K.-R.: You were in charge of Chiba Tetsuya's autobiographical work *Tomogaki*, which I really liked and found very moving. How did this manga originate? What was your role in this particular case? Did you visit him regularly? Did you exchange ideas and monitor his manuscript?

I. T.: I have any number of fascinating anecdotes to tell about the works of Chiba Tetsuya, which have appeared in magazine and book form. I had heard about the accident he describes in this manga from much older colleagues. I was surprised that no editor had asked him to make it into a manga before then. He himself didn't seem to think that it would be of any interest whatsoever. He even appeared very surprised when I asked him about it. This was in the fall of 2007. On December 24, the main outline was fixed. I had known Chiba Tetsuya for around twenty years but I had never had the opportunity of working with him personally. However, I had gleaned a lot of information from his previous editor, who is a close friend of mine. In February 2008, I went to see Mr. Chiba and we looked at the storyboard. I received the manuscript of Part One in May; it contained around thirty-two pages. I needed over sixty, but I didn't tell him that at the time. I suggested that

he proofread the whole thing and come back two months later, proposing that he expand the section where he was suffering during the operation and the part where Ishinomori Shōtarō and Akatsuka Fujio agreed to write the manga instead of him, even though they had never met him. In the end, the manga ran to ninety pages!

B. K.-R.: I think that an editor's job also entails discovering new talents. Is that so in your case?

I. T.: Of course! There are prizes for novices to help budding *mangaka* start out. Then editors become interested in them. But we sometimes consider the work of someone unknown, even if they have won no prizes, and help to guide them. Many come to see us, asking us to look at their drawings. If they are particularly good—which is very rare—we give them a chance. The most exceptional case I have experienced is that of a student who was selling a magazine, on the street, in which he had inserted his manga; I helped him to launch his career. The instructions I give vary according to personality. We don't learn how to manage *mangaka* within our company. There is no systematic method, and each person must reflect upon his own approach to this task.

B. K.-R.: Manga sales have currently fallen in Japan. What is the reason for this?

I. T.: The official reason given is that it is attributable to the fall in birth rate. But I don't believe this. This decrease in the number of births began twenty-five years ago. And we cannot really explain the drop in sales. Contrary to what we often hear, I don't think that it is linked to the economic slump either, which lasted for just two years, from 1987 to 1989, or to the recession of 1992! The magazine *Shōnen Jump* achieved its greatest print run in 1995 with six-and-a-half million copies, while it was the turn of *Shōnen*

Magazine in 1997, with four-and-a-half million copies, right in the middle of the recession. From this I would deduce that economic crisis has little to do with all of this. I think in particular that, in the main, today's manga are less interesting. The fault lies with all of us, the editors, and we need to make greater efforts.

B. K.-R.: Many manga are made into animated films. What are the conditions for a manga one day becoming an anime?

I. T.: At first sight, manga and anime are very similar. But in fact they are completely different. Of course, many manga are made into anime, but some are not suitable for this. Some stories can really only be appreciated in this form. On the other hand, some barely successful manga have become excellent animated films. TV channels have recently started to scout out manga that might one day be turned into successful cartoons.

B. K.-R.: How are manga and Japanese animated films going to evolve in the future?

I. T.: In economic terms, manga represent great richness. If the market is unable to grow, this richness will diminish. In the Edo period, *kabuki* and *rakugo* were popular with all social classes. They presented topical subjects and many people would go and see these shows. Then, in the ensuing Meiji [1868–1912] and Taishō [1912–26] periods, *kabuki* and *rakugo* went from the level of entertainment to that of cultural phenomenon. And once Japan sees something as a cultural product, it will progress no further. At the outset, there was nothing cultural about *kabuki* and *rakugo*. Their creators just wanted to portray their era. Today, they are of interest only to cultured folk and a few connoisseurs. If we don't make more effort to improve manga, they will suffer the same fate. In twenty years' time, we might find them in a museum. To avoid this, we need to see some *mangaka* and editors of genius, as in the past. I think that animation is in a different category and believe that it still has a bright future ahead. Japanese animation was long considered inferior to the work of Walt Disney. People have become interested in Japanese animation, thanks to Miyazaki Hayao and his films, which have received many awards; I am very pleased about this. But Mr. Miyazaki's are not the only films of quality. There are many Japanese anime that have never been seen abroad. Unlike Disney's films, our cartoons are not only intended for children. Some are also fascinating for adults.

B. K.-R.: What's the most interesting thing that has happened to you since you have been in this job?

I. T.: It is a difficult profession. I am always on the lookout for ideas and I never feel that I really rest. But my best memory is probably the joy I felt on seeing the first manga I edited in the bookstores. A customer took it and bought it. I rushed up to him, thanked him, and gave him my business card. You can imagine his surprise! I then felt deliriously happy when I realized that there were probably thousands of people like him who were going to read it!

B. K.-R.: You seem really passionate about your work.

I. T.: You have to be to continue—but I confess that I couldn't imagine doing anything else!

– June 2009 –

15 *(Facing page, top)*
Hiroaki Samura, *Mugen no jūnin (Blade of the Immortal),* 2008.
© 2008 Hiroaki Samura. Kōdansha/ Asano Dojo Revisionista.

In this animated film inspired by a manga by Samura Hiroaki, the action is set in the Edo period in 1770. Manji, the immortal samurai, finds himself forced to kill one thousand criminals to atone for his own misdeeds.

16 *(Facing page, bottom)*
Ken Akamatsu, *Mahoh Sensei Negima! (Magical Teacher Negima!),* 2008.
© 2008 Ken Akamatsu/Kōdansha.

The hero, Negima, has just finished studying magic. He is assigned to a junior high school as an English teacher. His magician's gifts are soon to be revealed.

17 *(Right)*
Masahi Kishimoto, *Naruto: Shippuden (Naruto: Hurricane Chronicles).*
© 2002 Kishimoto Masashi/2007/Shippuden.

Uzumaki Naruto (*uzumaki* means "whirlpool" and Naruto is the name of a city in Tokushima Prefecture, on the island of Shikoku, famous for its whirlpools that featured in Hiroshige's prints) is a young *ninja* who wants to become the best in his village. Humor and action prevail in this manga that became an animated film in 2002. Produced by Studio Pierrot and Aniplex, it is broadcast on the TV Tokyo channel.

From manga to anime

The blend of *mangaka* talent and efforts by editors and publishers has largely contributed to enhancing the quality of manga, many of which have been adapted in anime form. Publishing houses then sign agreements with production studios for the adaptations. Some works by the likes of Chiba Tetsuya or Akatsuka Fujio in particular were made into animated films; this trend continues today with more recent manga such as *xxxHOLic, Mugen no jūnin (Blade of the* Figs. 18–19; 15 *Immortal), Sayonara, Zetsubou-Sensei (Goodbye, Mr. Despair),* Figs. 20–21 *Mahoh Sensei Negima (Magical Teacher Negima),* or Kishimoto Fig. 16 Masashi's *Naruto,* first published in 1999 in *Shūkan Shōnen Jump.*

18–19
xxxHOLic: Kei, 2008. © 2008 CLAMP.
Kōdansha/Ayakashi Workshop.

xxxHOLic (pronounced "Cross Holic") was originally a manga by CLAMP. "xxx" stands for a variable, and *"holic"* simply refers to someone suffering from an addiction, as in "alcoholic" or "workaholic." A blend of humor and somewhat somber scenes, it is the story of an orphan, Watanuki Kimihiho, who suffers from visions linked to occult powers. He encounters Ichihara Yūko, a witch able to deliver him from this curse in exchange for a large sum of money, which the young man has to raise. A host of fantastic adventures ensues.

20–21
Sayonara, Zetsubou-Sensei
(Goodbye, Mr. Despair), 2008.
© 2008 Kohji Kumeta/Kōdansha.

This cartoon, based on a manga by Kumeta Kōji, tells the story of a very pessimistic teacher, Itoshiki Nozomu, who tries to commit suicide and is saved by one of his students.

22
Kazuo Umezu, *Red Fuji (Hokusai)*
& Makoto-chan. **© Kazuo Umezz/**
Shogakukan.

23
Kazuo Umezu, *Makoto-chan's Guwashi,*
Portrait. **© Kazuo Umezz/Shogakukan.**

Back to their roots

While animated films are often inspired by manga, whose roots lie largely in the graphics of Japanese prints, the Adachi Foundation for the Preservation of Woodcut Printing in Tokyo is now looking to the world of manga and animation. For decades, this foundation has endeavored to produce prints as they were in the Edo period, and continues to conduct research into pigments in particular.

Fig. 24 Over the summer of 2009, the foundation created for Shogakukan a range taken from the famous manga and animated film *Urusei Yatsura* by Rumiko Takahashi. It has also devoted several prints to the work of Umezu Kazuo, a famous contemporary artist and painter, also known for his manga character Makoto, which was made into an anime. To create these magnificent prints, the Adachi Foundation carved as many plates as there were colors, before printing them using stumping techniques and mica-tinted grounds, to give them a resolutely new look.

24
Rumiko Takahashi, *Urusei Yatsura,* 1982.
©1982 Rumiko TAKAHASHI/Shogakukan Inc.

Detail of fig. 23. © The Kawamoto Productions Ltd. Photo Tamura Minoru.

KAWAMOTO KIHACHIRŌ, GRAND MASTER OF PUPPET ANIMATION

<div style="text-align: right">Fig. 22</div>

Figs. 21–23

The entire Japanese population is familiar with this great artist's animated films which use dolls and puppets. Some of Kawamoto Kihachirō's works, such as *Sangokushi* (based on the Chinese *Romance of the Three Kingdoms*) or *Heike Monogatari (The Tale of the Heike)*, were broadcast on Japan's national NHK channel for several years (from 1982 to 1984 and from 1993 to 1995 respectively), bringing him international fame.

After studying architecture, Kawamoto Kihachirō spent four years working for Tohō Studios. He went freelance in 1950. One of his friends, Iizawa Tadasu, urged him to persist in the field of animation, but his true mentor was the Czech puppet-master, Jiří Trnka, whose disciple he became in 1963. With Trnka, Kawamoto Kihachirō learned to "listen" (as he himself puts it) to the puppets, and acquired the art of delicately animating them as if they had a life of their own. The three years that he spent training under Trnka were to be a determining factor in his career.

On his return to Japan in 1965, he began to make films for NHK. It was the start of a wonderful corpus of work, which reached its peak

1
Kawamoto Kihachirō, sketch.
© The Kawamoto Productions Ltd.
Photo Tamura Minoru.

2
© The Kawamoto Productions Ltd.
Photo Tamura Minoru.

Shaping the puppet's head using a kind of modeling clay. Its imprint is cast in plaster.

in 2006 with the feature-length puppet animation *Shisha no sho (The Book of the Dead)*. Fig. 42

Epic tales, accounts, or literary works almost always provide the inspiration for Kawamoto Kihachirō's masterful work (only the animated films using dolls and puppets are presented here). His extensive classical education allowed him to tackle any subject.

In the district of Shibuya, a few steps away from Yoyogi station, stands a white house in an oasis of calm and tranquillity, away from prying eyes and the bustle of the capital. On the door, a plaque bears the master's name. His friend Suzuki Shin.ichi, director of the Suginami Animation Museum, was kind enough to accompany me. Kawamoto Kihachirō received us with a smile. His eyes sparkling with intelligence, he exuded great kindness and extreme gentleness. "My studio is downstairs; please come in," he bade us amiably.

Over tea and cakes, as befits Japanese hospitality, the two friends mulled over some shared memories; I could not take my eyes off the master's "children," the five puppets he set down beside us as a sign of welcome. It was fascinating to be able to admire these terrifying-looking warriors or impish-looking princesses at such close quarters. Now it would take only the puppet-master's hands to make each of these famous characters from *The Tale of Heike* come alive.

Head mold for the warrior Kōu (232–202 BCE).

Kawamoto Kihachirō shaped their facial expressions one by one. It was he who implanted their hair, choosing its material, color, and texture. Some faces are articulated at the eyes and mouth. Their skin color also varies according to the character's supposed country of origin. In the garments, nothing is left to chance. All accessories are reproduced down to the tiniest detail. At the other end of the room, behind a long working table where the master had left his tools and a few outlines of dolls' heads, other heads are lined up on wooden rods, ready to come to life beneath his agile fingers, and awaiting only a body before they can join Kawamoto Kihachirō's large family.

Like all artists, Kawamoto Kihachirō is a man who is passionate about his work. Known and recognized internationally, and the winner of numerous awards in Japan and abroad, success has by no means tainted his humility and wisdom.

Performances using puppets, manipulated by experts completely clad in black, as in *bunraku* (to which Kawamoto Kihachirō lays claim), have delighted viewers for several years. And while his wonderful animated films using dolls, remarkable in their realism, were intended for the big screen, they have also been broadcast on TV and are now available on DVD in Japan.

Wet paper is placed in the plaster mold, shaped to take the form of the face, and then removed. The inside of the mold is coated with a blend of paste and strong adhesive, and the face's paper form is placed back inside. By pressing firmly the shape is obtained.

When dry, the paper is removed to give a papier-mâché head similar in form to the original.

6

© The Kawamoto Productions Ltd. Photo Tamura Minoru.

The two parts of the head are assembled. Thin sheets of Japanese paper are placed in layers in order to alter the face's contours; the ears are stuck on and shaped with the heat of an iron.

7

© The Kawamoto Productions Ltd. Photo Tamura Minoru.

The head is separated into two parts again and a hole bored at the site of the eyes and mouth ready for them to be articulated.

8

© The Kawamoto Productions Ltd. Photo Tamura Minoru.

Preparing the parts to be articulated.

9

© The Kawamoto Productions Ltd. Photo Tamura Minoru

Inside view of the parts to be articulated.

10
© The Kawamoto Productions Ltd. Photo Tamura Minoru.

The reconstructed head is covered with a very fine piece of leather.

11
© The Kawamoto Productions Ltd. Photo Tamura Minoru.

The portion linking the various articulation systems is fixed to the body, and a similar fine piece of leather placed on the neck; the head and neck are painted the same color.

12
© The Kawamoto Productions Ltd. Photo Fukusako Fukuyoshi.

Kawamoto Kihachirō in his workshop.

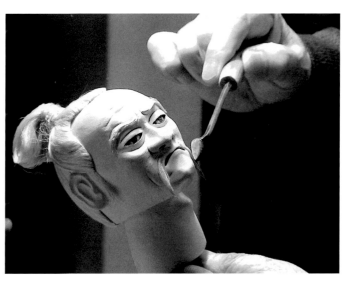

13
© The Kawamoto Productions Ltd. Photo Fukusako Fukuyoshi.

Make-up is applied to the puppet, and the hair, moustache, and eyebrows arranged. The head is finished.

14

© The Kawamoto Productions Ltd. Photo Fukusako Fukuyoshi.

Silicon molds are used to take the imprint of the arms and legs. Heated rubber is poured in and then left to set. Wires are inserted into the fingers on the hands.

15

© The Kawamoto Productions Ltd. Photo Fukusako Fukuyoshi.

A rubber band links the arms and legs to the body of the puppet (or doll).

16

© The Kawamoto Productions Ltd. Photo Fukusako Fukuyoshi.

Fabric covers the movable part of the legs and arms.

17

© The Kawamoto Productions Ltd. Photo Fukusako Fukuyoshi.

The upper part of the body, up to the shoulders, is modeled in papier-mâché. A wire girdle is used to attach the waist and hips to the rest of the body with strips of adhesive cotton.

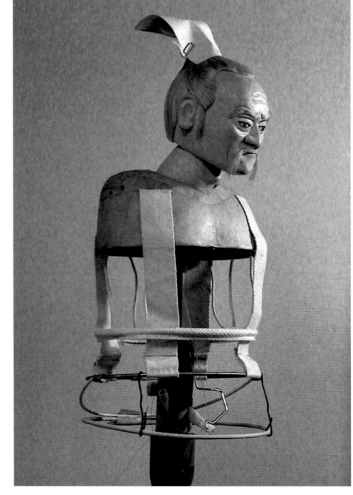

18 *(Top left)*
© **The Kawamoto Productions Ltd.**
Photo Fukusako Fukuyoshi.

The various parts of the body are linked together and the bust covered with cotton.

19 *(Above)*
© **The Kawamoto Productions Ltd.**
Photo Fukusako Fukuyoshi.

The pattern for the costume is traced directly on the puppet.

20 *(Left)*
© **The Kawamoto Productions Ltd.**
Photo Tamura Minoru.

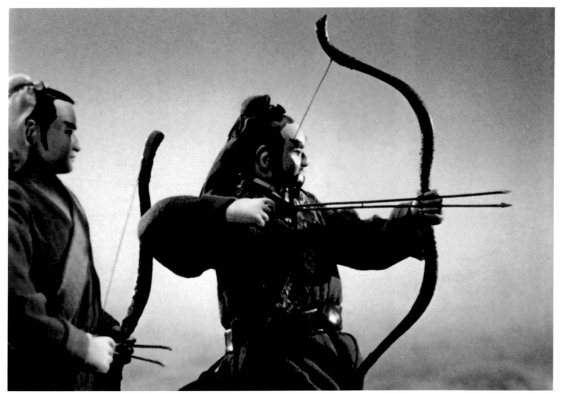

21
Fusha no sha (To Shoot without Shooting),
25 min. film, 1988.
© The Kawamoto
Productions Ltd. Photo
Ch'iao yüan ch'eng.

23 *(Above)*
Heike Monogatari (The Tale of the Heike). Ushiwakamaru on the Way from Kinone to Mount Kurama (Kyoto). © The Kawamoto Productions Ltd. Photo Tamura Minoru.

Written between 1202 and 1221, *Heike Monogatari* originally comprised twelve volumes, but it is its lyrical adaptation *(Heikyoku)* created in 1371 that is considered to be the definitive version. It tells the story of the Taira clan (the "Hei" of "Heike" also refers to the Taira family) that first held supremacy over the Minamoto clan (Genji), before being beaten by Minamoto no Yoritomo. With its numerous battle scenes, this epic tale, tinged with morality and Buddhist piety, is one of the gems among Japanese literary classics.

22 *(Facing page, bottom)*
Sangokushi (Romance of the Three Kingdoms). Ch'ang Fei, Liu Pei, K'uan Yu.
© The Kawamoto Productions Ltd. Photo Tamura Minoru.

Kawamoto Kihachirō designed all of the puppets in this film, which is based on a classic late third-century Chinese work, *Sanguozhi, The Romance of the Three Kingdoms.*

INTERVIEW
WITH KAWAMOTO KIHACHIRŌ

Brigitte Koyama-Richard: I am a great admirer of your work and it is really very exciting for me to be able to admire your puppets at such close quarters. I would like to know where your passion came from.

Kawamoto Kihachirō: It goes back to my early childhood. I remember making *anesama ningyō** paper dolls, just like my grandmother did, followed by rag dolls. In primary school, I even won the ward prize for dolls using modeling clay. I loved to make this kind of object and to go and see traveling theater performances or *kabuki*. I then imitated the acting.

B. K.-R.: How did you choose the literary accounts or stories that you have adapted?

K. K.: I am often asked this question, just as I am often asked why I didn't write any original stories myself. I think that Japan's literary tradition is sufficiently rich in works for this type of theatrical performance or animation. I didn't see the point in creating new ones. Some books are made to be adapted; others aren't.

B. K.-R.: How are you able to achieve such human expressions in your dolls and puppets?

K. K.: I imagine the face that each doll should have according to its role. Sometimes the face turns out differently to what I anticipated and the doll is telling me

that it isn't suitable for that role.
It is virtually impossible to make the same face twice. Each doll is a creation in its own right.

B. K.-R.: For you, what is a doll or a puppet?

K. K.: Originally, in the Far East, it was someone used to convey the words of men to the gods. The doll served as an intermediary when appealing to a divinity. This notion is also found in the *bunraku* theater and in other theatrical forms—in Indonesia, for example. When puppets or dolls are used in theater or animation, I would say that they have a deeper significance than it might appear. We do not use them merely because they are pleasant to look at.

B. K.-R.: What is the basic difference between animated dolls and puppets?

K. K.: First of all, their size. Puppets measure between sixty and seventy centimeters in height (around twenty-four to twenty-eight inches), while dolls measure only between twenty and thirty centimeters (around eight to twelve inches). Puppets are manipulated using rods, while dolls are filmed in stop motion every fraction of a second after the animator adjusts their position. As for the faces, those of puppets are made from paper, while a mold containing a special type of modeling clay from the Czech Republic that is steamed to make it set is used in the case of dolls.

B. K.-R.: The costumes and accessories belonging to your puppets and dolls are wonderful. Is it you who chooses the fabrics and who designs them?

K. K.: I obtain (often antique) silk kimono obi* from all over and store them in large trunks. I design the costumes and my assistants make them. I then get out all kinds of fabrics and select the color and material according to the doll's role and social class. Some of this antique silk is very expensive, but I have never calculated how much it costs to make a doll. Sometimes I make new costumes for dolls that have been on show in an exhibition for a long time and the color is faded.

B. K.-R.: How come the costumes fit so well and follow the doll's movements so precisely?

K. K.: We use fuse wire to support and solidify the doll's body, as well as some parts of the costumes, which allows the fabric to keep the shape or form required during filming.

B. K.-R.: In all of your animated films using dolls, the sets are wonderful and are completely in keeping with the story.

K. K.: One of my artist friends makes the sets; he can paint anything and makes marvelous reproductions of traditional paintings in the yamato-e* style. He uses gold dust unsparingly.

B. K.-R.: In films like Dōjōji [Dōjōji Temple] or Shisha no sho [The Book of the Dead], your dolls literally come to life, running with their hair blowing in the breeze. How do you achieve such perfection?

K. K.: I don't work alone but am surrounded by a whole team of excellent animators. It is a job that requires infinite patience and which can only be done well if you love dolls. Each movement of a kimono sleeve, every hair that moves is deliberate, fixed by fishing line that is invisible on the screen. It takes a week to film a sequence lasting about ten seconds.

B. K.-R.: The result is absolutely magnificent. My last question concerns your work Dōjōji Temple. How did you come upon the idea of using the subject of the famous painted scroll, now in Dōjōji Temple, whose history I will explain here?

K. K.: While studying this work I thought to myself that it would make an excellent subject. My film unfolds exactly like the scroll, from right to left, and the plot follows its story exactly.

B. K.-R.: In the course of my various meetings, I have been able to draw up a wide overview of Japanese animation from its origins to the present, showing how Japanese art and literature of past centuries have inspired many creators, both in terms of the graphics and the content of their offerings. Your work is a vibrant illustration of this. Thank you very much.

After this interview, Kawamoto Kihachirō gave me a privileged tour of his puppet reserve. Each one had a different personality and seemed to be waiting for the magician's hand to bring it to life just long enough for a film or performance. This unforgettable place exuded a surprisingly warm atmosphere, as if each puppet's gaze was turned toward the master in the hope of a sign from him as the cue to reply.

– July 2009 –

24–28

Oni (Demon),* **8 min. film, 1972.**

Kawamoto Kihachirō draws the viewer into a terrifying world. An old and bedridden woman sees both of her sons go off hunting. In a haze of gold dust they walk out in search of prey. The younger boy climbs a tree to spot an animal and suddenly feels his hair being tugged. He calls for help to his elder brother, who shoots an arrow in the direction of what they believe to be a demon. Seized with terror, they realize that the fallen object is an arm oozing with blood. Back at their mother's bedside, they find her with a bleeding arm. The old woman turns into a demon and runs around, holding—in her sole remaining hand—the arm that has been wrenched off. The *Konjaku monogatari (Anthology of Tales from the Past),* a famous collection of over one thousand short stories compiled by Minamoto no Takakuni (1004–1070) and designed to teach morality in line with Buddhist precepts, inspired this film.

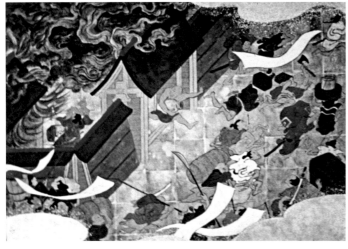

29–32

Rennyo to sono haha (Rennyo and His Mother), 93 min. film, 1981.
© The Kawamoto Productions Ltd. Photo Tamura Minoru.

Taken from Hirai Kiyotaka's eponymous novel published in 1977, this film recounts the moving reunion of the Buddhist priest Rennyo Shōnin (1415–1499) and his mother, from whom he was separated at the age of six. In 1457, Rennyo succeeded his father Zennyo at Kyoto's Hongan-ji Temple. A widower and father of seven children, he married his late wife's younger sister. Contested by the monks of Tendai Monastery, Rennyo took refuge at Mii-dera Temple in Ōmi province. It was there that fate allowed him to see once more the woman who had brought him into the world and who was on the verge of death. Rennyo then went to Yoshizaki and in 1475 rebuilt Hongan-ji close to Kyoto.

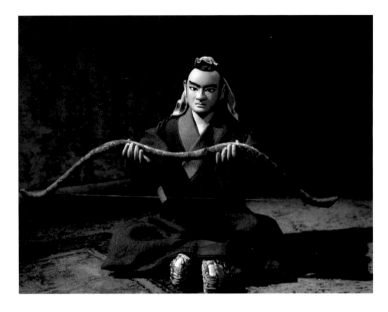

Here Kawamoto Kihachirō takes his inspiration from the book by Nakajima Atsushi (1909–1942), *Meijin den (The Story of a Master of Archery)*. Its Chinese hero, Ji Chang, wants to become the greatest archer of all time. His meeting with a master teaches him the wisdom of not shooting but of merely forming the movement. Ji Chang thereby achieves serenity and eventually forgets even his bow's existence.

37–39
Ibara hime mata wa nemuri hime (Briar Rose or the Sleeping Beauty), 22 min. film, 1990.

This adaptation of a short story published in 1978 orchestrates magnificent dolls, dressed in lavish costumes, against backdrops that are equally remarkable. While the story follows the framework of Charles Perrault's famous tale, it poses questions of love, fantasies, and the meaning of life. Here it is not a wicked fairy but a man, the queen's former lover, who utters the curse. The princess finds the spinning wheel on her fifteenth birthday but does not prick her finger on it. She finds her mother's diary from when she was young; in it she learns that her mother had loved a man before she married and, believing him to be dead, finally married the king. The young girl goes to find this man, asks him to forgive her mother, and offers herself to him. She cannot forget this encounter and rejects all suitors who appear. In the end she gets married and the story finishes with the ironic words, "She must have been happy because the story says so."

40
Self-portrait, 1 min. film, 1988.

This very brief film reveals Kawamoto Kihachirō's sense of humor, as he is shown modeling his portrait, which turns into a demon.

41

Fuyu no hi (Winter Days), **2003. The poet Bashō.**
© **The Kawamoto Productions Ltd. Photo Tamura Minoru.**

Long fascinated by the work of Bashō (1644-1694), Kawamoto Kihachirō initi-
ated an ambitious project, which consisted of bringing together around thirty
illustrious animators from all over the world to create an animated film illus-
trating one of the *renku** of the *Fuyu no hi* anthology written by the famous
Japanese poet and some of his disciples. Kawamoto was inspired to embark upon
this international experience when reading Ogata Tsutomu's book *The World of
Bashō.* The result is quite astonishing and reveals the sensibility of each of these
great names in animation. Kawamoto Kihachirō, for his part, selected the pas-
sage in which the poet Bashō arrives at his disciples' house.

42
Kawamoto Kihachirō, *Shisha no sho (The Book of the Dead)*, 2006. © Sakura Eiga-sha.

A distillation of his many earlier works, *Shisha no sho (The Book of the Dead)* is a feature-length film, produced in 2006 by Kawamoto Kihachirō. He and his team achieved such mastery in giving the characters fluidity of movement that viewers could easily forget that they are dolls. The facial expressions and slightest movements are skillfully studied and, as in his previous films, the decor and costumes are lavish. This work is set around 750, in the Nara period, when Buddhism was introduced in Japan. Iratsume, a noble daughter of the Fujiwara clan, becomes obsessed with this new religion and spends her time copying out *sutras* (prayers), in the hope of understanding Buddha's thinking. On the eve of every solstice, she catches sight of an incandescent, radiant face between the two peaks of Mount Futakami. One evening, just as she has finished the thousandth copy of a *sutra,* the long-awaited face reappears, only to disappear in a torrential downpour. She then runs out in search of this celestial apparition and comes to a temple out of bounds to women. There she learns that the face that has been haunting her by night and day is that of Prince Ōtsu. Executed some decades earlier, his soul roams between the world of the living and that of the beyond. On the day of his execution, the prince had noticed an attractive young girl, Iratsume's ancestor; this is why he now haunts the dreams of her descendant, whose face is like the one he barely glimpsed. Iratsume then sets about making a huge white *kesa* (part of a Buddhist monk's robe) covered in Buddhist symbols. When the souls of the young people come together as one, the prince finds peace at last.

The Dōjōji painted scroll

This work is based on a tale from the Heian period (c. 794–1185), though another version of it can be found in the *Konjaku monogatari (Anthology of Tales from the Past)*. One of the features of this magnificent scroll, now in the Dōjōji Temple (a Buddhist monastery in the Kii province of what is now Wakayama prefecture) is that it contains the characters' conversation, written in calligraphy, between the painted scenes. It dates from the Muromachi period (late fifteenth century).

A young monk on a pilgrimage to Kumano Temple stops at an inn to spend the night. The innkeeper's adopted daughter exchanges a

sidelong glance with the handsome youth and immediately falls in love with him. (There are variants on this story: in the *Konjaku monogatari*, the girl is a young widow and a superior accompanies the monk.) At nightfall she surreptitiously slips into his room and declares her feelings for him. Surprised, he rejects her, explaining that he is on his way to pray at Kumano and cannot infringe the rule he has set himself until he has made his offerings to the temple.

Greatly vexed, the young woman withdraws. The next morning, she makes him promise to return and the monk agrees, thinking he will be rid of her. But he doesn't reckon with the young woman's

43–44
Anonymous, *Dōjōji engi emaki*
(Dōjōji Painted Scroll), n.d.
© Dōjōji.

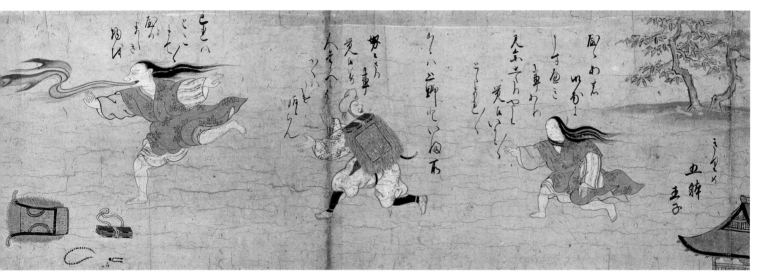

persistence; when he fails to reappear, she runs out to look for him. She has no qualms about brazenly lying to obtain information, accusing the monk of having stolen a valuable box from her. Seeing her state of disarray, passersby readily agree to help her. Soon she catches sight of the young man, goes up to him, and admonishes him. Her terrifying countenance gradually takes on the appearance of a snake.

Filled with dread, the monk lets go of his bag and objects of worship and heads for the river shore, where he beseeches a boatman to ferry him across as swiftly as possible. The woman throws off her clothes to swim across after him. The rest of her body then turns into a giant snake that slices through the waves.

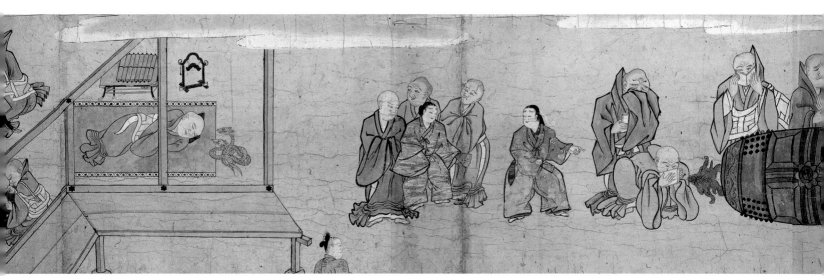

The young monk reaches the vicinity of Dōjōji Temple and asks the priests to protect him from this she-demon. They agree to hide him inside the bell. But the snake arrives, picks up the man's trail and, belching out flames, encircles the bell, before leaving the sacred site forever. The priests rush to throw water on the white-hot bell and weep as they extract the unfortunate monk's charred skeleton. Two snakes—none other than the she-devil and the young monk—come to haunt the dreams of one of the holy men. He decides to write *sutras* and to read them so that these two souls will attain wisdom and be reborn in another form. His wish is granted.

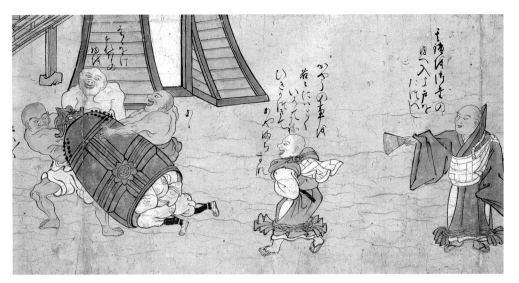

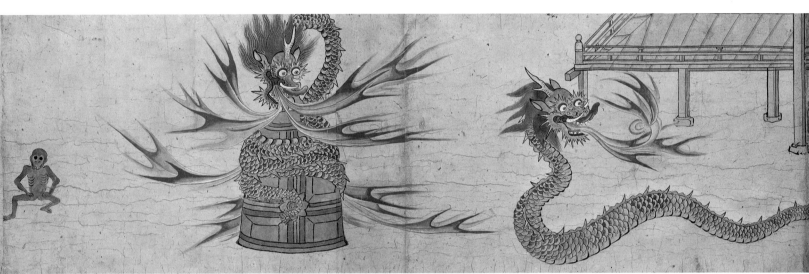

45–46
Anonymous, *Dōjōji engi emaki*
(Dōjōji Painted Scroll), n.d.
© Dōjōji.

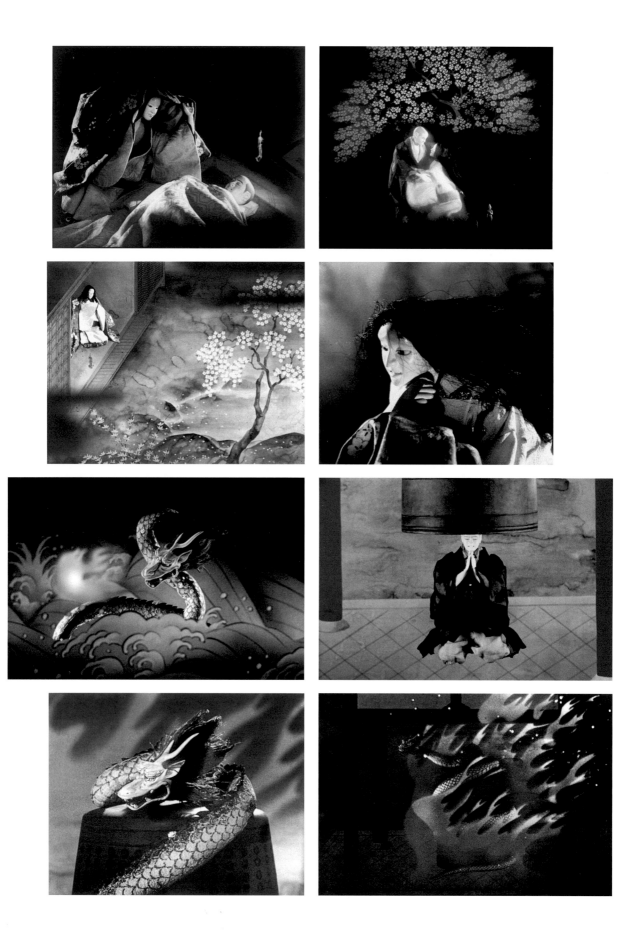

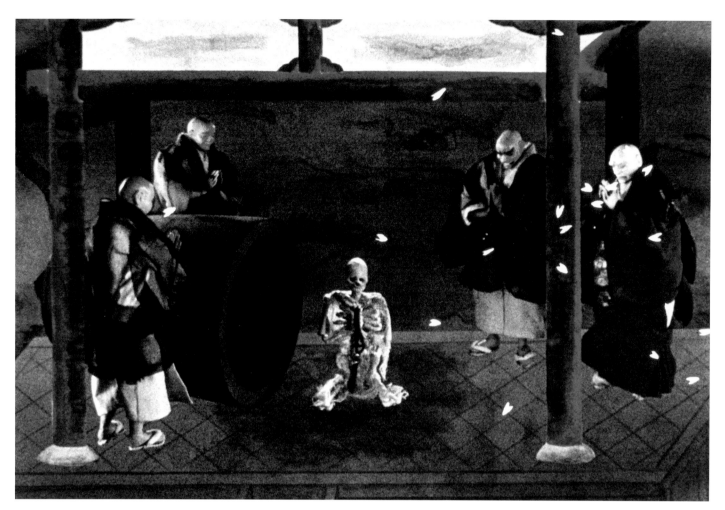

47–55
Kawamoto Kihachirō, *Dōjōji (Dōjōji Temple),*
19 min. film, 1976. © The Kawamoto
Productions Ltd. Photo Tamura Minoru.

This work by the master Kawamoto
Kihachirō is a very faithful reproduction of
the course of events on the famous Dōjōji
painted scroll.

Katō Kunio, *Aru Tabibito no Nikki (The Diary of Tortov Roddle)*, 2003. © ROBOT.

REVIVAL AND CONSECRATION OF JAPANESE ANIME

This story of Japanese animation will end, just as it began, with a mention of painted scrolls, which even today remain an abundant source of inspiration for many artists. From illuminated scrolls, through the search for perspective, movement, and light in *nishiki-e* (brocade prints,) *utsushi-e* magic lanterns, and the first attempts at cartoons, right up to the latest 3-D animations, the desire to bring life to images has made it possible to venture ever further in technical and visual terms.

Based on an original screenplay, or taken from a story, manga, novel, or video game, designed for children or adults, for girls or for boys, focusing on aesthetics or more specifically commercial concerns, Japanese animated films cover an infinite range.

Today Japanese animation is facing an economic crisis that it can and must overcome. The number of fans of Japanese anime continues to grow throughout the world. By maintaining its quality—and, in particular, its originality, namely the graphic and cultural richness at the root of its success—Japanese animation will continue to thrill future generations. Constantly evolving techniques also provide an essential element, and new forays in the field of 3-DCG are reaping

rewards. But one of the main factors in the past, present, and future success of Japanese animation (and what distinguishes it from cartoons made in Europe, the USA, or other Asian countries) is the fact that its creators continue to draw on their nation's cultural history, ever ready to return to their roots.

The new generation:
Katō Kunio, the poet of Japanese animation

Katō Kunio is one of a generation of artists who are trying to give Japanese animation a new lease of life. At a time when Japanese animation is exposed to crisis, and the word "business" crops up in every conversation about it, this talented young animator focuses instead on his love of drawing, the artists who inspired him, and his passion for animation.

Already the winner of prestigious awards throughout the world since his first work in 2001, Katō Kunio received the Oscar for the best short animation feature in 2009 for *Tsumiki no ie (The House of Small* Fig. 3 *Cubes)*. Tinged with precious memories from his childhood, Katō Kunio views the world with the eyes of a poet. His works, which are of great graphic beauty, draw the viewer into a dreamlike and nostalgic universe, sometimes highly whimsical, reflecting his boundless sensibility.

1
Katō Kunio, *The Apple Incident,* 2001.
© Katō Kunio.

INTERVIEW WITH KATŌ KUNIO

Animator at Robot Communications Inc.

Brigitte Koyama-Richard: All my congratulations on the award you received in the United States. Tell me, has it been your vocation since childhood to be an animator?

Katō Kunio: As a child, like all children, I loved to watch cartoons. I belong to the generation who adored the Studio Ghibli films. But I never thought that I would become an animator one day.

B. K.-R.: You liked to draw, didn't you?

K. K.: Yes. I am an only child and had no brother or sister to play with, so I would spend a lot of time drawing. I really had the opportunity to discover animation when I went to Tama Art University.

B. K.-R.: I feel that all of your work—from your first animated film, *The Apple Incident*, to the most recent, *Tsumiki no ie [The House of Small Cubes]*—refers to Western art. Have you enjoyed visiting museums since you were a child?

K. K.: I come from near Kagoshima, in the south of Kyushu island, where there are hardly any museums. It was books in particular that got me interested in painting. Then, as a student, I sometimes went to see exhibitions or to visit galleries.

B. K.-R.: I think that the painting of surrealists like Magritte or Dali inspired you as early as *The Apple Incident.*

K. K.: That's right. I like these artists and their world very much. When I was a junior high school student, I came across a painting by Magritte of a house lit up at night against a blue sky. This completely surrealist image fascinated me and continues to do so today.

B. K.-R.: Your animated films are particularly beautiful in terms of graphics, and above all the atmosphere they convey is quite unique. The dream world you describe leaves an unforgettable impression. The long-legged pig that accompanies the young man in your film *Aru tabibito no nikki [The Diary of Tortov Roddle]* looks to be inspired by one of Salvador Dalí's works.

K. K.: Yes. I love this artist, who I discovered just before going to university. His painting of a molten clock struck me at the time. I deliberately used the world of Dalí as the inspiration for this film.

B. K.-R.: Have you ever lived in the West?

K. K.: No. People often tell me that my drawings are very Western in style. But it is only recently that I have been out of Japan. It's true that the West appeals to me. I discovered Europe on a trip to Annecy where one of my films had been nominated. I loved that city's architecture and beauty.

B. K.-R.: Do you write the screenplays for your works?

K. K.: Yes. Most of the time I start from a drawing that I develop to become a story. The drawing sometimes comes from a dream or a nightmare, as in *The Diary of Tortov Roddle*. My films are generally short as I try to express something in a very brief space of time.

B. K.-R.: Your characters take on very different styles according to the film: they might be spindly, as in *The Diary of Tortov Roddle*, or quite plump, as in *The House of Small Cubes*.

K. K.: Yes, I like to vary the styles. It is very difficult to distort drawings and characters, but I take pains to make many attempts.

B. K.-R.: The butterfly is a recurring element in your work.

K. K.: It has no particular deep meaning, but, for me, conveys a sense of contentment. We may glimpse it by chance, for a fleeting moment, and the cadence of its flight fills us with joy.

B. K.-R.: What gave rise to *The House of Small Cubes*?

K. K.: I worked with Hirata Ken, who is also a scriptwriter for Robot Communications Inc. This film is part of a set entitled *Pieces of Love*. The producer asked us for an animated film to supplement this work, which also includes a ten-minute-long film using actors. I had wanted to make a cartoon about a house. I showed my drawings to Mr. Hirata and explained that I would like my main character to be an old man. The story went from there.

B. K.-R.: You used a great number of drawings in *The House of Small Cubes*?

K. K.: I haven't counted them, but we needed several thousand. I drew them in pencil and we used the computer to add the color. Of course, I had a team with me.

B. K.-R.: This fine story takes the viewer into the characters' pasts and provides a chance for him to think about the meaning of life, death, recollection, and memory.

K. K.: Animation is a way of conveying many kinds of emotion.

B. K.-R.: Dreams always occupy an important place in your work, don't they?

K. K.: Yes, they are a way of expressing sentiments that are usually difficult to convey. The grandfather in the film is also an echo of many personal memories. Dreams and reality are now intermingled in my work. I would also like to adapt short stories in the form of illustrated books and cartoons. I hope to be able to make many more animated films.

B. K.-R.: I look forward to your future offerings.

– July 2009 –

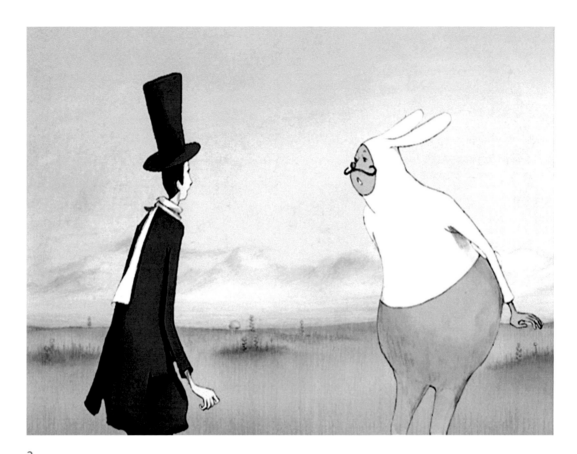

2
Katō Kunio, *Aru Tabibito no Nikki (The Diary of Tortov Roddle): A Red Fruit,* 2004. © ROBOT.

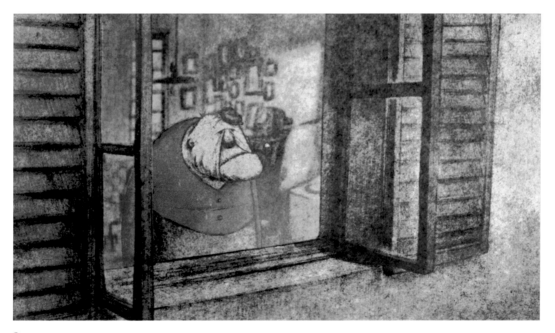

3
Katō Kunio, *Tsumiki no Ie (The House of Small Cubes),* 2008.© ROBOT.

The Suginami Animation Museum, Tokyo

The creation of a museum devoted to the cinema of animation is proof of the strong interest in Japanese animation today. Tokyo's Suginami district brings together many animation studios and production companies, which explains why it was chosen as the site for such a museum. The Animation Museum opened on March 5, 2005 and has since attracted large numbers of Japanese and foreign visitors. Groups of elementary, junior high, and high school students arrive every day, accompanied by their teachers.

The museum offers a highly detailed historical panorama of animation and organizes temporary exhibitions, workshops, and lectures. Not only does the particularly well-stocked book and video library allow the public to learn more about the subject, but it is also a place to relax and discover cartoons, both old and new.

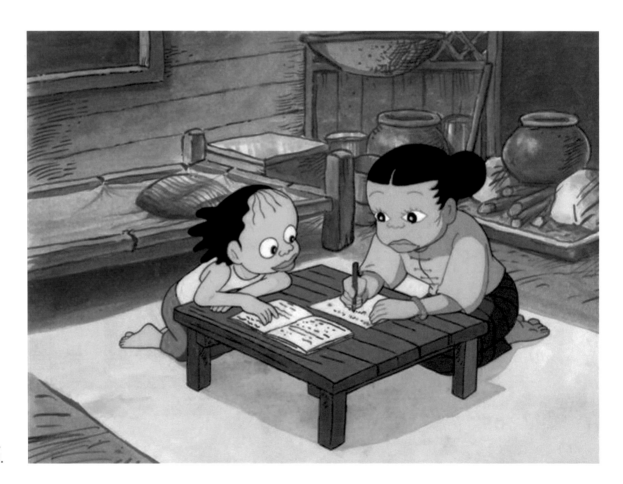

4
Suzuki Shin.ichi,
*Mina no egao
(Mina Smiles)*, n.d.
© Suzuki Shin.ichi.

INTERVIEW WITH SUZUKI SHIN.ICHI

Director of the Suginami Animation Museum

The museum's director, Suzuki Shin.ichi, a former pupil of Yokoyama Ryūichi, has made several anime. He was kind enough to show me around the establishment.

Brigitte Koyama-Richard: I was very interested to read your autobiographical work, *Anime ga sekai o tsunagu (Anime Unite the World)*[1]. It is a fine testimony to your passion.

Suzuki Shin.ichi: I've been very lucky to do this job and to have been surrounded by many friends who have helped me during the course of my career.

B. K.-R.: What made you want to enter this profession?

S. S.: Walt Disney's films. They fascinated me. I also read a lot of manga, like *Nora kuro, Fukuchan, Tanku tankuro*, etc.

B. K.-R.: You mainly read Japanese manga?

S. S.: Yes, because as a child Japanese was the only language I knew. I couldn't read American comics, even if I had heard of Popeye or other characters.

B. K.-R.: You liked to draw?

S. S.: Yes, I loved to copy drawings from manga and I dreamed of doing that professionally one day.

B. K.-R.: Many *mangaka* or producers of animated films had problems in making their parents accept the idea that they could do this for a living.

S. S.: That was never an issue for me. I lived in Manchuria as a child because my father worked there. My studies were fairly chaotic, as were those of many others in my generation. Once back in Japan, I had to make up for lost time. Unfortunately my mother became seriously ill and I had to look after her and the house, which hardly left me enough time to go to junior high school. Then I found a job at a printer's and remained there for four years. After that, I decided to go to Tokyo, where I stayed with a *mangaka* friend who worked for the press.

B. K.-R.: You went on to lodge in what is now the famous Tokiwasō house?

S. S.: Yes. Tezuka Osamu was the first to have rented a room there. After him came many young penniless *mangaka* who lived there in a very warm atmosphere. We shared the kitchen and washrooms. It was a place for singles. We all came from the provinces and helped one another. I then worked with the famous *mangaka* Yokoyama Ryūichi, lodging at his house. He had a large family and I loved the atmosphere of his home. We weren't pressed for time then in the way that *mangaka* are today. Mr. Yokohama knew how to take time out to enjoy himself and I have excellent memories of the months I spent in his employ.

Then my friends Fujiko Fujio and Ishinomori Shōtarō invited me to join them in the creation of Studio Zero. Tezuka Osamu had also offered me a very interesting proposition during that same period. But I opted for the former offer and we founded an animation studio that worked well for four or five years. Eventually my friends became so busy and famous that they no longer had time to deal with the studio. I decided to continue despite everything, and produced many animated advertising features there for big names such as Sony, National, and Hitachi.

B. K.-R.: Did Tezuka Osamu play a part in your life?

S. S.: Tezuka Osamu was the "god of manga" for all of us. He was very important for me both professionally and personally. I was lucky enough to go abroad with him on four occasions and it was wonderful.

B. K.-R.: You also work for the Asian Cultural Center for UNESCO (ACCU), don't you?

S. S.: Yes. Since 1993 I have made three animated films about environmental issues, which were produced in Malaysia and Thailand. The workforce is much cheaper there, but techniques have yet to reach Japanese levels. But it was a very enriching experience.

B. K.-R.: You also participated in Kawamoto Kihachirō's wonderful initiative *Fuyu no hi [Winter Days]*, in which great masters of animation from around the world each provided their own interpretation of one of Matsuo *Bashō's renku*?

S. S.: Yes. That was in 2003, and this unique experience produced a surprising result. Up to then, no one had ever dared attempt such an experiment; it took someone like my friend Kawamoto Kihachirō, who is so well versed in poetry, to think of it.

B. K.-R.: Nowadays, given the popularity of Japanese anime in the West, many Japanese animation studios are producing films designed to appeal to Western audiences. Don't you think that there is a risk that these examples of Japanese animation might lose their identity and whatever constitutes their charm?

S. S.: I share your opinion. The risk surely does exist. In the past I went to the USA with Tezuka Osamu. There was an incredible number of fans there. The Japanese were very surprised at first to see just how popular their films were in the West. They admired Walt Disney's films or those by other European directors very much, but had never imagined that Japanese anime would go down so well with Western, followed by Asian, audiences. With the help of publishing company editors, they then took pains to improve the quality of their work at manga level and to make them into excellent animated pictures.

B. K.-R.: What are your current projects?

S. S.: I want this museum to become as well known as possible to enable a wide audience to become acquainted with the techniques of animation. Every year, with a group of amateurs of all ages—the youngest are less than ten years old and the oldest are retired—we make a little animated film that we then sell in the museum in DVD form for a very modest sum. I hope that this might help some people to discover their vocation. I also want to continue making animated films with other professionals, simply for my own entertainment and to bring joy to others.

B. K.-R.: I have seen one of these films and I am convinced that you have achieved your aim. It is quite remarkable. It is clear that this museum will enjoy a growing success and spawn great names in animation. With your permission, I would like to quote an extract from your book's conclusion. I feel that it is the perfect expression of your sense of friendship and your love of this profession. You write that you have been able to tread the path of animation thanks to your masters and your friends. "I have not become wealthy, but my wealth has been the opportunity to meet all of those famous people I dreamed of knowing as a child, and to make the acquaintance of the talented friends who have become like brothers to me.... When I lived in Tokiwasō, I went from manga to animation, and did so with my friends, whose presence was invaluable. Together we lived through Japan's great transitional period; deep down we had the feeling of being bound together.... Today, with things like television, computers, or cell phones making life easier, human relations seem to be shallower. Some might envy the time we shared at Tokiwasō, but I am convinced that we can all find our own Tokiwasō."[1]

In March 2009 a commemorative monument was inaugurated in a park not far from the site of the Tokiwasō house. It represents the building as it was, and celebrates its main occupants.

– June 2009 –

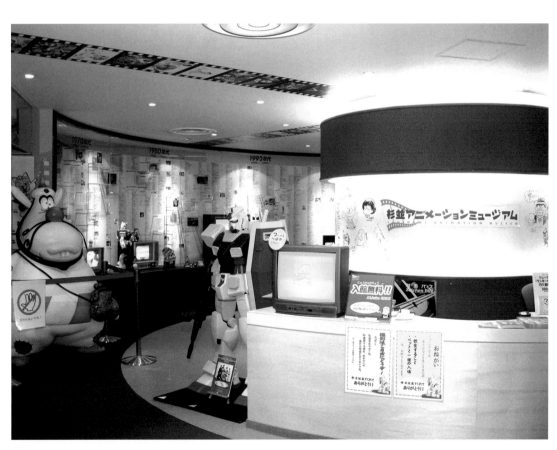

5
Entrance to the Suginami Animation Museum, Tokyo.

NOTES

ANIMATION'S LONG JOURNEY THROUGH TIME

1. Oka Yasumasa, a curator of this museum and the author of scholarly scientific works including *Megane-e shinkō, ukiyo-eshi tachi ga nozoita seiyō* (A New Approach to Stereoscopic Prints, or How the Ukiyo-e Masters Discovered the West through a Lens), very kindly shared with me his passion for these precious prints and optical viewing boxes.

2. A large number of *tane-ita* plates from *utsushi-e* shows were on display at the fine exhibition devoted to the Irie collection of optical games at the Hyōgo Prefectural Museum of History in July 2008. Through the kind cooperation of its curator, Mr. Kagawa Masanobu, we are able to reproduce some of them here, along with other works.

3. "Magic Lanterns: the deceptive art of transparency", in *Lumière, transparence, opacité, acte 2 du Nouveau Musée National de Monaco*, pp. 55–56; our translation.

4. Proust, Marcel. *Swann's Way*, Vintage International, 1989, trans. C. K. Scott Moncrieff, pp. 9–10.

PRE-CINEMA
AND GREAT INVENTIONS

1. Baudelaire, Charles, *A Philosophy of Toys* in *The Painter of Modern Life and Other Essays*, Phaidon Press, 1995, pp. 202–03

THE BIG PRODUCTION COMPANIES

1. *Tezuka Osamu manga zenshū, Tezuka Osamu Essei shū [The Complete Manga of Tezuka Osamu, Collected Essays of Tezuka Osamu].* Tokyo: Kōdansha, 2008 [pp. 181–82; our translation.]

2. In the 1950s, commercial lending libraries offered manga for a modest sum. Many mangaka made a name for themselves through these works, specially designed for loan, which young people would go and borrow after school. The color quality often left much to be desired, but the words and drawings were enthralling. Japanese people often look back on this period with nostalgia.

3. *Tezuka Osamu manga zenshū, Tezuka Osamu Essei shū [The Complete Manga of Tezuka Osamu, Collected Essays of Tezuka Osamu].* Tokyo: Kōdansha, 2008, p. 185.

4. *Ibid.*, p. 186.

5. *Ibid.*

6. *Garasu no chikyū o sukue, nijūisseki no kimitachi e [Save our Glass Planet, You Twenty-First-Century Folk].* Tokyo: Kobunsha, 2008, pp. 14–15.

7. *Ibid.*, pp. 27–29.

8. *Tezuka Osamu manga zenshū, Tezuka Osamu Kōen shū [The Complete Manga of Tezuka Osamu, Collected Lectures of Tezuka Osamu].* Tokyo: Kōdansha, 2008, p. 83.

9. *Tezuka Osamu manga zenshū, Tezuka Osamu Essei shū [The Complete Manga of Tezuka Osamu, Collected Essays of Tezuka Osamu].* Tokyo: Kōdansha, 2008, p. 192.

10. *Tezuka Osamu Gekijō [The Animation Filmography of Tezuka Osamu].* Tokyo: Tezuka Productions, 1997, p. 11.

11. A reminder of the definitions of the words "androids," "robots," and "cyborgs," which appear in many works. Robots (a term derived from "robota," meaning "work" in Czech and invented by Czech writer Karel Čapek in his play, RUR, in 1921 to refer to artificial workers) have artificial intelligence and an appearance often quite unlike that of human beings. Androids are robots with a human appearance and may share their intelligence, but there is nothing organic about them. The term "cyborg" is English in origin, a contraction of "cybernetic organism." Manfred E. Clynes and Nathan S. Kline coined it in 1960 to refer to a human being whose physical and intellectual capacities have been enhanced by electronic implants and who would be able to live on other planets.

12. Miyamoto Musashi (1584?-1645) was a renowned warrior and *suiboku* (ink and wash painting) artist. After the Battle of Sekigahara (1600), he was forced to become a *rōnin** for having fought the shogun. He then became a master of arms and invented the twin sword technique, becoming the most famous swordsman in Japan. He later went on to serve the Tokugawa shogun. His book *Gōrin no sho* (*The Book of Five Rings*) has been translated into many languages. His myriad feats have been the subject of novels and *kabuki* plays.

THE EMPIRE OF MANGA AND ANIMATION:
THE ROLE OF THE BIG PUBLISHERS

1. Created in 1968, this magazine has published works as famous as *Dragon Ball Z, Kinnikuman (Muscleman),* and *Slam Dunk.*

REVIVAL AND CONSECRATION
OF JAPANESE ANIME

1. *Anime ga sekai o tsunagu (Anime Unite the World),* Iwanami Junia shinsho, 2008 [pp. 203–04; our translation.]

GLOSSARY

Anesama ningyō: doll made from Japanese paper.

Animator: artist who uses a series of sketches to create movement.

Anime: Japanese animated cartoons.

Bansho Shirabesho: Western scientific institute founded in 1855.

Benshi: narrator who provided the commentary for a silent film.

Biwa: stringed musical instrument similar to a lute.

Bunraku: performance using large puppets manipulated by operators all dressed in black, which emerged in the seventeenth century. It took the name "Bunraku" in the nineteenth century.

Celluloids (cels): sheets of transparent cellulose. Drawings are outlined using a pen on the celluloids and color is then applied by hand on the reverse side of each cel using acrylic paint (a technique known as *"gouachage"*).

CG (Computer Graphics): computer-generated drawings or graphics.

Chiyogami: traditional Japanese paper decorated with various colorful motifs.

Cosplay or costume playing: a trend born in the United States (where it was very much in vogue in the 1980s), which entails dressing up as a manga, anime, or video game character. Many cosplay contests are now organized throughout the world.

Daimyō: overlord or governor of a province.

Edo: today's Tokyo. It was the capital of the Tokugawa from 1603 to 1867.

Emaki or *emakimono*: scroll paintings.

Fukinuki yatai: "blown-off roof"; a pictorial style of the *yamato-e** school, in which houses are represented without roofs, in a bird's-eye view that reveals the interior.

Full animation: animation technique that uses twenty-four drawings per second to produce a high-quality image; the drawings are meticulously detailed and the movements very fluid and realistic. In the USA, many of Walt Disney's cartoons are examples of full animation. In Japan, Tōei uses this method in its anime for the big screen.

Furo: Literally "bathtub"; wooden Japanese magic lantern.

Gekiga: type of manga that were published after the war, rooted in reality and social problems.

Giga: humorous drawings.

Kabuki: popular dramatic art that developed in Japan around the late seventeenth century.

Kage-e: "*ombres chinoises*" or shadowgraphs.

Kage ninge: shadow puppets.

Kaggikko: "latchkey child"; a term coined in the 1970s to refer to children who found themselves home alone after school as both of their parents were out at work.

Kami shibai: "paper theater"; street theater in which, for a few coins, a narrator would tell children a story using pictures and then reward their attention with some sweetmeats.

Kana: Japanese syllabary.

Kappa: mythical figure from Japanese folklore that lives in water. The size of a three- or four-year-old child, it has a human body and a tortoise's head, with short tufty hair like a crown. Although benevolent toward humans, it can play tricks on them.

Karakuri ningyō: mechanized doll or automaton.

Kashibon: book for loan.

Kawaii: cute.

Kibyōshi: Edo period chapbooks with a yellow cover.

Koto: stringed musical instrument similar to the zither.

Kuruma ningyō: traditional puppet theater, similar to the *bunraku*.

Kyōgen: type of satirical farce.

Limited animation: animation technique that uses eight to twelve images per second to produce a more stylized and less realistic image than in full animation*, with less detailed drawings and more jerky movements. One of the main advantages of limited animation is that it cuts production costs. In Japan, Tezuka Osamu was one of the first to use this technique in his televised anime, *Astro Boy* (1963–66).

Manga: term used for the first time by Katsushika Hokusai to designate a "collection of drawings for learning to paint." In the beginning, then, the word was synonymous with neither caricature nor comic strip. The meaning the term has today dates only from the twentieth century.

Mangaka: person who draws manga.

Mecha design or mechanical design: graphic charter for robots or technological items.

Media mix: optimized combination of various media for use in a marketing campaign. Since the 1970s this franchise method has been applied to Japanese manga and anime through the creation of tie-in merchandise including toys, video games, and film soundtracks.

Nara ehon: luxury illuminated book that reached its zenith during the Edo period.

Nihonga: "Japanese painting"; this style of painting, developed in the Meiji period, combined techniques or motifs specific to Western-style art with Japanese pictorial traditions, in particular the use of natural or mineral pigments on Japanese paper or silk.

Ninja: man specially trained in espionage and assassination.

Nishiki-e: polychrome, so-called "brocade" prints.

Nishiki kage-e: "images of shadow and brocade"; name given to *utsushi-e* magic lanterns in the Kansai region.

Noh: traditional form of theater with masked actors and complex symbolic body movements.

Nozoki karakuri: images in perspective that are observed through an optical box.

OVA (Original Video Animation): production of animated films in various formats (short, medium featurette, or full-length feature) made especially for video release. In Japan, sales of OVA (the first of which was Ishii Mamoru's *Dallos* in 1983) evolved directly alongside those of video recorders and accounted for a large market share before progressively tailing off.

Obake: phantom, ghost.

Obi: wide fabric sash for kimono.

Oni: name given to the various demons of Japanese folklore, complete with horns, protruding eyes, and red faces.

Ponchi-e: word derived from "Punch," meaning caricatures.

Rakugo: a kind of cabaret artist's one-man-show.

Rangaku: "Dutch studies"; the term refers to all the sciences and technologies that came from the West.

Renku: poem composed by several poets, each of whom adds verses of seventeen syllables (5-7-5) and fourteen syllables (7-7).

Rōnin: a samurai without a master.

Ryōgoku: one of the most famous bridges in Edo over the River Sumida, the site of splendid firework displays often represented in prints.

Samurai: a warrior attached to a feudal lord.

Sankin-kōtai: alternate service imposed by the Tokugawa government that obliged feudal nobles to reside in the city of Edo for months at a time.

Saya-e: "scabbard prints"; a print whose reflection is viewed in the lacquered sheath of a sword (anamorphosis).

Shakuhachi: a kind of straight bamboo flute.

Shamisen: stringed musical instrument similar to a lute.

Shogun: military governor.

Storyboard: pencil drawings that allow the director to visualize the film before the shooting.

Sutra: sacred Buddhist text.

Tane-ita: glass plate in a wooden frame containing painted images.

Tanuki: protean animal, a kind of raccoon dog, a member of the Japanese folklore bestiary.

Tokugawa: the surname of the shogun that seized power in 1603, keeping it until 1867.

Uchiwa-e: Fan-painting.

Ukiyo-e: paintings and prints of the "Floating World."

Utsushi-e: Japanese magic lantern performance.

Yamato-e: a style of painting that developed in the Heian period, recognizable by its bright colors and usually overhead viewpoint in particular.

Yōga: "Western-style" painting, using the mediums and pigments of Western painters.

Yōkai: supernatural being able to assume various forms.

Waka: classical poem made up of thirty-one syllables.

Timeline

PREHISTORY	TO 538 C.E.
538–710	Asuka period
710–94	Nara period
794–1185	Heian period
1185–1333	Kamakura period
1333–1573	Muromachi period
1573–1603	Momoyama period
1603–1868	Edo period
1868–1912	Meiji era
1912–26	Taishō era
1926–89	Shōwa era
1989–present	Heisei era

SELECTED BIBLIOGRAPHY

WORKS IN ENGLISH OR FRENCH

Baltrusaitis, Jurgis. *Le Moyen Âge fantastique, antiquités et exotisme dans l'art gothique.* Paris: Flammarion, 1981, 1993.

Baltrusaitis, Jurgis. *Aberrations. Les perspectives dépravées I.* Paris: Flammarion, "Champs," 1995.

Baltrusaitis, Jurgis. *Anamorphoses. Les perspectives dépravées II.* Paris: Flammarion, "Champs," 1996.

Barrès, Patrick. *Le Cinéma d'animation, un cinéma d'expériences plastiques.* Paris: L'Harmattan, 2007.

Baudelaire, Charles. "A Philosophy of Toys" in *The Painter of Modern Life and Other Essays,* trans. and ed. Jonathan Mayne. London: Phaidon Press, "Arts and Letters," 1995.

Boothroyd, Ninette and Muriel Détrie. *Le Voyage en Chine. Anthologie des voyageurs occidentaux du Moyen Âge à la chute de l'empire chinois.* Paris: Robert Laffont, "Bouquins," 1992.

Brown, Steven T., ed. *Cinema Anime, Critical Engagements with Japanese Animation.* New York: Palgrave Macmillan, 2006, 2008.

Clement, Jonathan and Helen McCarthy. *The Anime Encyclopedia Revised & Expanded Edition. A Guide to Japanese Animation since 1917.* Berkeley, CA: Stone Bridge Press, 2006.

Comentale, Christophe. *Les Estampes chinoises. Invention d'une image.* Paris: Éditions Alternatives, 2003.

Denis, Sébastien. *Le Cinéma d'animation.* Paris: Armand Colin, "Cinéma," 2007.

Foster, Michael Dylan. *Pandemonium and Parade, Japanese Monsters and the Culture of Yōkai.* London: University of California Press, 2009.

Gipouloux, François. *La Méditerranée asiatique. Villes portuaires et réseaux de marchands en Chine, au Japon et en Asie du Sud-Est, XVIᵉ-XXIᵉ siècle.* Paris: CNRS Éditions, 2009.

Iwerks, Leslie and John Kenworthy. *Ub Iwerks et l'homme créa la souris.* Paris: Bazaar & Co, 2008.

Jackson, Anna and Amin Jaffer. *Encounters: The Meeting of Asia and Europe.* London: V&A Publications, The Board of Trustees of The Victoria and Albert Museum (London), collective work, 2004.

Koyama-Richard, Brigitte. *Japon rêvé. Edmond de Goncourt et Hayashi Tadamasa.* Paris: Hermann, 2001.

Koyama-Richard, Brigitte. *La magie des estampes japonaises.* Paris: Hermann, 2003.

Koyama-Richard, Brigitte. *Kodome-e.* Paris: Hermann, 2004.

Koyama-Richard, Brigitte. *One Thousand Years of Manga.* Paris: Flammarion, 2008.

Mannoni, Laurent. *The Great Art of Light and Shadow: Archaeology of the Cinema,* trans. R. Crangle. Exeter: University of Exeter Press, 2000.

Napier, Susan J. *Anime from Akira to Howl's Moving Castle, Experiencing Contemporary Japanese Animation.* Reprint, New York: Palgrave Macmillan, 2005.

Napier, Susan J. *From Impressionism to Anime, Japan as Fantasy and Fan Cult in the Mind of the West.* New York: Palgrave Macmillan, 2007.

Oka, Isaburo. *Hiroshige, Japan's Great Landscape Artist.* Tokyo: Kōdansha International, 2003.

Pirazzoli-T'Serstevens, Michèle. *Giuseppe Castiglione, 1688–1766, peintre et architecte à la cour de Chine.* Paris: Thalia Édition, 2007.

Émile Reynaud, peintre de films 1844–1918. Paris: Cinémathèque française, "Les Maîtres du cinéma," 1945.

Screech, Timon. *The Lens Within the Heart. The Western Scientific Gaze and Popular Imagery in Later Edo Japan,* (1st ed.). Honolulu: University of Hawaii Press, 1996.

Screech, Timon. *The Shogun's Painted Culture, Fear and Creativity in the Japanese States 1760–1829.* London: Reaktion Books, 2000.

Wood, Gaby. *Le Rêve de l'homme-machine, de l'automate à l'androïde.* Paris: Autrement, "Passions complices," 2005.

EXHIBITION CATALOGS AND PERIODICALS
IN ENGLISH OR FRENCH

Animeland, le petit monde de la japanim et du manga, a special issue, no. 5, June 2003.

Aux sources: animation japonaise des années 20 aux années 50 (exh. cat.). Maison de la culture du Japon à Paris, 2002.

Cinémaction no. 51, *Le cinéma d'animation.* Vimenet, Pascal and Michel Roudévitch, eds. France: Corlet-Télérama, 1989.

Cinémaction no. 123, *CinémAnimationS,* a special edition on animation. Flocquet, Pierre, ed. France: Corlet Charles Publications, March 2007.

1895, revue of the Association française de recherche sur l'histoire du cinéma, special issue (chronology with comments by Vincent Pinel), December 1992.

Girveau, Bruno et al., *Il était une fois Walt Disney. Aux sources de l'art des studios Disney* (exh. cat.). Paris: RMN, 2006.

Images lumineuses. Tableaux sur verre pour lanternes magiques et vues sur papier pour appareils de projection. Inventaire des collections du Musée national de l'Éducation, vol. 1. Sentilhes, Armelle and Annie Renonciat, eds. Mont-Saint-Aignan and Rouen: Institut national de recherche pédagogique, Musée national de l'Éducation, 1995.

Japan Envisions the West, 16th–19th Century Japanese Art from Kobe City Museum (exh. cat.). Shirahara, Yukiko, ed. Seattle, WA: The Seattle Art Museum, 2007.

Lumière, transparence, opacité. Acte 2 du Nouveau Musée national de Monaco (exh. cat.). Bouhours, Jean-Michel, ed. Skira, Nouveau Musée National de Monaco, 2006.

Osamu Tezuka : dissection d'un mythe. Articles, chroniques, entretiens et mangas. Brient, Hervé, ed. Versailles: Éditions H, "10,000 Images," January 2009.

Passion du cinéma, collections de la Cinémathèque française, Beaux-Arts Magazine, special issue. Cinémathèque française collections, November 2006.

Voir/savoir, la pédagogie par l'image au temps de l'imprimé du XVIe au XXe siècle (exh. cat.). Lyon: Institut national de recherche pédagogique, n. d.

Weston, Helen. *Girodet et les lanternes magiques. Les Cahiers Girodet.* Montargis: Musée Girodet, November, 2006.

WORKS IN JAPANESE

Akita, Takahiro. *Koma kara firumu e Manga to mangaeiga (From Panel to Film, Manga and Manga Films).* Tokyo: NTT Shuppan, 2005.

Chiba, Yukiko, ed. *Chiba Tetsuya ochibo hiroishū "Tetchin" (Chiba Tetsuya. Collection of as yet unpublished stories).* Kuriēto: Kōdansha Komikku, 2009.

Enomoto, Noriko. *Utagawa Hiroshige.* Tokyo: Nihon No Rekishi Jinbutsu Shiri-Zu, Popula-Sha, 2004.

Fuyu no Hi (Official Book). Tokyo: *Esquire* Magazine Japan Co, 2003.

Hyōgo Prefectural Museum of History, ed. *Ima mukashi omocha daihakurankai (Large Exhibition of Toys from Today and Yesteryear).* Tokyo: Kawade Shobō Shinsha, 2004.

Ikeda, Hiroaki. *Tezuka Osamu Kanzen kaitaishinsho. The King O.T. (Dissecting the Work of Tezuka Osamu. The King O.T.).* Tokyo: Shūeisha, 2002.

Ikite iru Hīrō tachi Tōei TV no 30 nen (Living Heroes. Thirty Years of Tōei TV Programs). Tokyo: Kōdansha Hit Books 16, 1989.

Imamura, Taihei. *Manga eiga ron (Essay on Japanese Manga Films).* Tokyo: Studio Ghibli, 1965 (1st ed.), 2005.

Inoue, Shin.ichirō, ed. *Metropolis the Movie Memoir.* Tokyo: Kadokawa Shoten, 2001.

Ishiko, Jun. *Tezuka Osamu, mirai kara no shisha (Tezuka Osamu, the Messenger of the Future).* Tokyo: Dōshin-Sha, Four Bunko B200, 1998.

Ishiko, Jun. *Tezuka Osamu shōnen manga no sekai (Tezuka Osamu: the World of Manga for Boys),* Part 2. Tokyo: Dōshin-Sha Four Bunko B230, 2000.

Ishiko, Jun. *Tezuka Osamu shōjo manga no sekai (Tezuka Osamu: the World of Manga for Girls),* Part 3. Tokyo: Dōshin-Sha Four Bunko B247, 2002.

Iwamoto, Kenji. *Gentō no seiki eiga zen.ya no shikaku bunka shi (Centuries of Magic Lantern in Japan).* Tokyo: Shinwasha, 2002.

Kabat, Adam. *Edo bakemono zōshi (Illustrated Books from the Edo Period on Ghosts)*. Tokyo: Shogakukan, 1999.

Kajiyama, Sumiko. *Zassō damashi Ishikawa Mitsuhisa anime business o kaeta otoko (Spirit Weed. Ishikawa Mitsuhisa, the Man Who Changed the Business of Animation)*. Tokyo: Nikkei BP Shuppan Centā, 2006.

Karasawa, Fukutarō. *Meiji hyakunen no jidō shi (A Hundred Years of Children's Lives: Meiji Period)*, vol. 2. Tokyo: Kōdansha, 1968.

Katō, Akiko. *Nihon no ningyōgeki 1867–2007 (Puppet Theater in Japan, 1867–2007)*. Tokyo: Hōsei Daigaku Shuppan Kyoku, 2007.

Kawamoto, Kihachirō. *Animation & Puppet Master*. Kadokawa Shoten, New Type Illustrated Collection, 1994.

Kinoshita, Naoyuki. *Bijutsu to yū misemono (The Art of Entertaining Performances in the Edo Period)*. Tokyo: Chikuma Shobō, 1999.

Kishi, Fumikazu. *Enkinhō ukiyoe no shiten (Perspective in Japanese Prints)*. Tokyo: Keiso Shobō, 1994.

Komatsu, Kazahiko. *Hyakki yagyō no nazo (The Enigma of the Night Parade of One Hundred Demons)*. Tokyo: Shūeisha Shinsho Visual Ban, 2008.

Murase, Manabu. *Miyazaki Hayao no fukami e (Miyazaki Hayao. Toward a Deeper Understanding of His Work)*. Tokyo: Heibonsha, Heibonsha Shinsho 243, 2004.

Mushakōji, Minoru. *Emakimono no rekishi (A History of Illuminated Scrolls)*. Tokyo: Yoshikawa Kobunkan, 1990.

Nakajima, Tamotsu, ed. *Shashin kaiga shūsei, Nihon no kodomotachi, kingendai o ikiru, 1. Meiji kara Taishō Shōwa e (Collection of Photographs and Paintings: Japanese Children of Today and Yesteryear, vol. 1: From Meiji to Taishō and Shōwa)*. Tokyo: Nihon Tosho Centā, 1996.

Nihon emaki taisei (Japanese Illuminated Scrolls: Collected Main Works), vol. 13. Tokyo: Chūōkōron-Sha, 1982.

Nihon mangaka kanshū 500, 1945–1992. Tokyo: Henshū Iinkai Hen, 1992.

Nihon no emaki (Japanese Illuminated Scrolls), vol. 24. Tokyo: Chūōkōron-Sha, 1992.

Oguro, Yūichirō. *Anime Professional no shigoto, kono hito ni hanashi o kikitai, 1998–2001 (Animation Work by a Professional. I Want to Hear What This Person Has to Say, 1998–2001)*. Animestyle Archive, 2006.

Oguro, Yūichirō. *Anime Style Archive, Summer Wars E-konte*, Hosoda Mamoru. Tokyo: Style, 2009.

Oka, Yasumasa. *Megane-e shinkō, Ukiyo-eshi tachi ga nozoita seiyō (A New Approach to Stereoscopic Prints, or, How the Ukiyo-e Masters Discovered the West Through a Lens)*. Tokyo: Chikuma Shobō, 1992.

Okada, Emiko. *Disney, Tezuka kara Ghibli, Pixar e, rekishi o tsukutta anime kyarakuta-tachi (Anime Characters That Have Marked History, from Disney and Tezuka to Ghibli and Pixar)*. Tokyo: Kinema, 2006.

Okitsu, Kaname. *Edo shōbai ōrai (Traveling Merchants in the Edo Period)*. Tokyo: Purezidento-Sha, 1993.

Okitsu, Kaname. *Edo goraku shi (History of Entertainment in the Edo Period)*. Tokyo: Kōdansha Gakujutsu Bunko no. 1722, 2005.

Ōmori, Yasuhiro. *Shinka suru Eizō, kage-e kara maruchi media e no Minzoku gaku (Ethnological Study of the Evolution of the Image: from Shadowgraphs to Multimedia Images)*. Osaka: Senri Bunka Zaidan, 2007.

Oshii, Mamoru. *Anime wa ikani yume o miru ka, Sky Crowler seisaku genba kara (How Animation Makes Us Dream. "Sky Crawlers": the Anime Seen by Its Creators)*. Tokyo: Iwanami Shoten, 2008.

Ōshita, Eiji. *Japanese Hero wa sekai o seisu (Japanese Heroes Rule the World)*. Tokyo: Kadokawa Shoten, 1995.

Ōshita, Eiji. *Tezuka Osamu, Roman dai uchū (Tezuka Osamu, Novel: the Great Universe)*, 2 vols. Tokyo: Shio Shuppansha, 1995.

Sakakibara, Satoru. *Sugu wakaru Emaki no mikata (Understanding Illuminated Scrolls Easily)*. Tokyo: Tokyo Bijutsu Inc., 2004.

Suzuki, Kazuyoshi, ed. *Mite tanoshimu Edo no tekunoroji (Enjoy Watching: Edo Period Technology)*. Tokyo: Sūken Shuppan, Chart Books, 2006.

Suzuki, Shin.ichi. *Anime ga sekai o tsunagu (Anime Unite the World)*. Tokyo: Iwanami Junior Shinsho, 2008.

Suzuki, Toshio. *Shigoto dōraku Studio Ghibli no genba (Entertaining Work: Studio Ghibli)*. Tokyo: Iwanami Shinsho 1143, Iwanami Shoten, 2008.

Takahata, Isao. *Animation Manga eiga no kokorozashi. "Yabunirami no bōkun" to "O to Tori" (Essay on Animation Manga. "The Shepherdess and the Chimney Sweep" and "The King and the Bird")*. Tokyo: Iwanami, 2007.

Takahata, Isao. *Jūni seiki no anime-shon, kokuhō emakimono ni miru eigateki animeteki naru mono (Evocations of Cinema and Animated Films in Twelfth-Century Painted Scrolls Listed as "National Treasures")*. Tokyo: Studios Ghibli Company, Tokuma Shoten, 1999.

Takita, Seiichirō. *Biggu komikku sōkan monogatari namazu no ichi (Description of the Creation of the Magazine Big Comic as per the Catfish)*. Tokyo: Purejidento Sha, 2008.

Tanaka, Takako et al. *Hyakki yagyō emaki o yomu (Understanding Painted Scrolls of The Night Parade of One Hundred Demons)*. Tokyo: Kawade Shobō Shinsha, Fukurō No Hon, 1999.

Tatsukawa, Shōji et al. *Zusetsu Karakuri Asobi no Hyakka (Fun Visual Encyclopedia of Automata)*. Kawade Shobō Shinsha, Fukurō No Hon, 2002.

Tezuka, Osamu. *Tezuka Osamu manga zenshū*, no. 44, *Metropolis (The Complete Manga of Tezuka Osamu, no. 44)*. Tokyo: Kōdansha, 1979 (1st ed.), 2008 (16th repr.).

Tezuka, Osamu. *Garasu no chikyū o sukue, nijūisseki no kimitachi e (Save Our Glass Planet, You Twenty-First-Century Folk)*. Tokyo: Kobunsha, 1996 (1st ed.), 2008 (20th repr.).

Tezuka, Osamu. *Manga no kakikata (Method for Drawing Manga)*. Tokyo: Kobunsha, 1996 (1st ed.), 2007 (10th repr.).

Tezuka, Osamu. *Tezuka Osamu manga zenshū,* no. 383, bekkan 1, *Tezuka Osamu Essei shū 1 (The Complete Manga of Tezuka Osamu,* no. 383, separate vol. no. 1, *Collected Essays of Tezuka Osamu).* Tokyo: Kōdansha, 1996 (1st ed.), 2008 (4th repr.).

Tezuka, Osamu. *Tezuka Osamu manga zenshū,* no. 400, bekkan 18, *Tezuka Osamu Kōen shū 1 (The Complete Manga of Tezuka Osamu,* no. 400, separate vol. no. 18, *Collected Lectures I).* Tokyo: Kōdansha, 1996 (1st ed.), 2008 (4th repr.).

Tezuka, Osamu. *Boku no manga jinsei (My Manga Life).* Tokyo: Iwanami Shoten, Iwanami Shinsho No 509, 1997 (1st ed.), 2006 (17th repr.).

Tezuka Productions, ed. *Dai ni kai tokubetsukōrōshō (The 2nd Award of Merit, Tokyo International Anime Fair 2006).* Tokyo: Tezuka Productions, 2006.

Tezuka Productions, ed. *Nihon no anime o tsukutta 20 nin, tokubetsu kōrōshō (The Award of Merit, Tokyo International Anime Fair 2005).* Tokyo: Tokyo Kokusai Anime Fair Jikkō Iin Kai, 2005.

Tezuka Productions, ed. *Tezuka Osamu Gekijō, Tezuka Osamu no anime-shon firumogurafi (The Animation Filmography of Tezuka Osamu and Tezuka Productions).* Tokyo: Tezuka Productions, 1991 (1st ed.), 2006.

Tezuka Productions, ed. *Tezuka Osamu Genga no himitsu (The Secret of Tezuka Osamu's Original Drawings).* Tokyo: Shinchōsha, Tonbō No Hon, 2006.

Tōei Animation Kabushikigaisha, ed. *Tōei Animation 50 nen shi 1956–2006 hashiridasu yume no saki ni (Tōei Animation Fiftieth Anniversary. Beyond the Dream).* Tokyo: Tōei Animation, 2006.

Toriyama, Sekien. *Gazu Hyakki yagyō zengashū (Illustrated Book of The Night Parade of One Hundred Demons),* full edition of these illustrations. Tokyo: Kadokawa, Kadokawa Sofia Bunko, 2006.

Toshio, Ban & Tezuka Productions. *Tezuka Osamu Monogatari 1928–59. Debut as a Comic Artist (A Story of Osamu Tezuka 1928–1959. Debut as a Comic Artist).* Tokyo: Asahi Shinbunsha, Asahi Bunko, 1994 (1st ed.).

Toshio, Ban & Tezuka Productions. *Tezuka Osamu Monogatari 1960–89. Dream of Creating New Comics and Animated Films (A Story of Osamu Tezuka 1960–89. Dream of Creating New Comics and Animated Films).* Tokyo: Asahi Shinbunsha, Asahi Bunko, 1994 (1st ed.).

Tsugata, Nobuyuki. *Nihon no animation no chikara, 85 nen no rekishi o tsuranuku futatsu no shijiku (The Power of Japanese Animation. The Two Pillars of This Eighty-Five Year History).* Tokyo: NTT, 2004.

Tsugata, Nobuyuki. *Animation gaku nyūmon (Introduction to the Science of Animation).* Tokyo: Heibonsha Shinsho 291, Heibonsha, 2005.

Tsugata, Nobuyuki. *Anime sakka toshite no Tezuka Osamu sono kiseki to honshitsu (Tezuka Osamu, Creator of Animated Films: the Origin and Essence of His Work).* Tokyo: NTT, 2007.

Tsuji, Masaki. *Bokutachi no anime shi (Our History of Animation)*. Tokyo: Iwanami Junior Shinsho 587, Iwanami Shoten, 2008.

Tsuji, Nobuo. *Kisō no zufu (Extraordinary Illustrations)*. Tokyo: Chikuma Bungei Bunko, 2005.

Watanabe, Yoshinori Ryōtoku, ed. *Nihon mangaka meikan 500, 1945–1992 (List of Five Hundred Mangaka, 1945–92)*. Tokyo: Akua puraningu, 1992.

Yamaguchi, Eiichi. *Shichōkaku media to kyōiku (Audiovisual Media and Education)*. Tokyo: Tamagawa University, 2004.

Yamaguchi, Katsunori and Yasushi Watanabe. *Nihon animation eiga-shi (History of Japanese Animation)*. Osaka: Yubunsha, 1977.

Yamamoto, Keiichi. *Nozoki karakuri (Optical Boxes)*. Tokyo: self-published, 1973.

Yamamoto, Keiichi. *Edo no kage-e asobi, hikari to kage no bunkashi (Shadowgraph Games in the Edo Period; a Cultural History of Light and Shade)*. Tokyo: Soshisha, 1988.

Yokochi, Kiyoshi. *Enkinhō de miru ukiyo-e Masanobu, Ōkyo, Hiroshige made (Perspective in Japanese Prints, from Masanobu, Ōkyo, to Hiroshige)*. Tokyo: Sanseido, 1995.

EXHIBITION CATALOGS AND PERIODICALS IN JAPANESE

Animage, 30th Anniversary. Tokyo: Tokuma Shoten, July 2008.

Aodo Denzen no jidai (The Age of Aodo Denzen) (exh. cat.). Fuchu Art Museum, 2006.

Bungei. Akatsuka Fujio. "Bungei bessatsu," special issue of *Bungei* magazine devoted to Akatsuka Fujio. Tokyo: Kawade Shobō Shinsha, 2008.

Chūgoku no yōfūga ten (Exhibition of Western-style Chinese Painting) (exh. cat.). Machida City Museum of Graphic Arts, 1995.

Dai Robotto ten, Karakuri kara anime, saishin robotto made (The Great Robot Exhibition, from Automata to Anime and the Latest Robots) (exh. cat.). Tokyo: Kokuritsu Kagaku Hakubutsukan, October 23, 2007–January 27, 2008.

Edo no monozukuri Akagi korekushon shiryō chōsa hōkoku (Objects Manufactured in the Edo Period). Results of the survey on the Akagi Collection by the Edo-Tokyo Museum, 2006.

Eiga isan, Tokyo kokuritsu kindai bijutsukan film center collection yori (The Japanese Film Heritage —From the Non-Film Collection of the National Film Center) (exh. cat.). Tokyo: The National Museum of Modern Art, January 2004.

Eizō taiken Museum, imajine-shon no mirai e (Museum of Visual Experience: Imagination of the Future) (exh. cat.). Tokyo: Tokyo-to Shashin Bijutsukan, March 1–May 19, 2002.

Emakimono anime no genryū (Illustrated Narrative Handscrolls: Origin of Animation) (exh. cat.). Chiba Shi Bijutsukan (Chiba City Museum), August 10–September 12, 1999.

Hanga Tōzai kōryū no nami (Hanga Waves of East–West Cultural Interchange) (exh. cat.). Hagi Uragami Museum et al., 2004–05.

Hyōgo Prefectural Museum of History and Kyoto International Manga Museum, eds. *Yōkai ga no keifu (The Genealogy of Graphic Depictions of Yōkai).* Tokyo: Fukurō no Hon, Kawade Shobō, 2009.

Ikoku e no bōken, kindai nihon bijutsu ni miru jōhō to gensō (The Admiring of Exotic Art, Intellectual and Creative Images of Japanese Pre-modern Times) (exh. cat.). Kobe City Museum, September 15–October 21, 2001.

Irie Collection 2 kōgaku Kangu (Irie Collection 2: Optical Toys). Himeji: Hyogo Prefectural Museum of History, 2008.

Kage-e no 19 seiki (Nineteenth-century Shadowgraphs). Tokyo: Suntory Museum, 1995.

Kawamoto, Kihachirō. Ningyō kono inochi aru mono (Kawamoto Kihachirō. These Dolls with a Life). Heibonsha/Bessatsu Taiyō, September 2007.

Kinema Junpo, "Ni dai animation sakka to sono shinsaku o tettei kenshō, Miyazaki Hayao, Gake no ue no *Ponyo,* Oshii Mamoru *The Sky Crawlers*" (Two Great Authors of Animation. Observations of Their Latest Work: Miyazaki Hayao's *Ponyo* and Ishii Mamoru's *The Sky Crawlers),* no. 1513. Asuka Shinsha, 2008.

Mad Mad House ni muchū (Mad about Madhouse). Tokyo: Ōkura, 2001.

Matsue shi Ōgaki no kageningyō, Edo jidai no kara-animation, (Shadowgraph Dolls from Matsue City's Ōgaki District, Edo Period Animation) (exh. cat.). Osaka: Kokuritsu Bunraku Gekijō (National Bunraku Theater), 1987.

Megane-e to Tōkaidō gojūsantsugi ten, seiyō no eikyō o uketa ukiyo-e (Exhibition of Images in Perspective and "The Fifty-Three Views of the Tōkaidō." Japanese Prints and How the West Influenced Them) (exh. cat.). Kobe City Museum, 1984.

Meiji nihon no gyaggu masuta-Kawanabe Kyōsai ten (Special Exhibition Kyōsai Manga Festa) (exh. cat.). Kyoto International Manga Museum, April 8–May 11, 2008.

Mizuki Shigeru to sekai no yōsei ten (Shigeru Mizuki & Fairies in the World) (exh. cat.). Takamatsu City Museum, July 31–September 6, 1998.

Nihon Manga Eiga no zenbō (Japanese Animated Films: A Complete View from Their Birth to "Spirited Away" and Beyond) (exh. cat.). Tokyo: The National Museum of Modern Art, July 17–August 31, 2004.

Sande Magajin no DNA—Shūkan shōnen Manga Magajin (DNA of "Sunday" & "Magazine": The Fifty Years of Weekly Shonen Manga Magazines) (exh. cat.). Kawasaki Shimin Museum and Kyoto International Manga Museum, July 18, 2009–September 6, 2010. Tokyo: PIA Kabushikigaisha, July 2009.

Tatsunoko puro no sekai (World of Tatsunoko Production) (exh. cat.). Hachiyōji City Museum, August 2008.

Toyota Collection Monozukuri no genryū (Toyota Collection: the Origins of Object Manufacture). Toyota Jidōsha, 2005.

Yokoyama Ryūichi kinen manga Kan (Yokoyama Memorial Manga Museum). Kōchi, 2002.

Acknowledgments

Sometimes it seems much more difficult to obtain reproduction rights for photographs of contemporary animated films and manga than for a work of art, however famous it may be! I am therefore deeply indebted to all of those who placed their trust in me, aware that my aim was to let people discover and appreciate Japanese culture and animation by taking the reader on an exciting trip through the history of Japan, the land that has spawned a unique form of graphics. For me, this book has been the opportunity to meet some wonderful people, passionate about their professions, who seek to go increasingly further in the field of artistic creation; I see in it a strong symbol of friendship and gratitude toward all the animation artists and various figures mentioned from publishing houses and production companies. There is no doubt that Japanese animation still has some fine surprises in store for us!

I would also like to personally thank:
Paule Adamy, Geneviève Aitken, Catherine Alestchenkoff, Ataka Satomi, Alain Barbier Sainte Marie, Sylvie Biancheri, Alice Bounphane, Isabelle Buthion, Chiba Tetsuya, Marie-Claude Coudert, Jean-Paul Desroches, Sachiyo Desroches, Fujiyama Tōru, Fukuma Junko, Fukusako Fukuyoshi, Fuse Naoto, Audrey Gay-Mazuel, Goromaru Koji, Gosho Kōtaro, Haraguchi Naoko, Hayashi Jōji, Studio Pierrot Igarashi Takao, Asia Ireton, Ishii Tōru, Ishikawa Mitsuhisa, Iwasaki Shinichirō, Iwase Yasuaki, Kagawa Masanobu, Kamiyama Fumiko, Kashihara Kenji, Katayose Satoshi, Katō Kunio, Katō Yoshio, Kawamoto Kihachirō, Kawanabe Kusumi, Kawasaki Yukio, Kotoku Minoru, Hélène-Flore Koyama, Koyama Katsufumi, Kévin Koyama, Koyama Shūko, Kubo Masakazu, Kumagai Gensuke, Kusube Sankichirō, Laurent Mannoni, Christophe Marquet, Maruyama Masao, Matsukubo Yoriko, Matsutani Takayuki, Mizuki Shigeru, Jacques Mulon, Martine Mulon-Richard, Mura Yukio, Nakajō Masataka, Nakayama Meguri, Naniwa Hiroko, Narushima Koki, Nishibayashi Akira, Nishimura Junko, Michelle-Esther Nissato-Paschier, Noguchi Atsushi, Obata Kyōko, Ochiai Emiko, Ōga Masahiro, Oguro Yūichirō, Oka Yasumasa, Okada Hidenori, Okamura Hideki, Ōki Hiroshi, Okuda Nanami, Ozawa Hiromu, Isabelle Philippe, Francesco Prandoni, Corinne Quentin, Marie Richard, Robert Richard, Rintarō, Saitō Akiko, Laurent Salomé, Satō Katayose, Satō Tsutomu, Shimada Eiji, Shimada Shinji, Shimizu Isao, Shimizu Shinji, Shimizu Yasumasa, Shimizu Yoshihiro, Shinmi Hidekazu, Shirai Katsuya, Shirasaki Keisuke, Suzuki Hiroko, Suzuki Kazuyoshi, Suzuki Mika, Suzuki Mitsumoto, Suzuki Shin. ichi,

Suzuki Sōichirō, Takahashi Ai, Takahashi Hiroshi, Takahashi Norio, Takekura Kazuko, Tanaka Atsushi, Tanaka Yoriko, Tomita Kyōko, Tsunoda Kazuho, Uchiyama Takeshi, Ueda Yoko, Yamada Naruhiko, Yamagata Fumio, Yamanashi Emiko, Yamazaki Emi, Ariane Yanagi, Yanagi Tomiko, Yanagisawa Kae, Yano Seiichi, Watanabe Hajime, Watanabe Hiroko, Watanabe Ryōtoku, Watanabe Yasushi, Yamazaki Emi, my family, my friends, and my students from Musashi University in Tokyo.

(For the Japanese people who have been mentioned above, we have followed the Japanese custom of placing the surname before the first name.)

Organizations and museums

IN JAPAN

Adachi Foundation for the Preservation of Woodcut Printing, BeCom, CO. LTD, Chiba Tetsuya Production, Dōjōji Temple, Edo-Tōkyō Museum, Fujifilm Create Image Tech., Fujio Productions, Gekidan Minwaza, Hyōgo Prefectural Museum of History, Imagi Studios, The Kawamoto Productions, Ltd, Kawanabe Kyōsai Memorial Museum Foundation, Kobe City Museum, Kōdansha, Kumon Institute of Education, Machida City Museum of Graphic Arts, Madhouse, Inc., Magic Factory, Matsue Kyōdōkan, Mizuki Shigeru Production, Mushi Production, Co., Ltd, Mizuki Production, Nagoya TV Japan, National Film Center, The National Museum of Modern Art Tokyo, Pierrot Corporation, Planetto eiga shiryō toshokan, Production I.G., Co., Ltd, ROBOT Communications Inc., Sakura Eiga-sha, SHIN-EI Animation Co., Ltd., Shogakukan, Shūeisha, SANRIO Company, LTD., Studio Pierrot, Suginami Animation Museum, Tatsunoko Production, Tezuka Productions Co., Ltd, TMS Entertainment, Ltd, Tōei Animation Co., Ltd, Tōkyō Bunkazai Kenkyūjo, Tokyo TV, Toyota Collection, Yanoman Corporation, Yokoyama Memorial Manga Museum.

OUTSIDE OF JAPAN

Cinémathèque française – Conservatoire des techniques (Paris), Grimaldi Forum de Monaco, musée d'Art et d'Histoire de Neuchâtel (Switzerland), musée des Beaux-Arts de la Ville de Rouen, R.M.N. (Paris), Van Gogh Museum (Amsterdam), Victoria & Albert Hall Museum (London).